Marymount '72
spring

Leonardo's Las

Finch '72 fall

St. Theresa p. 61 . Bernini

p. 46 Velazquez.

p. 168 "

excludes Mannerism —

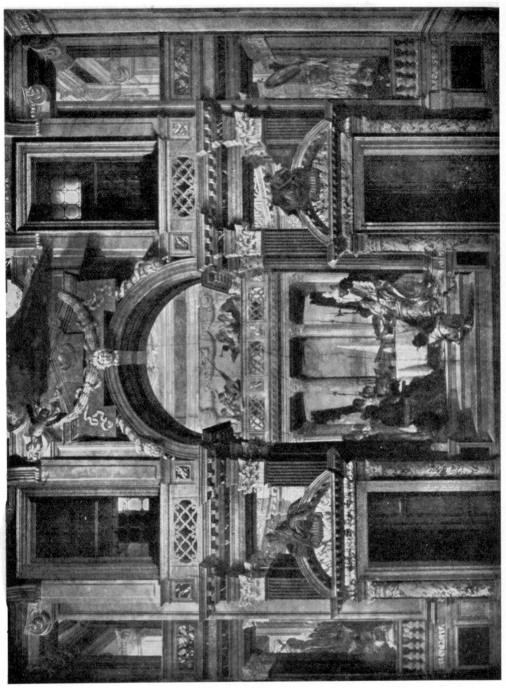

Venice, Palazzo Labia, G. B. Tiepolo. See Chaps. I. and II.

PRINCIPLES
OF ART HISTORY

THE PROBLEM OF THE DEVELOPMENT
OF STYLE IN LATER ART

BY

HEINRICH WÖLFFLIN

Translated by
M. D. HOTTINGER

DOVER PUBLICATIONS, INC.

This Dover edition, first published in 1950, is an
unabridged and unaltered republication of the Hot-
tinger translation of *Kunstgeschichtliche Grundbe-
griffe* originally published in 1932 by G. Bell and
Sons, Ltd.

Standard Book Number: 486-20276-3
Library of Congress Catalog Card Number: 50-4154

Manufactured in the United States of America
Dover Publications, Inc.
180 Varick Street
New York, N. Y. 10014

PREFACE TO THE SIXTH EDITION

THIS volume, the first [German] edition of which appeared in 1915,[1] is now for the sixth time issued in unaltered form. A few sentences, however, must here replace the lengthy prefaces to the earlier editions. The material which served to elucidate and amplify the original text has gradually grown to such dimensions that it can only find room in a separate second volume.

The following remarks will serve for general guidance. The "Principles" arose from the need of establishing on a firmer basis the classifications of art history: not the judgment of value—there is no question of that here—but the classifications of style. It is greatly to the interest of the historian of style first and foremost to recognise what mode of imaginative process he has before him in each individual case. (It is preferable to speak of modes of *imagination* rather than of modes of *vision*.) It goes without saying that the mode of imaginative beholding is no outward thing, but is also of decisive importance for the content of the imagination, and so far the history of these concepts also belongs to the history of mind.

The mode of vision, or let us say, of imaginative beholding, is not from the outset and everywhere the same, but, like every manifestation of life, has its development. The historian has to reckon with stages of the imagination. We know primitively immature modes of vision, just as we speak of "high" and "late" periods of art. Archaic Greek art, or the style of the sculptures on the west portal at Chartres, must not be interpreted as if it had been created to-day. Instead of asking "How do these works affect me, the modern man?" and estimating their expressional content by that standard, the historian must realise what choice of formal possibilities the epoch had at its disposal. An essentially different interpretation will then result.

The course of development of imaginative beholding is, to use an expression of Leibniz, "virtually" given, but in the actuality of history as lived, it is interrupted, checked, refracted in all kinds of ways. The present book, therefore, is not intended to give an extract from art history; it merely attempts to set up standards by which the historical transformations (and the national types) can be more exactly defined.

[1] The English translation, first published in 1932, is made from the Seventh German Edition.

Our formulation of the concepts, however, only corresponds to the development in later times. For other periods, they must undergo continual modification. Yet the schema has proved applicable even as far as the domains of Japanese and old Nordic art.

The objection that, by accepting a development of imagination determined by law, the significance of the artistic personality is destroyed, is puerile. Just as the growth of the human body proceeds by absolutely general laws without the individual form being prejudiced, so the law which governs the spiritual structure of mankind by no means conflicts with freedom. And when we say, men have always seen what they wished to see, that is a matter of course. The only question is how far this wish of mankind is subject to a certain inevitability, a question which certainly extends beyond aesthetics into the whole complex of historical life, even eventually into metaphysics.

A further problem, which this book only touches on without examining in detail, is the problem of continuity and periodicity. It is certain that history never returns to the same point, but it is just as certain that, within the total development, certain self-contained developments may be distinguished, and that the course of the development shows a certain parallelism. From our standpoint, namely, the course of development in later times, the problem of periodicity plays no part, but the problem is important, although it cannot be dealt with merely from the standpoint of the art historian.

And the further question of how far old products of vision are carried each time into a new phase of style, how a permanent development is commingled with special developments, can only be elucidated by detailed examination. We arrive thereby at units of very different degrees. Gothic architecture can be taken as a unit, but the whole development of northern medieval style can also be the unit whose curve is to be plotted out, and the results can claim equal validity. Finally, the development is not always synchronous in the different arts: a late style of architecture can continue to exist by the side of new original notions in plastic or painting, cf. the Venetian Quattrocento, until finally everything is reduced to the same visual denominator.

And as the great cross-sections in time yield no quite unified picture, just because the basic visual attitude varies, of its very nature, in the different races, so we must reconcile ourselves to the fact that within the same people —ethnographically united or not—different types of imagination constantly appear side by side. Even in Italy this disunion exists, but it comes most clearly to light in Germany. Grünewald is a different imaginative type from Dürer, although they are contemporaries. But we cannot say that that destroys the significance of the development in time: seen from a longer range,

these two types re-unite in a common style, *i.e.* we at once recognise the elements which unite the two as representatives of their generation. It is just this community co-existing with the greatest individual differences which this book sets out to reduce to abstract principles.

Even the most original talent cannot proceed beyond certain limits which are fixed for it by the date of its birth. Not everything is possible at all times, and certain thoughts can only be thought at certain stages of the development.

MUNICH, *Autumn*, 1922.

FOREWORD TO THE SEVENTH EDITION

THIS seventh edition is a reprint of the first with quite inessential alterations. The necessity of amplification referred to in the preceding foreword continues to exist. This will partly be remedied, as far as national differences in imaginative types are concerned, by a book shortly to be published, *Italien und das deutsche Formgefühl*. But for such problems of development as can only be imperfectly dealt with in the narrow limits of later art history, a book with the title *Entwickelungen* is projected.

ZURICH, *Summer*, 1929.

CONTENTS

The asterisks * behind the names of artists or works mentioned in the text refer to reproductions in the book.

PAGE

PREFACE TO THE SIXTH EDITION vii

FOREWORD TO THE SEVENTH EDITION ix

LIST OF ILLUSTRATIONS xiii

INTRODUCTION I
 The Double Root of Style—The Most General Representational Forms
 —Imitation and Decoration

I. LINEAR AND PAINTERLY
 General 18
 Linear (Draughtsmanly, Plastic) and Painterly—Tactile and
 Visual Picture—The "Picturesque" and its Opposite—Synthesis
 —Historical and National Characteristics
 Drawing 32
 Painting 41
 Painting and Drawing—Examples
 Sculpture 54
 General Remarks—Examples
 Architecture 62
 General Remarks

II. PLANE AND RECESSION
 Painting 73
 General Remarks — The Characteristic Motives — Subject
 Matter—Historical and National Characteristics
 Sculpture 106
 General Remarks—Examples
 Architecture 115

III. CLOSED AND OPEN FORM
 Painting 124
 General Remarks—The Principal Motives—Subject Matter—
 Historical and National Characteristics
 Sculpture 148
 Architecture 149

IV. Multiplicity and Unity PAGE

 Painting 155
 General Remarks—The Principal Motives—Subject Matter—
 Historical and National Characteristics
 Architecture 184
 General Remarks—Examples

V. Clearness and Unclearness

 Painting 196
 General Remarks—The Principal Motives—Subject Matter—
 Historical and National Characteristics
 Architecture 221

Conclusion 226
 External and Internal History of Art—Forms of Imitation and De-
 coration—The Why of the Development—Periodicity of the Develop-
 ment—The Problem of Recommencement—National Characteristics
 —Shifting of the Centre of Gravity

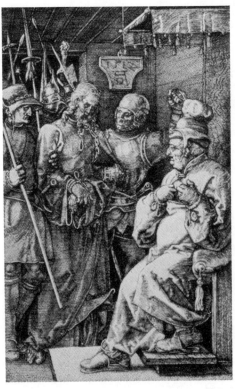

Dürer

LIST OF ILLUSTRATIONS

Names of places without special note (Berlin, Munich, etc.) refer to the great public collections.

1. PAINTING

	PAGE
Aertsen, Pieter, Kitchen Interior, Drawing, Berlin	96
Aldegrever, H., Male Portrait, Drawing (detail), Berlin . . .	35
Baroccio, F., Last Supper, Urbino, Cathedral	89
Berck-Heyde, G. A., Rathaus of Amsterdam, Dresden . . .	195
Bosch, H., Carnival, Drawing, Vienna, Albertina . . .	173
Botticelli, S., Venus (detail), Florence, Uffizi	2
Botticini, Franc., The Three Archangels, Florence, Accademia . .	102
Boucher, Girl on a Sofa, Munich	184
Bouts, Dirk, Portrait of a Man, New York, Metropolitan Museum . .	147
—— School of, St. Luke painting the Virgin, Penrhyn Castle . .	79
Bronzino, Aug., Eleanor of Toledo, Florence, Uffizi . . .	45
Brueghel, Jan, the Elder, Village on a River, Dresden . . .	213
Brueghel, Pieter, the Elder, Village Wedding, Vienna . . .	90
—— Huntsmen in the Snow	100
—— Rocky River Landscape	155
Canaletto, B., "Schlosshof", Vienna	122
Caroto, G. F., The Three Archangels, Verona	103
Cleve, Joos van (Master of the Death of Mary), The Death of Mary, Munich .	105
—— Pietà, Paris	212
Credi, Lor., Venus, Florence, Uffizi	3
—— Portrait of Verocchio, Florence, Uffizi	182
Dürer, Albrecht, Eve, Drawing, London (Lippmann 235) . . .	33
—— Portrait of B. van Orley, Dresden	42
—— St. Jerome in his Cell, Engraving	48
—— Landscape with Cannon, Etching	97
—— The Death of Mary, Woodcut from the Life of Mary . . .	159

xiii

PAGE

Dürer, Albrecht, Christ taken Prisoner, Woodcut from the Great Passion . 179

—— Christ before Caiaphas, Engraving from the Engraved Passion . . xii

Dyck, Ant. Van, The Miraculous Draught of Fishes, London . . 81

Franciabigio, Venus, Rome, Borghese Gallery 140

Goes, Hugo van der, Pietà, Vienna 92

—— Adam and Eve, Vienna 181

Goyen, Jan van, River Landscape, Drawing, Berlin 1

—— Huts among Trees, Dresden 83

Hals, Frans, Portrait of a Man, Petrograd 43

Hobbema, Landscape with Windmill, London, Buckingham Palace . 7

Holbein, Hans, the Younger, Portrait of Jean de Dinteville (detail) . 167

—— Costume Sketch, Basle 37

—— Tankard (Etching by Wenzel Hollar) 224

Hooch, Pieter, The Mother, Berlin 205

Huber, Wolf, Golgotha, Drawing, Vienna, Albertina 39

Isenbrant, Adr., Rest on the Flight, Munich 143

Janssens, Pieter, Woman Reading, Munich 133

Lievens, Jan, Portrait of the Poet Jan Vos (detail), Frankfort, Städel. . 36

Massys, Quinten, Pietà, Antwerp 91

Master of the Life of Mary, The Birth of Mary, Munich . . . 104

Master of the Death of Mary (Joos van Cleve), The Death of Mary, Munich 105

—— Pietà, Paris 212

Metsu, G., The Music Lesson, The Hague 5

—— Costume Sketch, Vienna 38

Neefs, Pieter, the Elder, Church Interior, Amsterdam . . . 215

Orley, Barend van, Portrait of Carandolet, Munich 136

—— Rest on the Flight, Vienna 144

Ostade, Adr. van, Studio 49

—— Peasant Inn, Drawing, Berlin 173

Palma Vecchio, Adam and Eve, Brunswick 76

Patenir, Baptism of Christ, Vienna 145

Raphael, Disputa (Baroque Copy in Relief), Munich, National Museum . 130

—— The Miraculous Draught of Fishes, London 81

—— Portrait of Pietro Aretino (Engraving by Marc Anton) . . . 183

Rembrandt, Female Nude, Drawing, Budapest 34

—— The Good Samaritan, Paris 95

—— Landscape with Hunters, Etching 99

PAGE

Rembrandt, The Supper at Emmaus, Paris 129

—— Deposition, Etching 157

—— The Death of Mary, Etching 160

—— Christ Preaching, Etching 164

—— The "Staalmeesters", Amsterdam 172

—— Landscape with Three Oaks, Etching 177

—— Emmaus, Etching 201

—— The So-called Woman with the Arrow, Etching 217

Reni, Guido, Mary Magdalene, Rome, Capitoline Gallery . . . 139

Rubens, Landscape with Cattle, London, Buckingham Palace . . 8

—— Abraham and Melchisidec (Engraving by J. Witdoek) . . . 80

—— The Bearing of the Cross (Engraving by P. Pontius) . . . 93

—— Pietà, Vienna 123

—— Portrait of Dr. Thulden, Munich 137

—— Andromeda, Berlin 141

—— The Virgin with Saints (Engraving by H. Snyers) . . . 142

—— The Assumption (Engraving by Schelte a Bolswert) . . . 162

—— The Mechlin Hay Harvest, Florence, Pitti 176

Ruysdael, Jakob, Marsh in a Wood, Munich 7

—— Castle of Bentheim (Etching by W. Unger), Amsterdam . . 86

—— View of Haarlem, The Hague 146

Schongauer, Martin, Christ taken Prisoner, Engraving . . . 178

—— Christ before Annas, Engraving 219

Scorel, Jan van, Magdalene, Amsterdam 138

Terborch, Ger., Chamber Music, Paris 4

—— The So-called Paternal Admonishment (Etching by W. Unger), Amster-
dam 207

Tiepolo, G. B., The Last Supper, Paris 88

—— Fresco in the Palazzo Labia, Venice . . . *Frontispiece*

Tintoretto, Adam and Eve, Venice, Accademia 77

—— The Presentation of the Virgin in the Temple, Venice, Santa Maria
dell' Orto 210

—— Pietà, Venice, Accademia 211

Titian, Venus, Florence, Uffizi 170

—— Mountain Village, Drawing, Paris 98

Velde, A. v. d., Hut in Trees, Drawing, Berlin 40

Velasquez, Infanta Margareta Theresa, Vienna 46

PAGE

Velasquez, Cardinal Borgia, Frankfort, Städel 168

—— Venus, London 171

Vellert, Dirk, The Child Saul before the High Priest, Drawing, Vienna,

 Albertina 166

Vermeer, Jan, Painter with Model, Vienna, Czernin Gallery . . . 78

—— The Music Lesson, Windsor 84

—— Street in Delft, Amsterdam 214

Witte, E. de, Church Interior, Amsterdam 216

2. SCULPTURE

Bernini, Cardinal Borghese, Rome, Borghese Gallery 58

—— Ecstasy of St. Theresa, Rome, S. Maria della Vittoria . . . 61

—— Tomb of Alexander VII., Rome, St. Peter's 107

—— The Blessed Albertona, Rome, S. Francesco a ripa . . . 112

Majano, Benedetto da, Portrait of Pietro Mellini, Florence, Museo Nazionale 57

Puget, The Blessed A. Sauli, Genoa, S. Maria di Carignano . . . 60

Sansovino, J., St. James, Florence, Duomo (the staff has been added in the

 reproduction) 59

3. ARCHITECTURE

Florence, Palazzo Rucellai 188

Munich, Archiepiscopal Palace (Pal. Holnstein) 191

—— Choir Stalls, St. Peter's (Munich) 193

Rome, S. Agnese, Piazza Navona 17

—— SS. Apostoli 69

—— S. Andrea della Valle 70

—— Fontana Trevi 113

—— Villa Borghese 117

—— Scala Regia, Vatican 118

—— Palazzo della Cancelleria 189

—— Palazzo Odescalchi 190

—— Palazzo Madama 192

Vienna, Vase in the Schwarzenberg Garden 225

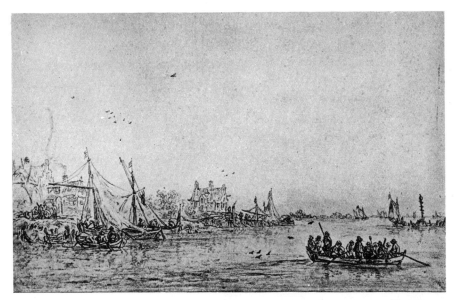

Van Goyen

INTRODUCTION

1. THE DOUBLE ROOT OF STYLE

LUDWIG RICHTER relates in his reminiscences how once, when he was in Tivoli as a young man, he and three friends set out to paint part of the landscape, all four firmly resolved not to deviate from nature by a hair's-breadth; and although the subject was the same, and each quite creditably reproduced what his eyes had seen, the result was four totally different pictures, as different from each other as the personalities of the four painters. Whence the narrator drew the conclusion that there is no such thing as objective vision, and that form and colour are always apprehended differently according to temperament.

For the art historian, there is nothing surprising in this observation. It has long been realised that every painter paints "with his blood". All the distinction between individual masters and their "hand" is ultimately based on the fact that we recognise such types of individual creation. With taste set in the same direction (we should probably find the four Tivoli landscapes rather similar, of a Preraphaelite type), the line will be in one case more angular, in another rounder, its movement here rather halting and slow, there more streaming and urgent. And, just as proportions tend now to the slender, now to the broad, so the modelling of the human body appeals to the one as

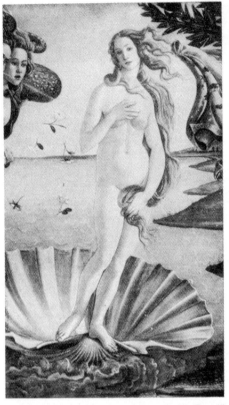

Botticelli (Detail)

something rather full and fleshy, while the same curves and hollows will be seen by another with more reticence, with much more economy. It is the same with light and colour. The sincerest intention to observe accurately cannot prevent a colour looking now warmer, now cooler, a shadow now softer, now harder, a light now more languid, now more vivid and glancing.

If we are no longer bound by a common subject from nature, these *individual styles* become, of course, much more distinct. Botticelli and Lorenzo di Credi are two painters related by epoch and race, both Florentines of the later Quattrocento. But when Botticelli*[1] draws a female body, its stature and shape is perceived in a way peculiar to him, and as radically and unmistakably different from any female nude of Lorenzo's* as an oak from a lime. The impetuosity of Botticelli's drawing endows every form with a peculiar verve and animation. In Lorenzo's deliberate modelling, vision is essentially fulfilled by the object in repose. Nothing is more illuminating than to compare the similar curve of the arm in the two pictures. The sharp elbow, the spirited line of the forearm, the radiant spread of the fingers on the breast, the energy which charges every line—that is Botticelli. Credi, on the other hand, produces a more flaccid effect. Though very convincingly modelled, that is, conceived in volumes, his form still does not possess the impetus of Botticelli's contours. That is a difference of temperament, and that difference penetrates throughout, whether we compare the whole or the details. In the drawing of a mere nostril, we have to recognise the essential character of a style.

For Credi, a definite person posed. That is not the case with Botticelli, yet

[1] Asterisks behind the names of artists or works mentioned in the text refer to reproductions in the book, to find which the List of Illustrations should, if necessary, be consulted.

it is not difficult to see that the conception of form in the two artists is bound up with a definite notion of beautiful form and beautiful movement, and if Botticelli has given full play to his ideal of form in the slender erectness of his figure, even with Credi we feel that the special case of reality has in no way prevented him from expressing *his* temperament in the pose and proportions of his figure.

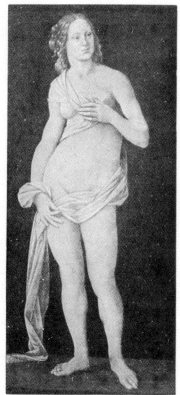

Lorenzo di Credi

The psychologist of style finds a particularly rich booty in the stylised drapery of this epoch. With relatively few elements, an enormous variety of widely differing individual expression has here come to birth. Hundreds of artists have depicted the Virgin seated with the drapery pouched between the knees, and every time a form has been found which reveals a whole man. And yet it is not only in the great line of Italian renaissance art, but even in the painterly[1] style of the Dutch genre painters of the seventeenth century that drapery has this psychological significance.

As is well known, satin was a favourite subject of Terborch's,* and he painted it specially well. It seems as if the fine material could not look otherwise than it is shown here, yet it is only the artist's innate distinction which speaks to us in his forms, and even Metsu* saw the phenomenon of these fold-formations essentially differently. The fabric is apprehended as something rather weighty in fall and fold, the ridge of the fold is less delicate, each of its curves lacks elegance, and from the whole sequence of folds, the pleasing ease, the brio has vanished. It is still satin, and painted by a master, but seen beside Terborch's, Metsu's fabric looks almost dull.

And now, in our picture, that is not merely the result of a chance off-day. The spectacle is repeated, and so characteristic is it that we can continue on

[1] *Malerisch.* This word has, in the German, two distinct meanings, one objective, a quality residing in the object, the other subjective, a mode of apprehension and creation. To avoid confusion, they have been distinguished in English as "picturesque" and "painterly" respectively. (Tr.)

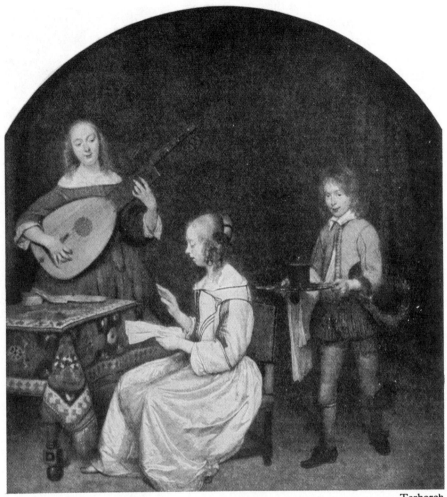

Terborch

the same lines if we proceed to the analysis of figures and grouping. Consider the bare arm of the music-making lady in Terborch's picture—how finely it is felt in joint and movement, and how much heavier Metsu's figure seems— not because it is less skilfully drawn, but because it is felt differently. In Terborch, the grouping is light and the figures are bathed in air. Metsu gives something more massive and compact. An accumulation such as the bundled folds of the thick table-cloth with the writing materials could not be found in Terborch.

And so on. And if, in our reproduction, there is little trace of the shimmering lightness of Terborch's tonal gradations, the rhythm of the whole still

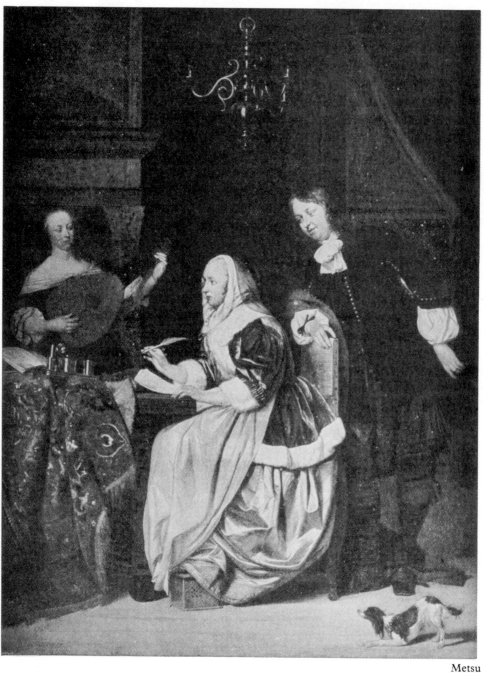

Metsu

speaks an audible language, and it requires no special persuasion to see in the equipoise of the parts an art inwardly related to the drawing of the folds.

The problem remains identical in the trees of landscape painters. A bough, a fragment of a bough, and we can say whether Ruysdael or Hobbema is the painter, not from isolated external features of the "manner", but because all the essentials of the sense of form exist even in the smallest fragment. Hobbema's* trees, even when he paints the same species as Ruysdael,* will always seem lighter, their outlines are freer, they rise more airily in space. Ruysdael's graver style charges the line with a peculiar ponderous emphasis, he loves the slowly undulating outline, he holds the masses of foliage more compactly together, and thoroughly characteristic of his pictures is the way in which he prevents any separation of the individual forms, but gives a close-knit weft. Trees and mountain contours meet in sombre contact. While Hobbema, on the other hand, loves the graceful, bounding line, the diffused mass, the variegated terrain, and charming vignettes and vistas—every part seems like a picture within a picture.

With ever-increasing subtlety, we must try in this way to reveal the connection of the part with the whole, so that we may arrive at the definition of individual types of style, not only in design, but in lighting and colour. We shall realise that a certain conception of form is necessarily bound up with a certain tonality and shall gradually come to understand the whole complex of personal characteristics of style as the expression of a certain temperament. For descriptive art history there is much to be done here.

The course of the development of art, however, cannot simply be reduced to a series of separate points. Individuals fall into larger groups. Botticelli and Lorenzo di Credi, for all their differences, have still, as Florentines, a certain resemblance when compared with any Venetian, and Hobbema and Ruysdael, however divergent they may be, are immediately homogeneous as soon as to them, as Dutchmen, a Fleming like Rubens is opposed. That is to say: to the personal style must be added *the style of the school, the country, the race.*

Let us define Dutch art by contrasting it with Flemish art. The flat meadows round Antwerp present in themselves no other scene than the Dutch pastures to which native artists have given the expression of the most widespread tranquillity. But when Rubens* handles these themes, the subject looks totally different: the earth rolls in vigorous waves, tree-trunks writhe passionately upwards, and their foliage is handled so completely in closed masses that Ruysdael and Hobbema in comparison appear as equally delicate silhouettists. Dutch subtlety beside Flemish massiveness. In comparison with

Hobbema

Ruysdael

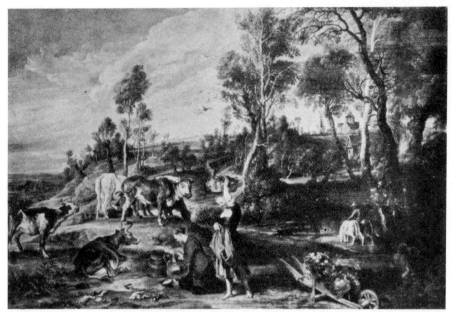

Rubens

the energy of movement in Rubens' design, Dutch design in general is restful, whether it be the rise of a hill or the curve of a petal. No Dutch tree-trunk has the dramatic force of the Flemish movement, and even Ruysdael's mighty oaks look slender beside Rubens' trees. Rubens raises the horizon high and makes the picture heavy, the Dutch relation of sky and earth is radically different: the horizon lies low, and it even happens that four-fifths of the picture is given up to air.

These are considerations which only become valuable when they can be generalised. The subtlety of Dutch landscape must be linked up with allied phenomena and pursued into the domain of the tectonic. The courses of a brick wall or the weaving of a basket are felt in Holland as peculiarly as the foliage of the trees. It is characteristic that not only a miniaturist like Dow but even a narrator like Jan Steen has time, in the midst of the most boisterous scene, for the accurate drawing of a wicker work. And the network of whitened joints on a brick wall, the pattern of neatly set flagstones, all these small details are really enjoyed by the architectural painters. As to Dutch architecture proper, however, we may say that stone seems here to have achieved a quite specific lightness. A typical building such as the Rathaus of Amsterdam avoids everything which, had it been conceived by a Flemish imagination, might have invested the great mass of stone with an appearance of weight.

We encounter here at all points the bases of national feeling, where the sense of form comes into immediate contact with spiritual and moral elements, and art history has grateful tasks before it as soon as it takes up systematically this question of the national psychology of form. Everything hangs together. The still poses of the Dutch figure pictures also form the bases of the objects of the architectural world. But if we bring Rembrandt into the matter, with his feeling for the living quality of light which, withdrawing from every substantial form, moves mysteriously in infinite spaces, we might easily be tempted to develop the observation into an analysis of Germanic art in contrast to Romanesque art in general.

But here the problem already branches. Although in the seventeenth century, Dutchman and Fleming are still clearly distinguishable, we cannot forthwith base a general judgment of a national type on one single epoch. Different times give birth to different art. Epoch and race interact. We must first establish how many general traits a style contains before we can give it the name of a national style in a special sense. However profoundly Rubens may impress his personality on his landscape, and however many talents may veer to his pole, we cannot admit that he was an expression of "permanent" national character to the same extent as contemporary Dutch art. The colour of time is stronger with him. His art is powerfully affected by a particular cultural current, the mode of feeling of Roman baroque, and so it is he, rather than the "timeless" Dutch artists, who challenges us to form an idea of what we must call *"period" style*.

This idea is best to be obtained in Italy, because the development there fulfilled itself independently of outside influences and the general nature of the Italian character remains fully recognisable throughout. The transition from renaissance to baroque is a classic example of how a new *zeitgeist* enforces a new form.

Here we enter upon much-trodden paths. Nothing is more natural to art history than to draw parallels between periods of culture and periods of style. The columns and arches of the High Renaissance speak as intelligibly of the spirit of the time as the figures of Raphael, and a baroque building represents the transformation of ideals no less clearly than a comparison between the sweeping gestures of Guido Reni and the noble restraint and dignity of the Sistine Madonna.

Let us this time remain on strictly architectural ground. The central idea of the Italian Renaissance is that of perfect proportion. In the human figure as in the edifice, this epoch strove to achieve the image of perfection at rest within itself. Every form developed to self-existent being, the whole freely

co-ordinated: nothing but independently living parts. The column, the panel, the volume of a single element of a space as of a whole space—nothing here but forms in which the human being may find an existence satisfied in itself, extending beyond human measure, but always accessible to the imagination. With infinite content, the mind apprehends this art as the image of a higher, free existence in which it may participate.

The baroque uses the same system of forms, but in place of the perfect, the completed, gives the restless, the becoming, in place of the limited, the conceivable, gives the limitless, the colossal. The ideal of beautiful proportion vanishes, interest concentrates not on being, but on happening. The masses, heavy and thickset, come into movement. Architecture ceases to be what it was in the Renaissance, an art of articulation, and the composition of the building, which once raised the impression of freedom to its highest pitch, yields to a conglomeration of parts without true independence.

This analysis is certainly not exhaustive, but it will serve to show in what way styles express their epoch. It is obviously a new ideal of life which speaks to us from Italian baroque, and although we have placed architecture first as being the most express embodiment of that ideal, the contemporary painters and sculptors say the same thing in their own language, and whoever tries to reduce the psychic bases of style to abstract principles will probably find the decisive word here more readily than with the architects. The relationship of the individual to the world has changed, a new domain of feeling has opened, the soul aspires to dissolution in the sublimity of the huge, the infinite. "Emotion and movement at all costs." Thus does the Cicerone formulate the nature of this art.

We have, in thus sketching three examples of individual style, national style, and period style, illustrated the aims of an art history which conceives style primarily as expression, expression of the temper of an age and a nation as well as expression of the individual temperament. It is obvious that with all that, the quality of the work of art is not touched: temperament certainly makes no work of art, but it is what we might call the material element of style taken in the broad sense that the particular ideal of beauty (of the individual as of the community) is included in it too. Works of art history of this kind are still far from the perfection they might attain, but the task is inviting and grateful.

Artists are certainly not readily interested in historical questions of style. They take work exclusively from the standpoint of quality—is it good, is it self-sufficing, has nature found a vigorous and clear presentment? Everything else is more or less indifferent. We have but to read Hans van Marées when

he writes that he is learning to attach less and less value to schools and personalities in order only to keep in view the solution of the artistic problem, which is ultimately the same for Michelangelo as for Bartholomew van der Helst. Art historians who, on the other hand, take the differences between the finished products as their point of departure have always been exposed to the scorn of the artists: they have taken the detail for the essence: they cling just to the non-artistic side in man in wishing to understand art as expression only. We can very well analyse the temperament of an artist and still not explain how the work came into being, and the description of all the differences between Raphael and Rembrandt is merely an evasion of the main problem, because the important point is not to show the difference between the two but how both, in different ways, produced the same thing—namely, great art.

It is hardly necessary here to take up the cudgels for the art historian and defend his work before a dubious public. The artist quite naturally places the general canon of art in the foreground, but we must not carp at the historical observer with his interest in the variety of forms in which art appears, and it remains no mean problem to discover the conditions which, as material element—call it temperament, *zeitgeist*, or racial character—determine the style of individuals, periods, and peoples.

Yet an analysis with quality and expression as its objects by no means exhausts the facts. There is a third factor—and here we arrive at the crux of this enquiry—the mode of representation as such. Every artist finds certain visual possibilities before him, to which he is bound. Not everything is possible at all times. Vision itself has its history, and the revelation of these visual strata must be regarded as the primary task of art history.

Let us try to make the matter clear by examples. There are hardly two artists who, although contemporaries, are more widely divergent by temperament than the baroque master Bernini and the Dutch painter Terborch Confronted with the turbulent figures of Bernini, who will think of the peaceful, delicate little pictures of Terborch? And yet, if we were to lay drawings by the two masters side by side and compare the general features of the technique, we should have to admit that there is here a perfect kinship. In both, there is that manner of seeing in patches instead of lines, something which we can call painterly, which is the distinguishing feature of the seventeenth century in comparison with the sixteenth. We encounter here a kind of vision in which the most heterogeneous artists can participate because it obviously does not bind them to a special mode of expression. Certainly an artist like Bernini needed the painterly style to say what he had to say, and it is absurd to wonder how he would have expressed himself in the draughtsmanly style of the six-

teenth century. But we are clearly dealing with other concepts here than when we speak, for instance, of the energy of the baroque handling of masses in contrast to the repose and reserve of the High Renaissance. Greater or less movement are expressional factors which can be measured by one and the same standard: painterly and draughtsmanly, on the other hand, are like two languages, in which everything can be said, although each has its strength in a different direction and may have proceeded to visibility from a different angle.

Another example. We can analyse Raphael's line from the point of view of expression, describe its great noble gait in contrast to the pettier fussiness of Quattrocento outlines: we can feel in the movement of the line in Giorgione's Venus the kinship with the Sistine Madonna and, turning to sculpture, discover in Sansovino's youthful Bacchus the new, long, continuous line, and nobody will deny that we feel in this great creation the breath of the new sixteenth century feeling: it is no mere superficial history-writing to connect in this way form and spirit. But the phenomenon has another side. By explaining great line, we have not explained line. It is by no means a matter of course that Raphael and Giorgione and Sansovino sought expressive force and formal beauty in line. But it is again a question of international connections. The same period is for the north, too, a period of line, and two artists who, as personalities, have little in common, Michelangelo and Hans Holbein the Younger, resemble each other in that they both represent the type of quite strictly linear design. In other words, there can be discovered in the history of style a substratum of concepts referring to representation as such, and one could envisage a history of the development of occidental seeing, for which the variations in individual and national characteristics would cease to have any importance. It is certainly no easy task to reveal this inward visual development, because the representational possibilities of an epoch are never shown in abstract purity but, as is natural, are always bound to a certain expressional content, and the observer is then generally inclined to seek in the expression the explanation of the whole artistic product.

When Raphael erects his pictorial edifices and, by strict observance of rules, achieves the impression of reserve and dignity to an unprecedented degree, we can find in his special problem the impulse and the goal, and yet the tectonics of Raphael are not entirely to be attributed to an intention born of a state of mind: it is rather a question of a representational form of his epoch which he only perfected in a certain way and used for his own ends. Similar solemn ambitions were not lacking later, but it was impossible to revert to his formulas. French classicism of the seventeenth century rests on

another visual basis, and hence, with a similar intention, necessarily arrives at other results. By attributing everything to expression alone, we make the false assumption that for every state of mind the same expressional methods were always available.

And when we speak of the progress of imitation, of the new impressions of nature which an epoch produced, that is also a material element which is bound to *a priori* forms of representation. The observations of the seventeenth century were not merely woven into the fabric of Cinquecento art. The whole groundwork changed. It is a mistake for art history to work with the clumsy notion of the imitation of nature, as though it were merely a homogeneous process of increasing perfection. All the increase in the "surrender to nature" does not explain how a landscape by Ruysdael differs from one by Patenir, and by the "progressive conquest of reality" we have still not explained the contrast between a head by Frans Hals and one by Dürer. The imitative content, the subject matter, may be as different in itself as possible, the decisive point remains that the conception in each case is based on a different visual schema—a schema which, however, is far more deeply rooted than in mere questions of the progress of imitation. It conditions the architectural work as well as the work of representative art, and a Roman baroque façade has the same visual denominator as a landscape by Van Goyen.

2. The Most General Representational Forms

This volume is occupied with the discussion of these universal forms of representation. It does not analyse the beauty of Leonardo but the element in which that beauty became manifest. It does not analyse the representation of nature according to its imitational content, and how, for instance, the naturalism of the sixteenth century may be distinguished from that of the seventeenth, but the mode of perception which lies at the root of the representative arts in the various centuries.

Let us try to sift out these basic forms in the domain of more modern art. We denote the series of periods with the names Early Renaissance, High Renaissance, and Baroque, names which mean little and must lead to misunderstanding in their application to south and north, but are hardly to be ousted now. Unfortunately, the symbolic analogy bud, bloom, decay, plays a secondary and misleading part. If there is in fact a qualitative difference between the fifteenth and sixteenth centuries, in the sense that the fifteenth had gradually to acquire by labour the insight into effects which was at the free disposal of the sixteenth, the (classic) art of the Cinquecento and the

(baroque) art of the Seicento are equal in point of value. The word classic here denotes no judgment of value, for baroque has its classicism too. Baroque (or, let us say, modern art) is neither a rise nor a decline from classic, but a totally different art. The occidental development of modern times cannot simply be reduced to a curve with rise, height, and decline: it has two culminating points. We can turn our sympathy to one or to the other, but we must realise that that is an arbitrary judgment, just as it is an arbitrary judgment to say that the rose-bush lives its supreme moment in the formation of the flower, the apple-tree in that of the fruit.

For the sake of simplicity, we must speak of the sixteenth and seventeenth centuries as units of style, although these periods signify no homogeneous production, and, in particular, the features of the Seicento had begun to take shape long before the year 1600, just as, on the other hand, they long continued to affect the appearance of the eighteenth century. Our object is to compare type with type, the finished with the finished. Of course, in the strictest sense of the word, there is nothing "finished": all historical material is subject to continual transformation; but we must make up our minds to establish the distinctions at a fruitful point, and there to let them speak as contrasts, if we are not to let the whole development slip through our fingers. The preliminary stages of the High Renaissance are not to be ignored, but they represent an archaic form of art, an art of primitives, for whom established pictorial form does not yet exist. But to expose the individual differences which lead from the style of the sixteenth century to that of the seventeenth must be left to a detailed historical survey which will, to tell the truth, only do justice to its task when it has the determining concepts at its disposal.

If we are not mistaken, the development can be reduced, as a provisional formulation, to the following five pairs of concepts:

(1) The development from the linear to the painterly, *i.e.* the development of line as the path of vision and guide of the eye, and the gradual depreciation of line: in more general terms, the perception of the object by its tangible character—in outline and surfaces—on the one hand, and on the other, a perception which is by way of surrendering itself to the mere visual appearance and can abandon "tangible" design. In the former case the stress is laid on the limits of things; in the other the work tends to look limitless. Seeing by volumes and outlines isolates objects: for the painterly eye, they merge. In the one case interest lies more in the perception of individual material objects as solid, tangible bodies; in the other, in the apprehension of the world as a shifting semblance.

(2) The development from plane to recession. Classic[1] art reduces the parts of a total form to a sequence of planes, the baroque emphasises depth. Plane is the element of line, extension in one plane the form of the greatest explicitness: with the discounting of the contour comes the discounting of the plane, and the eye relates objects essentially in the direction of forwards and backwards. This is no qualitative difference: with a greater power of representing spatial depths, the innovation has nothing directly to do: it signifies rather a radically different mode of representation, just as "plane style" in our sense is not the style of primitive art, but makes its appearance only at the moment at which foreshortening and spatial illusion are completely mastered.

(3) The development from closed to open form. Every work of art must be a finite whole, and it is a defect if we do not feel that it is self-contained, but the interpretation of this demand in the sixteenth and seventeenth centuries is so different that, in comparison with the loose form of the baroque, classic design may be taken as *the* form of closed composition. The relaxation of rules, the yielding of tectonic strength, or whatever name we may give to the process, does not merely signify an enhancement of interest, but is a new mode of representation consistently carried out, and hence this factor is to be adopted among the basic forms of representation.

(4) The development from multiplicity to unity. In the system of a classic composition, the single parts, however firmly they may be rooted in the whole, maintain a certain independence. It is not the anarchy of primitive art: the part is conditioned by the whole, and yet does not cease to have its own life. For the spectator, that presupposes an articulation, a progress from part to part, which is a very different operation from perception as a whole, such as the seventeenth century applies and demands. In both styles unity is the chief aim (in contrast to the pre-classic period which did not yet understand the idea in its true sense), but in the one case unity is achieved by a harmony of free parts, in the other, by a union of parts in a single theme, or by the subordination, to one unconditioned dominant, of all other elements.

(5) The absolute and the relative clarity of the subject. This is a contrast which at first borders on the contrast between linear and painterly. The representation of things as they are, taken singly and accessible to plastic feeling, and the representation of things as they look, seen as a whole, and rather by their non-plastic qualities. But it is a special feature of the classic age that it developed an ideal of perfect clarity which the fifteenth century

[1] "Klassisch." The word "classic" throughout this book refers to the art of the High Renaissance. It implies, however, not only a historical phase of art, but a special mode of creation of which that art is an instance. (Tr.)

only vaguely suspected, and which the seventeenth voluntarily sacrificed. Not that artistic form had become confused, for that always produces an unpleasing effect, but the explicitness of the subject is not longer the sole purpose of the presentment. Composition, light, and colour no longer merely serve to define form, but have their own life. There are cases in which absolute clarity has been partly abandoned merely to enhance effect, but "relative" clarity, as a great all-embracing mode of representation, first entered the history of art at the moment at which reality is beheld with an eye to other effects. Even here it is not a difference of quality if the baroque departed from the ideals of the age of Dürer and Raphael, but, as we have said, a different attitude to the world.

3. IMITATION AND DECORATION

The representational forms here described are of such general significance that even widely divergent natures such as Terborch and Bernini—to repeat an example already used—can find room within one and the same type. The community of style in these two painters rests on what, for people of the seventeenth century, was a matter of course—certain basic conditions to which the impression of living form is bound without a more special expressional value being attached to them.

They can be treated as forms of representation or forms of beholding: in these forms nature is seen, and in these forms art manifests its contents. But it is dangerous to speak only of certain "states of the eye" by which conception is determined: every artistic conception is, of its very nature, organised according to certain notions of pleasure. Hence our five pairs of concepts have an imitative and a decorative significance. Every kind of reproduction of nature moves within a definite decorative schema. Linear vision is permanently bound up with a certain idea of beauty and so is painterly vision. If an advanced type of art dissolves the line and replaces it by the restless mass, that happens not only in the interests of a new verisimilitude, but in the interests of a new beauty too. And in the same way we must say that representation in a plane type certainly corresponds to a certain stage of observation, but even here the schema has obviously a decorative side. The schema certainly yields nothing of itself, but it contains the possibility of developing beauties in the arrangement of planes which the recessional style no longer possesses and can no longer possess. And we can continue in the same way with the whole series.

But then, if these more general concepts also envisage a special type of beauty, do we not come back to the beginning, where style was conceived as

the direct expression of temperament, be it the temperament of a time, of a people, or of an individual? And in that case, would not the only new factor be that the section was cut lower down, the phenomena, to a certain extent, reduced to a greater common denominator?

In speaking thus, we should fail to realise that the second terms of our pairs of concepts belong of their very nature to a different species, in so far as these concepts, in their transformations, obey an inward necessity. They represent a rational psychological process. The transition from tangible, plastic, to purely visual, painterly perception follows a natural logic, and could not be reversed. Nor could the transition from tectonic to a-tectonic, from the rigid to the free conformity to law.

To use a parable. The stone, rolling down the mountain side, can assume quite different motions according to the gradient of the slope, the hardness or softness of the ground, etc., but all these possibilities are subject to one and the same law of gravity. So, in human psychology, there are certain developments which can be regarded as subject to natural law in the same way as physical growth. They can undergo the most manifold variations, they can be totally or partially checked, but, once the rolling has started, the operation of certain laws may be observed throughout.

Nobody is going to maintain that the "eye" passes through developments on its own account. Conditioned and conditioning, it always impinges on other spiritual spheres. There is certainly no visual schema which, arising only from its own premisses, could be imposed on the world as a stereotyped pattern. But although men have at all times seen what they wanted to see, that does not exclude the possibility that a law remains operative throughout all change. To determine this law would be a central problem, the central problem of a history of art.

We shall return to this point at the end of our enquiry.

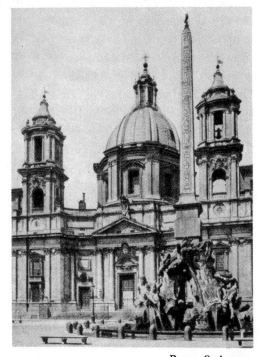

Rome, S. Agnese

I

LINEAR AND PAINTERLY

GENERAL OBSERVATIONS

1. Linear (draughtsmanly, plastic) and Painterly
Tactile and Visual Picture

IF we wish to reduce the difference between the art of Dürer and the art of Rembrandt to its most general formulation, we say that Dürer is a draughtsman and Rembrandt a painter. In speaking thus, we are aware of having gone beyond a personal judgment and characterised a difference of epoch. Occidental painting, which was draughtsmanly in the sixteenth century, developed especially on the painterly side in the seventeenth. Even if there is only one Rembrandt, a decisive readjustment of the eye took place everywhere, and whoever has any interest in clearing up his relation to the world of visible forms must first get to grips with these radically different modes of vision. The painterly mode is the later, and cannot be conceived without the earlier, but it is not absolutely superior. The linear style developed values which the painterly style no longer possessed and no longer wanted to possess. They are two conceptions of the world, differently orientated in taste and in their interest in the world, and yet each capable of giving a perfect picture of visible things.

Although in the phenomenon of linear style, line signifies only part of the matter, and the outline cannot be detached from the form it encloses, we can still use the popular definition and say for once as a beginning—linear style sees in lines, painterly in masses. Linear vision, therefore, means that the sense and beauty of things is first sought in the outline—interior forms have their outline too—that the eye is led along the boundaries and induced to feel along the edges, while seeing in masses takes place where the attention withdraws from the edges, where the outline has become more or less indifferent to the eye as the path of vision, and the primary element of the impression is things

seen as patches. It is here indifferent whether such patches speak as colour or only as lights and darks.

The mere presence of light and shade, even if they play an important part, is still not the factor which decides as to the painterly character of the picture. Linear art, too, has to deal with bodies and space, and needs lights and shadows to obtain the impression of plasticity. But line as fixed boundary is assigned a superior or equal value to them. Leonardo is rightly regarded as the father of chiaroscuro, and his *Last Supper* in particular is the picture in which, for the first time in later art, light and shade are applied as a factor of composition on a large scale, yet what would these lights and darks be without the royally sure guidance which is exercised by the line? Everything depends on how far a preponderating significance is assigned to or withdrawn from the edges, whether they *must* be read as lines or not. In the one case, the line means a track moving evenly round the form, to which the spectator can confidently entrust himself; in the other, the picture is dominated by lights and shadows, not exactly indeterminate, yet without stress on the boundaries. Only here and there does a bit of palpable outline emerge: it has ceased to exist as a uniformly sure guide through the sum of the form. Therefore, what makes the difference between Dürer and Rembrandt is not a less or more in the exploitation of light and shade, but the fact that in the one case the masses appear with stressed, in the other with unstressed edges.

As soon as the depreciation of line as boundary takes place, painterly possibilities set in. Then it is as if at all points everything was enlivened by a mysterious movement. While the strongly stressed outline fixes the presentment, it lies in the essence of a painterly representation to give it an indeterminate character: form begins to play; lights and shadows become an independent element, they seek and hold each other from height to height, from depth to depth; the whole takes on the semblance of a movement ceaselessly emanating, never ending. Whether the movement be leaping and vehement, or only a gentle quiver and flicker, it remains for the spectator inexhaustible.

We can thus further define the difference between the styles by saying that linear vision sharply distinguishes form from form, while the painterly eye on the other hand aims at that movement which passes over the sum of things. In the one case, uniformly clear lines which separate; in the other, unstressed boundaries which favour combination. Many elements go to produce the impression of a general movement—we shall speak of these—but the emancipation of the masses of light and shade till they pursue each other in independent interplay remains the basis of a painterly impression. And that means,

too, that here not the separate form but the total picture is the thing that counts, for it is only in the whole that that mysterious interflow of form and light and colour can take effect, and it is obvious that here the immaterial and incorporeal must mean as much as concrete objects. ·

When Dürer * or Cranach places a nude as a light object on a dark ground, the elements remain radically distinct: background is background, figure is figure, and the Venus or Eve we see before us produces the effect of a white silhouette on a dark foil. Conversely, if a nude in Rembrandt * stands out on a dark ground, the light of the body seems as it were to emanate from the darkness of the picture space: it is as if everything were of the same stuff. The distinctness of the object in this case is not necessarily impaired. While the form remains perfectly clear, that peculiar union between the modelling lights and darks can have acquired a life of its own, and without the exigencies of the object being in any way prejudiced, figure and space, corporeal and incorporeal, can unite in the impression of an independent tonal movement.

But certainly—to make a preliminary remark—it is of considerable advantage to "painters" to liberate lights and darks from their function of mere form-definition. A painterly impression most easily comes about when the lighting no longer subserves the distinctness of the objects, but passes over them: that is to say, when the shadows no longer adhere to the forms, but, in the conflict between the distinctness of the object and the illumination, the eye more willingly surrenders to the play of tones and forms in the picture. A painterly illumination—say in a church interior—is not the one which will make the columns and walls as distinct as possible, but, on the contrary, the one which will glide over the form and partially veil it. And in the same way, the silhouettes—if the notion can be used at all in this connection—will be apt to become inexpressive: a painterly silhouette never coincides with the form of the object. As soon as it speaks too clearly of the object, it isolates itself and checks the coalescence of the masses in the picture.

But with all that the decisive word is not yet said. We must go back to the fundamental difference between draughtsmanly and painterly representation as even antiquity understood it—the former represents things as they are, the latter as they seem to be. This definition sounds rather rough, and to philosophic ears, almost intolerable. For is not everything appearance? And what kind of a sense has it to speak of things as they are? In art, however, these notions have their permanent right of existence. There is a style which, essentially objective in outlook, aims at perceiving things and expressing them in their solid, tangible relations, and conversely, there is a style which, more subjective in attitude, bases the representation on the *picture*, in which the

visual appearance of things looks real to the eye, and which has often retained so little resemblance to our conception of the real form of things.

Linear style is the style of distinctness plastically felt. The evenly firm and clear boundaries of solid objects give the spectator a feeling of security, as if he could move along them with his fingers, and all the modelling shadows follow the form so completely that the sense of touch is actually challenged. Representation and thing are, so to speak, identical. The painterly style, on the other hand, has more or less emancipated itself from things as they are. For it, there is no longer a continuous outline and the plastic surfaces are dissolved. Drawing and modelling no longer coincide in the geometric sense with the underlying plastic form, but give only the visual semblance of the thing.

Where nature shows a curve, we perhaps find here an angle, and instead of an evenly progressive increase and decrease of light, light and shade now appear fitfully, in ungraded masses. Only the *appearance* of reality is seized —something quite different from what linear art created with its plastically conditioned vision, and just for that reason, the signs which the painterly style uses can have no further direct relation to the real form. The pictorial form remains indeterminate, and must not settle into those lines and curves which correspond to the tangibility of real objects.

The tracing out of a figure with an evenly clear line has still an element of physical grasping. The operation which the eye performs resembles the operation of the hand which feels along the body, and the modelling which repeats reality in the gradation of light also appeals to the sense of touch. A painterly representation, on the other hand, excludes this analogy. It has its roots only in the eye and appeals only to the eye, and just as the child ceases to take hold of things in order to "grasp" them, so mankind has ceased to test the picture for its tactile values. A more developed art has learned to surrender itself to mere appearance.

With that, the whole notion of the pictorial has shifted. The tactile picture has become the visual picture—the most decisive revolution which art history knows.

Now we need not, of course, immediately think of the ultimate formulations of modern impressionist painting if we wish to form an idea of the change from the linear to the painterly type. The picture of a busy street, say, as Monet painted it, in which nothing whatsoever coincides with the form which we think we know in life, a picture with this bewildering alienation of the sign from the thing is certainly not to be found in the age of Rembrandt, but the principle of impressionism is already there. Everybody knows the example of

the turning wheel. In our impression of it, the spokes vanish, and in their place there appear indefinite concentric rings, and even the roundness of the felly has lost its pure geometric form. Now not only Velasquez, but even so discreet an artist as Nicolas Maes has painted this impression. Only when the wheel has been made indistinct does it begin to turn. A triumph of seeming over being.

And yet that is, after all, only an extreme case. The new representation includes the stationary as well as the moving. When a sphere at rest is no longer represented by a geometrically pure circular form, but with a broken line, and where the modelling of the surface of a cube has degenerated into separate blocks of light and dark, instead of proceeding uniformly by imperceptible gradations, we stand everywhere on impressionist ground.

And now if it is true that the painterly style does not body forth things in themselves, but represents the world as seen, that is to say, as it actually appears to the eye, that also implies that the various parts of a picture are seen as a unity from the same distance. That seems to be a matter of course, but it is not so at all. The distance required for distinct seeing is relative: different things demand different vicinities of the eye. In one and the same form-complex, totally different problems may be presented to the eye. For instance, we see the forms of a head quite distinctly, but the pattern of the lace collar beneath it requires closer approach, or at least, a special adjustment of the eye if its forms are to become distinct. The linear style, as representation of being, had no difficulty in making this concession to the distinctness of the object. It was quite natural that things, each in its particular form, should be rendered in such a way as to be perfectly distinct. The demand for unified visual perception is radically non-existent for this type of art in its purest developments. Holbein, in his portraits, pursues the design of small goldsmith's work and embroidery into their smallest details. Frans Hals, on the other hand, occasionally painted a lace collar only as a white shimmer. He did not wish to give more than is perceived by the eye taking a general view of the whole. But, of course, the shimmer must look as if all the details were actually there, and the indistinctness were only the momentary effect of distance.

The measure of what can be seen as a unity has been taken very variously. Although we are accustomed to describe only the higher degrees as impressionism, we must always bear in mind that these do not signify something essentially new. It would be difficult to fix the point at which the merely "painterly" ceases and "impressionist" begins. Everything is transition. And in the same way, it is hardly possible either to establish any ultimate expression of impressionism which might be taken as its classic completion. That is

much more possible on the opposite side. What Holbein gives is, as a matter of fact, an unsurpassable embodiment of the art of being, from which all elements of semblance have been eliminated. Curiously enough, there is no special term for this mode of representation.

A further point. Unified seeing, of course, involves a certain distance. But distance involves a progressive flattening of the appearance of the solid body. Where tactile sensations vanish, where only light and dark tones lying side by side are perceived, the way is paved for painterly presentment. Not that the impression of volumes and space is lacking; on the contrary, the illusion of solidity can be much stronger, but this illusion is obtained precisely by the fact that no more plasticity is introduced into the picture than the appearance of the whole really contains. That is what distinguishes an etching by Rembrandt from any of Dürer's engravings. In Dürer everywhere the endeavour to achieve tactile values, a mode of drawing which, as long as it is in any way possible, follows the form with its modelling lines; in Rembrandt, on the other hand, the tendency to withdraw the picture from the tactile zone and, in drawing, to drop everything which is based on immediate experiences of the organs of touch, so that there are cases in which a rounded form is drawn as a completely flat one with a layer of straight lines, though it does not look flat in the general impression of the whole. This style is not present from the beginning. Within Rembrandt's work, there is a distinct development. Thus the early *Diana Bathing* is still modelled throughout in a (relatively) plastic style with curved lines following the separate form: the late female nudes, on the other hand, little is used but flat lines. In the first case, the figure stands out; in the later compositions, on the other hand, it is embedded in the totality of the space-creating tones. But what comes clearly to light in the pencil work of the drawing is, of course, also the foundation of the painted picture, although in the latter case it is perhaps more difficult for the layman to realise it.

In establishing such facts, however, which are peculiar to the art of representation on flat surfaces, we must not forget that we are aiming at a notion of the painterly which is binding beyond the special domain of painting and means as much for architecture as for the arts of the imitation of nature.

2. The "Picturesque" and its Opposite

In the preceding paragraphs the "painterly" is treated essentially as a matter of perception in the sense that it does not matter about the object, but that the eye, of its own free will, can perceive everything in one way or the other, painterly or not painterly.

But now it cannot be denied that there are in nature certain things and situations which we denote as "picturesque". The character of the picturesque seems to be inherent in them apart from perception by a painterly eye. Naturally, there is no absolute "picturesque", and even the so-called "picturesque" object only becomes so for a perceiving eye, but for all that, we can still isolate as something special those themes whose picturesque character consists in actual conditions which can be demonstrated. These are themes in which the single form is so entwined in a great context that an impression of all-pervading movement arises. If real movement is present, so much the better, but it is not necessary. It may be intricacies of the form which of their very nature produce a picturesque effect, or peculiar aspects and illuminations; over the solid, static body of things there will always play the stimulus of a movement which does not reside in the object, and that also means that the whole only exists as a *picture* for the eye, and that it can never, even in the imaginary sense, be grasped with the hands.

We call the ragged beggar, with his weather-beaten hat and gaping shoes, a picturesque figure, while the boots and hats which have just come out of the shop are regarded as unpicturesque. They lack the rich, rustling life of the form which we might compare to the ripple of the waves when a breeze ruffles the surface of the water. And if this illustration does not suit the beggar's rags very well, we have but to think of more costly costumes, where, with the same effect, the surfaces are broken up by slashes or brought into movement by the mere cast of the folds.

On the same principles, there is a picturesque beauty of the ruin. The rigour of the tectonic form is broken up, and while the wall crumbles and holes and fissures arise, a life quickens which quivers and shimmers over the surface. And when the edges become restless and the geometric lines and order disappear, the building can unite in a picturesque whole with the freely moving forms of nature, with trees and hills, which is impossible for non-ruinous architecture.

An interior is looked upon as picturesque when the scaffolding of walls and ceiling is not the most important thing, but when darkness lurks in the depths and all kinds of paraphernalia tone down the corners, so that over the whole, now louder, now lower, an impression of all-pervading movement comes to birth. Even the room in Dürer's * St. Jerome engraving looks picturesque, but when we compare it with the huts and hovels in which Ostade's * peasant families huddle, the decorative picturesque content is so much greater here that it would be well to reserve the word for these cases.

Fullness of lines and masses will of itself always lead to a certain illusion

of movement, but it is especially rich groupings which yield picturesque pictures. What is it that makes a picturesque nook in a little old town so interesting? Apart from the lively variation in the axial directions, the fact that forms are covered and cut into has clearly much to say here. That does not only mean that a secret remains to be guessed, but also that in the interweaving of the forms, a total figure is created which is something different from the sum of the parts. The picturesque value of this figure must be rated the higher, the more it contains some element of surprise in relation to the familiar form of things. Everyone knows that, of the possible aspects of a building, the front view is the least picturesque: here the thing and its appearance fully coincide. But as soon as foreshortening comes in, the appearance separates from the thing, the picture-form becomes different from the object-form, and we speak of a picturesque movement-effect. Certainly, in such a picturesque movement-effect, recession plays an essential part in the impression—the building *moves* away from us. The visual fact, however, is that in this case objective distinctness retreats behind an appearance in which outline and surfaces have separated from the pure form of the thing. It has not become unrecognisable, but a right angle is no longer a right angle and the parallel lines have lost their parallelism. As everything—silhouette and interior forms—is shifted, a totally independent play of forms is developed which is the more enjoyable, the more the basic form, the point of departure, is perceptible throughout all change in the appearance. A picturesque silhouette can never coincide with the form of the object.

Restless architectural forms will, of course, always have the advantage in picturesque effect over quiet forms. If real movement is present, the effect sets in more easily. There is nothing more picturesque than the busy crowd of the market, where the attention is not only diverted from the separate form of the object by the wealth and confusion of men and things, but where the spectator, just because he has a moving object before him, is challenged to surrender to the mere visual impression without scrutinising the plastic form of the single object. Not all obey the challenge, and whoever does so can do so in varying degrees—that is, the picturesque beauty of the scene can be understood in more than one way. But even in a purely linear presentment— and this is the decisive point—a certain decorative picturesque effect would remain.

Finally, in this connection, the factor of picturesque lighting must not be omitted. Here, too, it is question of objective facts to which, apart from the particular mode of perception, we accord a picturesque-decorative character. For ordinary feeling, these are particularly the cases in which the light or the

shadow passes over the form, *i.e.* conflicts with the distinctness of the object. We have already quoted the example of the picturesquely illuminated church interior. If here the falling sunbeam breaks through the darkness and, apparently wilfully, traces its figures on columns and floor, that is typically a sight at which popular taste says with satisfaction, "How picturesque!" But there are cases in which the light flits and glides in space just as strikingly without the conflict between form and lighting becoming so crassly visible. The picturesque twilight hour is a case in point. Here the object is overcome in another way. Forms are dissolved in the dimly lighted atmosphere, and instead of a number of separate objects, we see indeterminate lighter or darker masses which flow together in a common tonal movement.

A host of examples of such picturesque effects offer themselves. Let us leave it at these chance instances. They are obviously not all of the same calibre. There are rougher and finer picturesque movement-effects according to whether the plastic object has more or less part in the impression. All of them have the quality of offering themselves easily to painterly treatment, but they do not unconditionally demand it. Even where we meet them in the linear version, an impression is created which cannot well be defined otherwise than by the notion painterly, as can be seen in Dürer's St. Jerome engraving.*

The really interesting question now is this—what is the relation between the painterly style of treatment and the picturesque quality of the theme?

Firstly, so much is clear, that common speech denotes every total form as picturesque which, even when it is at rest, yields an impression of movement. The notion of movement, however, belongs too to the essence of painterly vision: the painterly eye perceives everything as vibrating, and suffers nothing to settle into definite lines and surfaces. So far there is a fundamental relationship. But a glance at art history will show that the flower of painterly presentment does not coincide with the development of themes commonly felt to be picturesque. A delicate architectural painter does not require picturesque buildings to make a painterly picture. The stiff costumes of the princesses whom Velasquez had to paint, with their linear patterns, are by no means what we call picturesque in the popular sense, but Velasquez saw them with so painterly an eye that they excel the ragged beggar of the young Rembrandt, although Rembrandt, it would appear at first, had the better of it as regards subject matter.

It is just the example of Rembrandt which shows that the progress in painterly perception can go hand in hand with increasing simplicity. When he was young he certainly thought that beauty resided in the ragged beggar.

And as regards heads, he preferred the rugged faces of old men. He gives ruinous buildings, twisted staircases, violent illuminations, oblique aspects, teeming crowds: later the "picturesque" vanishes and in the same ratio the real painterly content increases.

Can we, therefore, in this connection, distinguish between imitative and decorative? Yes and no. There is obviously a picturesqueness more inherent in the object, and there is temporarily no objection to denoting this as decorative-picturesque. But it does not cease where the picturesqueness of the object ceases. Even the late Rembrandt, to whom picturesque things and picturesque arrangements had become indifferent, remains painterly-decorative. But the painterly movement is no longer borne by the separate objects in the picture. It lies like a breath over the picture now at rest.

What is commonly denoted as a picturesque theme is more or less only the preliminary stage to the higher forms of the painterly taste, and is historically of the greatest importance, for it is just in these more outward picturesque effects that the feeling for a completely painterly apprehension of the world seems to have developed.

Yet just as there is a beauty of the picturesque, so there is a beauty of the unpicturesque. We only lack the particular word for it. But within our survey here, it is an axiom, to which we shall return from all points, that all transformations of the representative style are accompanied by transformations of decorative feeling. Linear and painterly are not only problems of imitation, but of decoration too.

3. SYNTHESIS

The great contrast between linear and painterly style corresponds to radically different interests in the world. In the former case, it is the solid figure, in the latter, the changing appearance: in the former, the enduring form, measurable, finite; in the latter, the movement, the form in function; in the former, the thing in itself; in the latter, the thing in its relations. And if we can say that in the linear style the hand has felt out the corporeal world essentially according to its plastic content, the eye in the painterly stage has become sensitive to the most various textures, and it is no contradiction if even here the visual sense seems nourished by the tactile sense—that other tactile sense which relishes the kind of surface, the different skin of things. Sensation now penetrates beyond the solid object into the realm of the immaterial. The painterly style alone knows a beauty of the incorporeal. From differently orientated interests in the world, each time a new beauty comes to birth.

It is true that the painterly style first renders the world as really seen, and on that account it has been called illusionism. But we must not imagine that it was this later stage which first dared to measure itself with nature, and that the linear style was only a temporary reference to the real. Even linear style was absolute, and seemed to need no enhancement in the direction of illusion. For Dürer, painting, as he understood it, was a complete "optical illusion", and Raphael would not have laid down his arms before Velasquez' portrait of the Pope: his pictures are simply built up on different foundations. The difference between these foundations is, I repeat, not only imitative but also, and quite essentially, decorative in kind. The development did not take place in such a way that the same goal was always kept in view, and that, in the effort to achieve the "true" expression of nature, the manner had gradually changed. The painterly is not a higher stage in the solution of the one problem of the imitation of nature, but a totally different solution. Only where decorative feeling has changed can we expect a transformation of the mode of representation. Not with the cool decision to perceive things from another side for once, in the interests of verisimilitude or completeness, do painters strive to seize the picturesque beauty of the world, but struck by the *charm* of the picturesque. It is no progress due to a more consistently naturalistic attitude if painters learned to separate the fragile painterly semblance-picture from tangible visible things. That is determined by a new sense of beauty, by the feeling for the beauty of that all-pervading mysterious movement which, for the new generation, at the same time meant life. All the processes of the painterly style are only means to an end. Even unified vision is not an achievement of independent value, but is a process which arose with the ideal and declined again with it.

From this point of view we can understand that it does not go to the root of the matter if someone objects: those signs, alienated from the form, which the painterly style uses, meant nothing in particular; for, observed from a distance, the unconnected patches coalesced again into a closed form, the line broken by angles softened down into a curve, so that the impression was, after all, the same as in earlier art, only achieved in other ways and hence more intense in its effect. That is certainly not the truth of the matter. It is not a head with a stronger power of illusion which emerges from the portrait of the seventeenth century. What radically distinguishes Rembrandt from Dürer is the vibration of the picture as a whole, which persists even where the eye was not intended to perceive the individual form-signs. Certainly it powerfully supports the illusive effect if an independent activity in the building up of the picture is assigned to the spectator, if the separate brush-strokes coalesce only

in the act of contemplation. But the picture which comes to birth is fundamentally disparate from the picture of the linear style. The presentment *remains* indeterminate, and is not meant to settle into those lines and planes which have a meaning for the tactile sense.

We can even go further. The form-alienated drawing does not need to disappear. Painterly painting is not a long-range style in the sense that the technical execution is intended to become invisible. We have missed the best if the brushwork in Frans Hals or Velasquez is lost. Nobody thinks of holding a Rembrandt etching so far away that he can no longer see the single lines. They are, of course, no longer the beautiful lines of the drawing in the classic copper-engraving, but that does not mean that the lines have suddenly lost all meaning: on the contrary, they are meant to be seen, these new, wild lines, broken, dispersed, and multiplied as they are. The form-effect aimed at will come about all the same.

A last point. As even the most perfect imitation of the natural appearance is still infinitely different from reality, it can imply no essential inferiority if linearism creates the tactile rather than the visual picture. The purely visual apprehension of the world is *one* possibility, but no more. By the side of this there will always arise the need for a type of art which does not merely catch the moving appearance of the world, but tries to do justice to being as revealed by tactile experiences. It would be well if in all teaching representation in both types were practised.

Certainly there are things in nature which are more congenial to the painterly style than to the linear, but it is a prejudice to think that the earlier type must have felt itself limited on that account. It was able to represent all that it wanted to represent, and we first have a real idea of its power when we realise that it found a linear expression for quite unplastic things—for bushes and hair, for water and clouds, for phenomena of smoke and fire. Nay, is there any basis for the assertion that these things are more difficult to master with line than plastic bodies? Just as we can hear all kinds of words into the ringing of bells, so we can arrange the visible world in very different ways for ourselves, and nobody can say that one way is truer than the other.

4. HISTORICAL AND NATIONAL CHARACTERISTICS

If ever a fact of art history has become popular, it is that the primitives were essentially draughtsmen, and that then light and shade came in and finally took the lead, that is, delivered art over to the painterly style. So that it will be a novelty to nobody if we place the linear style first. But, while we prepare

to consider typical examples of linearism, we must say that these are not to be found among the primitives of the fifteenth century, but first among the classics of the sixteenth. In our sense Leonardo is more linear than Botticelli, and Hans Holbein the Younger more linear than his father. The linear type did not inaugurate the new development, but only gradually worked itself free of a still impure species of style. That light and shade makes its appearance as an important factor in the sixteenth century does not affect the supremacy of line. Certainly the primitives were draughtsmanly too, but I would say they made use of line, they did not fully exploit it. To be tied down to linear vision, and consciously to envisage linear presentment, are two different things. Complete freedom as regards line came exactly at the moment at which the opposing element, light and shade, matured. Not the fact that lines are present decides as to the linear character of a style, but—as we have already remarked—the power with which they compel the eye to follow them. The contour of the classic design exercises an absolute power: it is the contour which tells us the facts and on it the picture as decoration rests. It is charged with expression and all beauty resides in it. Wherever we meet pictures of the sixteenth century, a decided line-theme leaps to the eye. In the song of the line the truth of the form is revealed. It is the great achievement of the Cinquecento to have quite consistently subjected the visible world to line. Compared with classic design, is the linearism of the primitives only a half-measure? [1]

In this sense we have forthwith taken Dürer as one starting-point. As regards the concept painterly, nobody will object if we connect it with Rembrandt, although art history needs him much earlier—indeed, he has insinuated himself into the immediate neighbourhood of the classics of linear art. Grünewald is called painterly in comparison with Dürer; among the Florentines, Andrea is the avowed "painter"; the Venetian school, as a whole, is the painterly school as contrasted with the Florentine, and nobody will wish to characterise Correggio otherwise than with the definitions of the painterly style.

Here the poverty of language comes home to us. We should need a thousand words to denote all the transitions. It is throughout a question of relative judgments. Compared with one style, the next can be called painterly. Grünewald is certainly more painterly than Dürer, but beside Rembrandt he all the

[1] In this connection, we must be clear that the Quattrocento forms no unit of style. The process of linearisation, which debouches into the sixteenth century, only begins in the middle of the Quattrocento. The first half is less sensitive to line, or, to put it differently, more painterly, than the second. The feeling for the silhouette only becomes more living after 1450—in the south, of course, earlier and more generally than in the north.

same bears the stamp of the Cinquecentist, that is, the man of the silhouette. And if Andrea is accorded a specifically painterly talent, we must certainly admit that he tones down the outline more than the others and that there is quite a peculiar quiver here and there in the surfaces of his draperies, yet he keeps within an essentially plastic feeling, and it would be well if we could reserve awhile the concept painterly. Even the Venetians, if we really wish to apply our concepts, cannot be excepted from linearism. Giorgione's recumbent Venus is as much a linear work of art as the Sistine Madonna.

Of all his compatriots, Correggio departed farthest from reigning opinion. In him we can clearly see the endeavour to conquer line as dominating element. He still works with lines—long flowing lines—yet for the most part he complicates their course in such a way that it is difficult for the eye to follow them, and into the shadows and lights there comes a flicker and dancing as though of their own power they were striving towards each other and wished to emancipate themselves from line.

Italian baroque was able to link up with Correggio. But more important for European painting was the development which the later Titian and Tintoretto went through. Here the decisive steps were taken which led to a representation of appearance, and a scion of this school, El Greco, at once drew conclusions from it which, in their way, could never be surpassed.

We do not give here a history of the painterly style, but are seeking the general concept. It is known that the movement to the goal is no uniform one, and that individual advances very often mean recoil. Much time must pass before individual achievements become common property, and here and there the development seems absolutely to turn back on itself. In a general way, however, it is a question of a homogeneous process which lasts till towards the end of the eighteenth century, and puts forth its final flowers in the pictures of a Guardi or a Goya. Then comes the great break. A chapter of occidental art history has closed and the new one is once more inaugurated by the acknowledgment of line as sovereign.

The course of art history is, looked at from a distance, roughly the same in south and north. Both have their classic linearism at the beginning of the sixteenth century and both pass through a painterly phase in the seventeenth. It is possible to show Dürer and Raphael, Massys and Giorgione, Holbein and Michelangelo in the essentials as akin, and on the other hand, Rembrandt, Raphael, and Bernini, for all their differences, circle round a common centre. If we look at the matter more closely, very definite contrasts of national feeling certainly play their part from the beginning. Italy, which even in the fifteenth century possessed a very clear feeling for line, is, in the sixteenth

century, in the real sense of the word, the *haute école* of "pure" line, and in the (painterly) break-up of line, Italian baroque never went so far as the north. For the plastic feeling of the Italians, line has always been more or less the element in which every artistic form manifests itself.

That we cannot say the same of Dürer's homeland is perhaps remarkable, as we are accustomed to recognise the peculiar strength of old German art precisely in firm drawing. But while the classic German drawing, which only slowly and with difficulty frees itself from the late Gothic painterly tangle, can certainly at moments seek its model in Italian line, it is fundamentally averse from the isolated, pure line. Germanic imagination at once entwines line with line; instead of the clear, simple track, there appears the skein, the web of lines. Light and dark early unite in a painterly life of their own and the separate form is submerged in the rolling waves of the total movement.

In other words, for Rembrandt, whom the Italians could absolutely not understand, the way was early prepared in the north. But what has here been brought forward to illustrate the history of painting is, of course, equally valid for the history of sculpture and architecture.

DRAWING

In order to make the contrast between the linear and the painterly style clear, it is well to seek the first examples in the domain of pure drawing.

We compare first a plate by Dürer★ with a plate by Rembrandt.★ The subject in both cases the same—a nude female figure. And now let us leave out of account for the moment the fact that we have to do in the one case with a study from life, in the other with a more derived figure, and that Rembrandt's etching is certainly self-sufficing as a picture, yet quickly sketched, while Dürer's work is carefully finished as the study to a copper-engraving. Even the difference in the technical instrument—in the former pen, in the latter chalk—is only a secondary point. What makes these two drawings look so different is above all this—that the impression in Dürer is based on tactile, in Rembrandt, on visual values. A figure as light upon a dark ground is the first feeling with Rembrandt: in the older drawing, the figure is also drawn on a dark foil, yet not in order that the light may emanate from the dark, but only that the silhouette may stand out the more sharply. The line edge running round it has the principal accent. In Rembrandt it has lost its significance. It is no longer the essential bearer of the formal impression and there lies no special beauty in it. If we were to attempt to move along it, we should soon see that that is now hardly possible. In place of the continuous, uniformly

moving contour line of the fifteenth century, the broken line of the painterly style has come.

And now we must not object that that is simply typical for the sketch in general, and that we could find the same process of feeling the way at all times. Certainly, the sketcher, rapidly setting the figure roughly on the paper, will also work with unconnected lines, but Rembrandt's line remains broken even in completely finished plates. It is not allowed to settle into a tangible contour, but always preserves its indeterminate character.

If we analyse the strokes of the modelling, the older plate also stands the test as a product of the art of line, in that the shadows are kept perfectly transparent. Line is uniformly clearly drawn round line, and each single one seems to know that it is a beautiful line and combines beautifully with its mates. But their shape follows the movement of the plastic form, and only the lines of the cast shadows pass beyond the form. For the style of the seventeenth century, these considerations have no further value. Very different in type, now more, now less distinguishable by their direction and accumulation, the strokes have now only one point in common—that they are effective as a mass and that, to a certain extent, they are submerged in the impression of the whole. It would be difficult to say by what rule they are formed, but this is clear—that they no longer follow the form, that is, they do not appeal to the tactile sense but give, without prejudice to the effect of solidity, rather the purely visual appearance. Seen singly, they look to us quite senseless, but to the eye taking a general look, as we have said, they unite in a particularly rich effect.

And this is remarkable; this type of drawing can even tell us something about the quality of material. The more the attention is withdrawn from the plastic form as such, the more

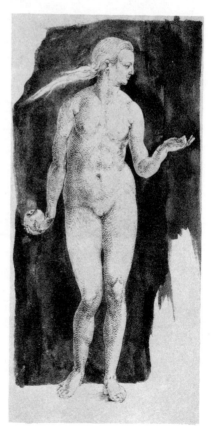

Dürer

active is the interest in the surface of things, in how objects feel. Flesh in Rembrandt is clearly rendered as a soft material, yielding to pressure, while Dürer's figure in this respect remains neutral.

And now we may frankly admit that Rembrandt cannot forthwith be taken as equivalent to the seventeenth century, and that it would be even less admissible to judge German drawing of the classic period by one example. Yet just because of this one-sidedness, it is illuminating to do so in a comparison, the primary object of which is to bring out quite sharply the opposition between the concepts.

What the transformation of style means for the conception of form in detail becomes quite clear if we pass from the theme of the whole figure to that of the head alone.

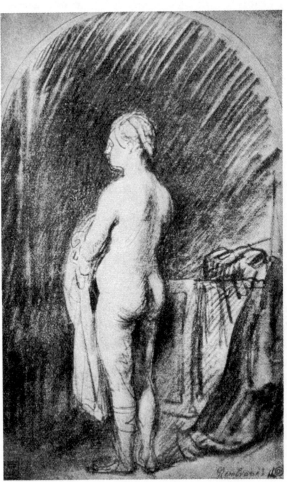

The special quality of a head by Dürer by no means depends only on the artistic quality of his individual line, but on the fact that lines are worked out at all, great, evenly guiding lines in which everything is contained and which can be apprehended without difficulty. This quality, which Dürer has in common with his contemporaries, gives us the essence of the matter. The primitives also dealt with the problem in drawing and a head can, in its general lay-out, have much resemblance, but the lines do not stand out, they do not leap to the eye as in the classic drawing: the form has not been compressed into the line.

Rembrandt

H. Aldegrever (Detail)

We take as example a drawing by Aldegrever* which, akin to Dürer and still more to Holbein, establishes the form in definite and surely guiding outlines. In uninterrupted rhythmic sequence, as a long, uniformly strong line, the facial contour flows from the temple to the chin: nose and mouth and the edges of the lids are also drawn with even, complete lines, the cap combines as a pure silhouette form with the whole system and even for the beard a homogeneous expression has been found.[1] The stumped modelling, however, completely adheres to the wholly tangible form.

The most perfect contrast is offered in a head by Lievens,* Rembrandt's contemporary. Expression has entirely vanished from the edges and sits in the interior parts of the form. Two dark, lively glancing eyes, a twitch of the lips, here and there the line flashes out, only to disappear again forthwith. The long tracks of the linear style are completely absent. Separate fragments of line

[1] Some smudges in the reproduction are due to the plate being tinted in colour in places.

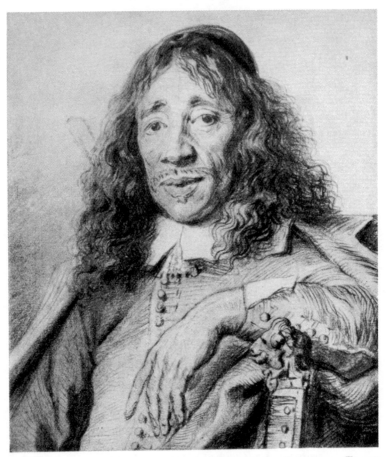

Jan Lievens (Detail)

define the form of the mouth, a few broken strokes the form of the eyes and
eyebrows. Sometimes the drawing stops completely. The modelling shadows
have no longer any objective validity. In the handling of the contour of cheek
and forehead, however, everything is done to prevent the form from develop-
ing a silhouette, that is, to exclude the possibility of its being read in lines.

Although less strikingly than in the example of the Rembrandt female nude,
the aiming at combination of light, at the interplay of light and dark masses is
still decisive for the habitus of the drawing. And while the older style, in the
interests of formal lucidity, fixes the presentment, the impression of move-
ment combines spontaneously with the painterly style, and it obeys its most
inward essence when it takes for its special problem the representation of
the changing and the transitory.

A further case—the garment. For Holbein,* the drapery of a fabric was a spectacle which he not only considered possible to master with lines, but which seemed to him only to express its real meaning in the linear version. Here too, our eye first stands in the opposite camp. What do we see but changing lights and shadows in which it is just the modelling which makes itself felt? And if someone wished to attack the problem with lines, it seems to us that perhaps only the course of the edge could be so described. But even this edge plays no essential rôle: in varying degrees, we are made aware of the cessation of the surface at certain points as something special, but we by no means feel the motive as a leading motive. It is again obviously a radically different mode of observation when the drawing traces out the course of the edge for its own sake and sets out to make it visible by means of uniform, uninterrupted delineation. And not only the edge of the stuff where it comes to an end, but, in the same way, the interior forms of the grooves and ridges of the folds. Everywhere clear, firm lines. Light and shade fully applied but—and here lies the difference from the painterly style —thoroughly subordinate to the sovereignty of line.

A painterly costume — we give as illustration a drawing by Metsu*—will, on the other hand, not quite eliminate the element of line, but will not let it take the lead. On principle the eye is first interested in the life of the surface. We can therefore no longer bring out the content with lines. And the rise and fall of these surfaces immediately obtains much greater mobility as soon as the interior design goes into free masses of light and dark. We note that the geometric configuration of such patches of shadow is no longer strictly binding: we get the idea of a form which remains variable within certain limits and by that very fact does justice to

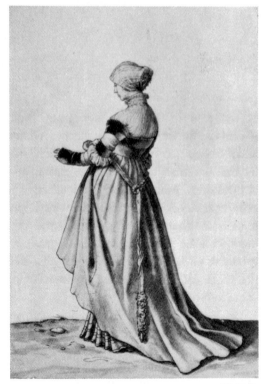

Holbein

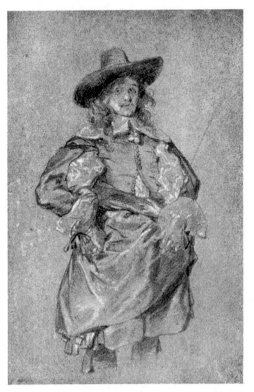

Metsu

the constant change of the appearance. To this is added the fact that the texture of the fabric is more important than formerly. Dürer certainly applied many an observation of how the feel of a thing can be rendered, yet the classic drawing style tends rather to neutrality in the rendering of material. For the seventeenth century, however, with the interest for the picturesque, there arises naturally the interest for the quality of surfaces. Nothing is drawn without hardness and softness, roughness and smoothness being indicated too.

The most interesting application of the principle of the linear style is where the object is least congenial to it, or is even refractory to it. This is the case with foliage. The single leaf can be rendered in the linear style, but the mass, the thicket of leaves, in which the separate form as such has become indistinguishable, scarcely offers a basis for linear treatment. Nevertheless, the problem was not felt by the sixteenth century to be insoluble. There are magnificent solutions in Altdorfer, Wolf Huber,⋆ and others. The apparently inassimilable has been reduced to a linear form which speaks very energetically and fully renders the characteristic quality of the tree. Whoever knows such drawings must often be reminded of them by reality, and they hold their own beside the most astounding achievements of a more painterly technique. They do not represent a more imperfect mode of presentment: it is simply nature seen from another angle.

Let A. van de Velde⋆ be taken as representative of the painterly drawing. The intention here is no longer to reduce the appearance to a schema with strokes that can clearly be followed. Here the limitless triumphs—the mass of lines which makes it quite impossible to grasp the drawing by its separate elements. With lines that· preserve hardly any perceptible relation

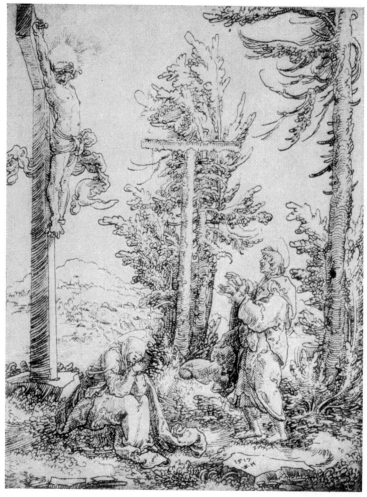

Wolf Huber

to the form of the object, and can only be achieved intuitively, an effect is produced which makes us think we see the moving foliage of great trees before us. And it is quite clearly stated what kind of trees they are. The inexpressibility of an infinitude of form which seems to defy any attempt at fixation has here been mastered by painterly methods.

If we cast a glance, finally, at a whole landscape, the general look of a purely linear plate, which separates the objects on highway and byway, near and far, with clear-cut outlines, is more intelligible than that form of land-scape drawing which consistently carries out the principle of the painterly fusion of separate objects. There are such plates, for instance, by van Goyen.*

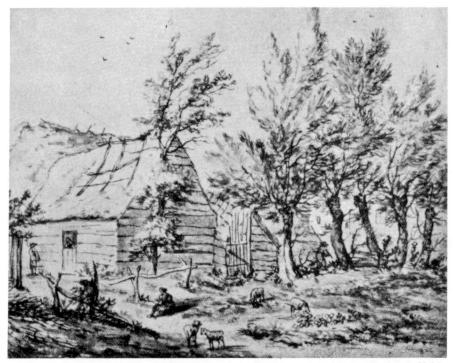

A. van de Velde

They are the pendants of his tonal and almost monochrome paintings. And as his hazy veiling of things and their local colours is looked upon as a pre-eminently painterly motive, such a drawing may be quoted here as particularly typical of the painterly style. (See reproduction, p. 1, dated 1646.)

The boats on the water, the bank with the trees and houses, animate and inanimate figures—all is woven into a web of lines not easily to be unravelled. Not that the forms of the separate objects have been suppressed—what has to be seen is perfectly clearly to be seen—but they are as closely entwined in the drawing as if all were of the same element and were quivering with the same movement. Whether we can see this boat or that and how the house on the bank is built is not important: the painterly eye is trained to take in the total appearance in which the single object has no further essential significance. It is submerged in the whole and the vibration of all the lines facilitates the process of interweaving into a homogeneous mass.

PAINTING

1. Painting and Drawing

In his treatise on painting, Leonardo repeatedly warns artists not to trace out the form with outlines.[1] That sounds like a contradiction of everything that has been stated hitherto of Leonardo and the sixteenth century. But the contradiction is only apparent. What Leonardo meant is a matter of technical execution, and it is very possible that the remark referred to Botticelli, who was much enamoured of the manner of outlining in black. But, in a higher sense, Leonardo is much more linear than Botticelli, although his modelling is softer and has overcome the harsh relief of the figures on the background. The decisive factor is just the new power with which the outline speaks from the picture and compels the spectator to follow it.

While we thus pass to the analysis of pictures, we should not lose sight of the relation between painting and drawing. We are so used to see everything from the painterly angle that even when confronted with linear works of art, we apprehend the form somewhat more laxly than was intended, and where mere photographs are at our disposal, painterly blurring goes a stage further, not to speak of the little zinc plates of our books (reproductions of reproductions). It needs some practice to see things in as linear a way as they are meant to be seen. Mere good intention is not enough. Even when we think we have mastered line, we shall find, after a period of systematic work, that there is linear seeing and linear seeing, and that the intensity of the effect which is due to this element of form-definition can be considerably increased. We can see a Holbein portrait better if we have previously seen and learnt by heart Holbein's drawings. The quite unique enhancement which linearism here went through, in that, everything else being omitted, only those parts of the appearance "where the form curves" have been reduced to line, produces its most immediate effect in the drawing, yet the painted picture rests absolutely on this foundation and the schema of the drawing must always make itself felt in the painting as the essential factor.

But while it is true of the mere drawing that the expression "linear style" only covers part of the phenomenon because, as is the case with Holbein as well as in the example of Aldegrever used above, the modelling can be rendered by non-linear means, we shall only fully realise in painting how far the traditional manner of denoting styles is based one-sidedly on a single attribute. Painting, with its all-covering pigments, on principle creates surfaces, and

[1] Leonardo, *Trattato della pittura.*

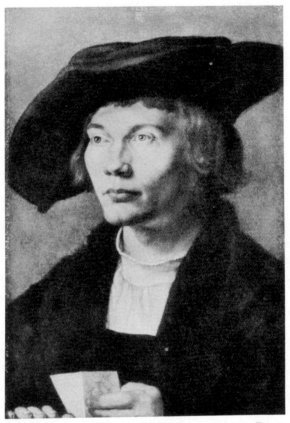

Dürer

thereby, even where it remains monochrome, is distinguished from any drawing. Lines are there, and are to be felt everywhere, but only as the limits of surfaces plastically felt and modelled throughout by the tactile sense. The emphasis lies on this notion. The tactile character of the modelling decides as to whether a drawing is to be classed as linear, even if the shadows, perfectly unlinear, lie on the paper as a mere breath. In painting, the kind of shading is, of course, given. In contrast to the drawing, however, where the edges, in relation to the modelling of the surfaces, receive a disproportionate predominance, the balance is here restored. In the one case, the outline acts as a frame in which the modelling shadows are enclosed; in the other, both elements appear as a unity, and the persistently even plastic definiteness of the form-limits is only the correlative of the persistently even plastic definiteness of the modelling.

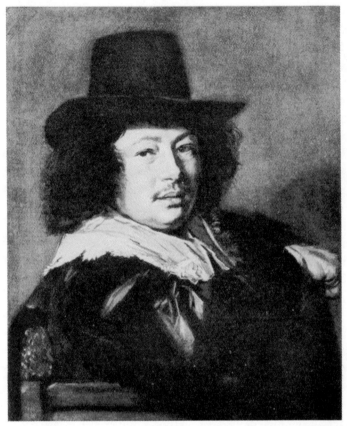

Hals

2. EXAMPLES

So much by way of introduction. We can now contrast a few examples of linear and painterly style. The painted head by Dürer (1521)* is built up on quite a similar plan to Aldegrever's drawing, the reproduction of which is given above. The silhouette from the forehead down strongly stressed; the space between the lips a sure, quiet line; nostrils, eyes, everything uniformly definite to the last corner. But just as the form-limits are established for the tactile sense, so the smooth, firm surfaces are modelled for apprehension by the tactile organs and the shadows taken as the darks immediately appertaining to the form. Thing and appearance fully coincide. The close view yields no other picture than the distant view.

In contrast to this, Frans Hals'* form is radically withdrawn from tangibility. It is no more to be grasped than a bush moving in the wind or the

ripples on a river. The close view and the distant view diverge. Although the
single stroke is not meant to be lost sight of, confronted with the picture one
still feels obliged to take a long-range view. A very close view is senseless.
Modelling by gradation has yielded to modelling in patches. The rough,
furrowed surfaces have lost any possibility of comparison with life. They
appeal only to the eye, and are not meant to appeal to the senses as tangible
surfaces. The old form-lines are destroyed. No single stroke can be taken
literally. The nose twitches, the mouth quivers, the eyes twinkle. It is exactly
the same system of form-alienated signs as we have already analysed in
Lievens. Our *little* reproductions can, of course, only make the facts of the
matter very imperfectly clear. Perhaps the treatment of the white stuff comes
out most convincingly.

If we bring the great contrasts of style into immediate opposition, individual
differences become less important. We see then that what Frans Hals gives
exists in the essence in Van Dyck and Rembrandt. They are separated only
by a difference of degree and, compared with Dürer, they unite to form a
closed group. Instead of Dürer we can put Holbein or Massys or Raphael.
On the other hand, in an isolated consideration of the individual painter, we
shall not be able to avoid having recourse to the same concepts of style to
characterise beginning and end of his development. Rembrandt's early por-
traits are seen in a (relatively) plastic and linear way in contrast to the master's
pictures in his maturity.

But while the power to surrender to purely visual appearance always signi-
fies a later stage of development, that does not by any means assume that the
purely plastic type stands at the beginning. The line-style of Dürer is not only
the enhancement of an existing homonymous tradition, but implies at the
same time the elimination of all refractory elements in the style handed down
by the fifteenth century.

How, then, the transition from pure linearism to the painterly vision of the
seventeenth century is fulfilled in detail can be very clearly demonstrated
in the portrait. We cannot, however, go into that here. In a general way we
can go so far as to say that it is an even stronger combination of light and shade
which prepares the way for the definitely painterly conception. What that
means will become clear to anyone who compares say an Antonio Moro with
a Hans Holbein, who is, all the same, akin to him. Although the plastic char-
acter is not neutralised, even there the lights and darks begin to unite in a
more independent life. At the moment at which the even keenness of the
edges of the form weakens, what is not line acquires greater significance in
the picture. It is also said that the form is seen more broadly. That simply

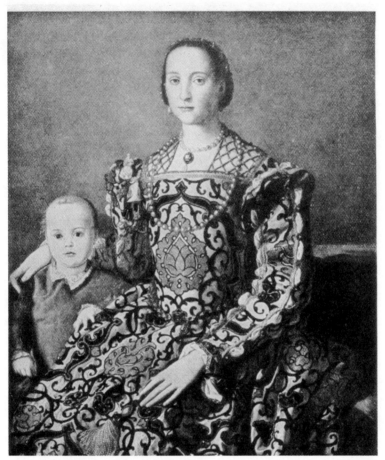

Bronzino

means that the masses have become freer. It is then as though lights and shadows had come into livelier contact with each other, and in these effects the eye first learned to confide itself to the appearance and finally to take a design quite alienated from the form for the form itself.

We continue with two examples which illustrate the typical contrast of the styles in the subject of the costume figure. They are examples of Latin art, Bronzino★ and Velasquez.★ Although they did not grow on one branch, that does not matter here: our object is only to draw the distinction between the concepts.

Bronzino is, in a certain sense, the Holbein of Italy. Very characteristic in the drawing of the heads with the metallic distinctness of lines and surfaces, his picture is peculiarly interesting as the presentment of a sumptuous

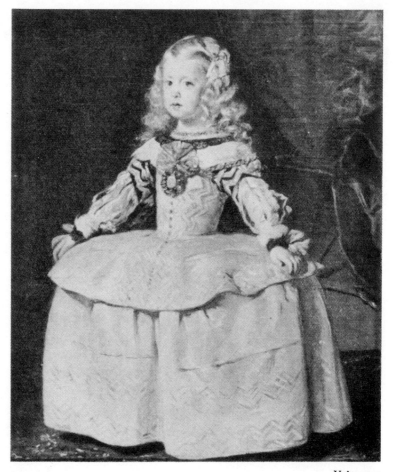

Velasquez

costume perceived by an exclusively linear taste. No human eye can see things in this way—I mean with this even firmness of the line. Not for a moment does the artist depart from the absolute distinctness of the object. It is as if, in the representation of a bookcase, an artist were to attempt to paint book by book, each equally clearly outlined, while an eye attuned to appearance only grasps the shimmer playing over the whole in which, in varying degrees, the separate form is submerged. Velasquez had an eye thus attuned to appearance. The dress of his little princess was embroidered in zigzag patterns: what he gives, however, is not the ornamentation in itself, but the shimmering image of the whole. Seen uniformly from a distance, the patterns have lost their distinctness, yet without looking indistinct; we can see perfectly clearly what is meant, but the forms cannot be grasped, they come and go, the high

lights of the fabric play over them, and the whole is dominated by the rhythm of the light-waves—indistinguishable in the reproduction—which also fills the background.

We know that the classic sixteenth century did not always paint materials like Bronzino, and that Velasquez represents only *one* possibility of painterly interpretation, but beside the great contrast of style, individual variations have not much importance. Within his epoch, Grünewald is a miracle of painterly style, and the *Disputation of St. Erasmus with St. Mauritius* (in Munich) is one of his last pictures, but if we compare the gold-embroidered chasuble of this Erasmus even with Rubens, the effect of the contrast comes out so forcibly that we should not even think of separating Grünewald from the ground of the sixteenth century.

Hair in Velasquez looks thoroughly substantial, yet neither the individual curl nor the single hair is represented, but a phenomenon of light which has only a loose connection with its objective basis. Matter has never been more perfectly rendered than when Rembrandt in his age paints an old man's beard with broad strokes of pigment, yet that palpable resemblance of the form, which Dürer and Holbein strove to achieve, is completely lacking. Even in graphic work, where there is a great temptation to bring out the single hair with the single stroke—at any rate, here and there—the later etchings of Rembrandt cut themselves off from any possibility of comparison with the palpable reality and adhere merely to the semblance of the whole.

And so it is—to pass on to another theme—with the representation of the infinity of leaves on tree and bush. Here, too, classic art tried to achieve the typical tree in full leaf—that is, it has, whenever possible, rendered the foliage with single visible leaves. But to this desire there are, of course, narrow limits. Even at short range, the sum of the separate forms coalesces in a mass and not even the finest brush can follow it in detail. And yet, plastic art of the linear type has won through even here. If it is not possible to render the single leaf with determinate form, it gives the bunch of leaves, the separate leaf-group with determinate form. And from such bunches, at first clearly distinct, came the development—promoted by an increasingly lively interflow of light and dark—of the unlinear tree of the seventeenth century, in which flecks of colour are set side by side without the individual fleck claiming to be congruent with the leaf-form underlying it.

But even classic linearism knew a mode of representation in which the brush gives a form design in perfectly free lines and dots. To give an example, Albrecht Aldegrever has treated in this way the leafy thicket in his St. George landscape in the Munich Pinakothek (1510). Certainly these dainty linear

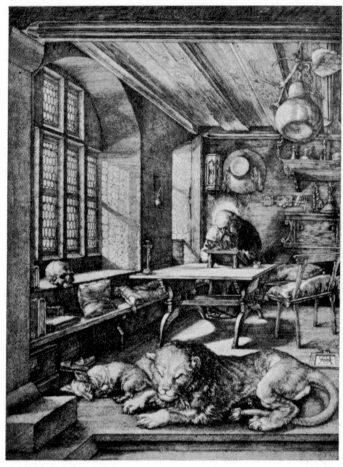

Dürer

patterns do not coincide with objective facts, but for all that, they are lines, clear, ornamental patterns which are intended to be seen for themselves, which do not merely assert themselves in the impression of the whole but can hold their own even at the closest range. Therein lies the difference from the painterly foliage painting of the seventeenth century.

If we wish to speak of premonitions of the painterly style, we shall find them rather in the fifteenth century than in the sixteenth. We find there, indeed, in spite of the prevailing tendency towards the linear, sporadic modes of expression which are not in accord with linearism and were later eliminated as impure. They also find their way into graphic art. Thus, in the old Nuremberg woodcut (Wohlgemuth) there are drawings of bushes which, with their form-alienated, tangled lines, produce an effect which can only be described

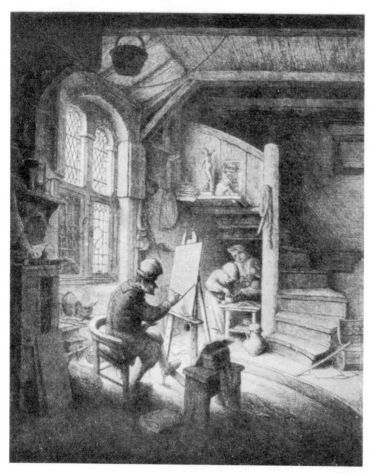

Ostade

as impressionist. As we have said, Dürer was the first to consistently subject the whole contents of the visible world to the form-defining line.

In conclusion, we can further compare Dürer's engraving of St. Jerome * with the painterly version of the same theme in Ostade.* The ordinary stock of reproductions is insufficient if we wish to demonstrate linearity in its full definiteness in a scenic whole. Everything looks blurred in small reproductions of pictures. We must turn to an engraving to make clear how the spirit of clear-cut corporeality asserts itself beyond the single figure on the three-dimensional stage. Ostade's picture, too, is reproduced in an etching, because, even here, photography is too inadequate. From such a comparison, the essence of the contrast leaps to the eye very forcibly. One and the same theme —an enclosed space illuminated from the side—is made to produce a totally

different effect. In the one case, everything is boundary, tangible surface, separate object; in the other, everything is transition and movement. Light, not plastic form, speaks: a twilit whole, in which single objects become distinct, while in Dürer the objects are felt to be the principal thing, the light an adjunct. What Dürer primarily sought—to make the separate objects palpable by their plastic limits—is in Ostade on principle avoided: all the edges are unsteady, the surfaces elude plastic sensation, and light rolls freely over the whole like a stream which has burst its bounds. Concrete objects are not indistinguishable, but they are, to a certain extent, dissolved in a super-concrete effect. We see clearly enough the man at his easel and at his back the projecting dark corner, but the dark mass of one form unites with the dark mass of the other and, with the patches of light between, introduces a movement which, with manifold branching, dominates the picture-space throughout as an independent force.

There is no doubt, with Dürer we feel a type of art which includes Bronzino too, and to Ostade, the parallel, for all the differences, is Velasquez.

With that, we must not fail to realise that the mode of representation goes hand in hand with an arrangement of the form which envisages the same effect. Just as light operates as a homogeneous movement, so the form of the object is drawn into a similar stream of movement. Rigidity has begun to live and stir. The coulisse on the left, in Dürer a dead column, has become oddly unsteady, the ceiling and the spiral staircase, though not dilapidated, are still from the outset manifold in form, the corners no longer clean and neat, but mysteriously disfigured with all sorts of lumber—a characteristic example of "picturesque" arrangement. The dying twilight in the room is in itself a "picturesque" motive *par excellence*.

But painterly vision is, as we have said, not necessarily bound to the picturesque decorative setting. The theme can be much simpler—can even lack any picturesque quality, yet receive in the treatment the interest of a never-ending movement which transcends all the picturesque quality residing in the subject matter. It is precisely the really painterly talents who soon laid aside the "picturesque". How little there is to be found in Velasquez!

3.

Painterly and coloured are two totally different things, yet there is painterly and unpainterly colour and that is here the point at issue, at any rate in a general way. The impossibility of reproducing illustrations may excuse the brevity of the treatment.

The concepts "tactile" and "visual" picture can no longer be applied here

directly, but the contrast of painterly and unpainterly colour is based on a quite analogous notional difference in that colour is, in the one case, taken as a definitely given element, while in the other the variation in the appearance is the essential: the most varied colours "play" over the monochrome object. Of course, according to their position in the light, certain changes in the local colours had always been accepted, but now more happens. The notion of uniformly persisting ground colours is shaken, the appearance oscillates in the most manifold tones, and over the totality of the world, colour lies only as a gleam, hovering and in endless movement.

As in drawing, the nineteenth century first drew the more extreme conclusions from the representation of appearance, so later, impressionism went far beyond the baroque in the handling of colour. All the same, in the development from the sixteenth to the seventeenth century, the fundamental difference is perfectly clear.

For Leonardo or Holbein, colour is the beautiful substance which possesses in the picture, too, a concrete reality and bears its value within itself. The painted blue cloak obtains its effect by means of the same material colour as the cloak had or might have in reality. In spite of certain differences in the light and dark parts, the colour remains fundamentally the same. Therefore, Leonardo requires that the shadows shall be painted only with a mixture of black to the local colour. That is the "true" shadow.[1]

This is the more remarkable in that Leonardo possessed precise knowledge of the appearance of complementary colours in the shadows. But it never occurred to him to make artistic use of this theoretic knowledge. In exactly the same way, L. B. Alberti had observed that a person walking over a green meadow takes on a green colour in the face, but even to him this fact seemed to have no binding significance for painting.[2] We see here how little style is determined by observations of nature alone, and that it is always decorative principles, convictions of taste, to which the last decision is assigned. That the young Dürer behaves quite otherwise in his coloured studies from nature than in his pictures is connected with the same principle.

If then, on the other hand, later art gives up this notion of the nature of local colour, that is not merely a triumph of naturalism, but is determined by a new ideal of the beauty of colour. It would be going too far to say that local colour no longer existed, but the transformation is based precisely on the fact that the real existence of any matter becomes of secondary importance and the chief thing is what happens to it. Both Rubens and Rembrandt pass into quite

[1] Leonardo, *op. cit.* "qual' è in se *vera* ombra da colori in corpi."
[2] L. B. Alberti, *Della pittura libri tre.*

a different colour in the shadows, and it is only a difference of degree if this other colour should no longer appear independent, but only as a component of mixture. When Rembrandt paints a red cloak—I am thinking of the red cape of his *Hendrickje Stoffels* in Berlin—the essential thing is not the red of the natural colour, but the way in which the colour, as it were, changes under the eye of the spectator: in the shadow there stand intense green and blue tones, and only at moments does the pure red rise into the light. We see that the emphasis lies no longer on being, but on becoming and change. Thereby colour has achieved quite a new life. It eludes definition and is, at every point and at every moment, different.

To this can be added the disintegration of the surface which we have already observed. While the style of straightforward local colour models by gradation, the pigments can here stand immediately side by side. In this way colour still further loses its substance. Reality is no longer the colour-surface as a positively existing thing; reality is that semblance which is born of the separate flecks, strokes, and dots of colour. One must, of course, in this case, take up one's stand at some distance, yet it is certainly not intended that only the long-range view, which fuses the colours, should be the right one. It is more than a mere pleasure for the initiate if we perceive the juxtaposition of the strokes of colour. The ultimate aim is that effect of impalpability which, here in the colouring as elsewhere in the drawing, is quite essentially conditioned by the form-alienated technique.

If we wish to make the development metaphorically clear by a quite elementary phenomenon, we might think of water bubbling in a vessel at a given temperature. It is still the same element, but repose has given place to unrest and the palpable to the impalpable. And only in this form did the baroque recognise life.

We might have used the comparison earlier. Just the interflow of light and dark in the painterly style must give rise to such ideas. But what is now new in colour is the multiplicity of its component elements. Light and shade is, after all, a homogeneity: in colouring, on the other hand, it is a question of a combination of different colours. Our exposition hitherto has not assumed this multiplicity. We have spoken of colour, not of colours. If we now look at the total complex, we disregard the question of colour harmony—that is the subject of a later chapter—and insist only on the fact that in classic colouring the single elements stand side by side in isolation, while in painterly colouring the individual colour appears as firmly rooted in the general ground as the water lily in the bottom of the pond. The enamel of Holbein's colour is separated like the cells of a cloisonné, in Rembrandt the colour flashes here

and there out of a mysterious depth as when—to use another metaphor—the volcano vomits its glowing stream, while we know that, at any moment, the gulf can open at a fresh point. The various colours are borne on a homogeneous movement and this impression is obviously to be attributed to the same causes as the homogeneous movement in light and shade which we know. We then say that the colouring is held in tone-relations.

While we give this further definition of the painterly in colour, the objection will certainly be made that it is no longer a matter of seeing, but only of a certain decorative arrangement. Here we are confronted with a certain choice of colours, not a special conception of visible things. We are ready for the objection. A "picturesque" certainly exists in the domain of colour, but the effect which is sought by means of choice and arrangement is not incompatible with what the eye can draw from mere reality. Nor is the colour system of the world fixed. It can be interpreted in various ways. We can observe with an eye to isolated colour, and we can observe with an eye to combination and movement. Certainly there are coloured situations which contain from the outset a higher measure of homogeneous movement than others, but, after all, everything can be conceived in a painterly way, and it is unnecessary to take refuge in a hazy atmosphere which absorbs colour, as certain Dutch masters of the transition are prone to do. But that even here the imitative process is accompanied by a definite demand of decorative feeling is quite in order.

The movement-effect of painterly drawing and of painterly colouring have this in common that, in the same way as light in the drawing, colour in the painting acquires a life detached from the object. Hence too, those motives from nature are called pre-eminently picturesque in which the object underlying the colour has become less easily distinguishable. A tricolour flag hanging still is not picturesque, and even an assemblage of such flags scarcely yields a picturesque sight, although in the repetition of the colour with the perspective gradations there lies a favourable theme, but as soon as the flags flutter in the wind, when the clearly defined stripes disappear and only isolated bits of colour appear here and there, popular taste is ready to recognise a picturesque sight. This is still more the case with the spectacle of a busy, gaily coloured market. It is not the brilliancy of the colour, but the flashing in and out of colours which can scarcely be localised on individual objects and in which, in contrast to the mere kaleidoscope, we are still convinced of the objective significance of the separate colours. That goes together with the observations on the painterly silhouette which have already been made. Conversely, there is in the classic style no impression of colour which is not bound to an impression of form.

SCULPTURE

1. General Remarks

Winckelmann, criticising baroque sculpture, exclaims scornfully, "What a contour!" He regards the self-contained expressive contour line as an essential element of all sculpture and loses interest when the outline yields him nothing. Yet, beside sculpture with a stressed, significant outline, we can imagine sculpture with depreciated outline, where the expression is not formed in the line, and the baroque possessed such an art.

In the literal sense, sculpture as the art of corporeal masses knows no line, but the contrast between linear and painterly sculpture exists for all that, and the effect of the two types of style is hardly less different than in painting. Classic art aims at boundaries: there is no form that does not express itself within a definite line-motive, no figure of which we could not say with an eye to what view it is conceived. The baroque negates the outline: not in the sense that silhouette effects are excluded altogether, but the figure evades consolidation within a definite silhouette. It cannot be tied down to a particular view. It at once eludes the spectator who tries to grasp it. Of course, classic sculpture can be viewed from different standpoints, but other views are clearly *secondary* with reference to the principal view. There is a jerk when we return to the principal motive, and it is obvious that the silhouette is here more than the fortuitous cessation of the visibility of the form: it asserts, beside the figure, a kind of independence, just because it represents something self-sufficing. Conversely, the essence of a baroque silhouette is that it does not possess this independence. No line-motive is intended to set up an existence of its own. No view completely exhausts the form. We can even go further—only the form-alienated outline is the painterly outline.

And the surfaces are handled in the same way. There is not only the objective difference that classic art loves quiet and baroque restless surfaces: the handling of the form is different. In the one case, only definite, tangible values; in the other, transition and change: the representation reckons with effects which no longer exist for the hand but only for the eye. While in classic art, lights and darks are subordinated to the plastic form, the lights here seem to have awakened to an independent life. In apparently free movement, they play over the surfaces, and it can even happen now that the form is completely submerged in the darkness of the shadows. Nay, even without possessing the possibilities which painting on surfaces, by definition the art of semblance, has at its disposal, sculpture in its turn has recourse to indications of form which

no longer have anything to do with the form of the object and cannot be called anything but impressionist.

While sculpture thus allies itself with mere visual appearance and ceases to set up the palpable and real as the essential, it enters upon quite new territory. It rivals painting in the representation of the transitory and stone is made to subserve the illusion of every kind of texture. The bright glance of the eye can be rendered just as well as the shimmer of silk or the softness of flesh. Every time since then that a classic tendency has revived and defended the rights of line, it has considered it necessary to protest against this illusionism in texture in the name of the purity of style.

Painterly figures are never isolated figures. The movement must re-echo, and must not coagulate in a motionless atmosphere. Even the shadow in the niche is now far more important for the figure than formerly. It is no longer a mere foil, but springs into the play of movement: the darkness of the recess unites with the shadow of the figure. For the most part, architecture must collaborate with sculpture, preparing or prolonging movement. If, then, great objective movement is added, there arise those wonderful total effects, such as are to be found especially in northern baroque altars, where the figures combine to such an extent with the structure that they look like the foam on the tossing wave of the architecture. Torn out of their context, they lose all their meaning, as is proved by some unfortunate exhibitions in modern museums.

As regards terminology, the history of sculpture offers the same difficulties as the history of painting. Where does linear cease and painterly begin? Even within classicism, we shall have to distinguish varying degrees of the painterly, and when then light and dark increase in importance and the determinate form yields more and more to the indeterminate, we can denote the process in general as a development into the painterly, but it is absolutely impossible to lay one's finger on the point at which movement in light and form has reached so great a freedom that the notion painterly in the real sense of the word must be applied.

It is, however, not unnecessary to state here clearly that the character of definite linearity and plastic limitation was only attained after a long development. It is only in the course of the fifteenth century that Italian sculpture develops a clearer sensitiveness to line, and without certain painterly effects of movement being eliminated, the form-boundaries begin to acquire independence. It is certainly one of the most delicate tasks of the history of style to estimate correctly the degree of silhouette effect or, conversely, to appreciate the shimmer of a relief by Antonio Rossellino according to its original

painterly content. Here the way lies open to the dilettante. Everyone imagines that, as he sees things, they are well seen, and the more painterly effects he can blink out of the thing, the better. Instead of losing time in individual criticism, let us refer to the painful subject of reproductions in books of our time in which, according to perception and standpoint, the essential character is so often missed.

These remarks relate to the history of Italian art. For Germany the matter is somewhat different. It took a long time for the feeling for line to develop out of the late Gothic painterly tradition. Typical is the German delight in altar shrines with figures set closely side by side and bound together by orna-ment, in which the main interest lies in the—painterly—entwining. But the warning not to look at things in a more painterly way than they are meant to be looked at is here doubly necessary. The standard is always to be found in contemporary painting. Other painterly effects than such as were obtained by artists from nature were, of course, not experienced by the public in face of late Gothic sculpture, however much it may tempt us to look at it in quite disintegrated pictures.

But something of the painterly essence persists in German sculpture even later. The linearity of the Latin race was apt to look cold to Germanic feeling, and it is significant that it was an Italian, Canova, who again rallied occidental sculpture to the banner of line.

2. Examples

For the illustration of the concepts, we shall confine ourselves in the main to Italian examples. The classic type was developed in Italy in unsurpassable purity, and within the painterly style, Bernini signifies the greatest artistic power of the occident.

On analogy with the previous series of analyses, let us take two busts. Benedetto da Majano★ is certainly no Cinquecentist, but the incisiveness of his plastic form leaves nothing to be desired. Perhaps the details come out a little too sharply in the photograph. The essential point is that the form is enclosed in a firm silhouette, and that each separate form—mouth, eyes, the separate wrinkles—has been given an appearance of determinateness and immobility based on the notion of permanence. The following generation would have taken the forms together in bigger units, but the classic character of substantial volume throughout is here perfectly expressed. What in the drapery might be regarded as a shimmer is only an effect of the reproduction. Originally the separate patterns of the stuff were given uniform distinctness

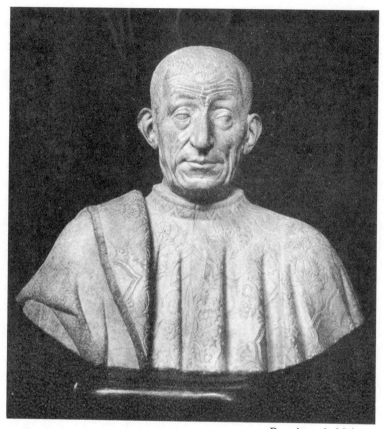

Benedetto da Majano

by colour. In the same way, the eye-balls, in which the sideways movement can easily be overlooked, were brought out by painting.

With Bernini,* the work is so conceived that it can at no point be come at with linear analysis, and that also means that the cubic element withdraws from immediate tangibility. The surfaces and folds of the garment are not only of their very nature restless, but are fundamentally envisaged with an eye to the plastically indeterminate. There is a flicker over the surfaces and the form eludes the exploring hand. The high lights of the folds flash away like lizards, just like the high lights, heightened with white, which Rubens introduces into his drawings. The total form is no longer seen with a view to the silhouette. Compare the look of the shoulders—in Benedetto a calmly flowing line, in Bernini a contour which, restless in itself, at all points leads the eye beyond the edge. The same play is continued in the head. Everything is arranged with a view to the impression of change. It is not the open mouth

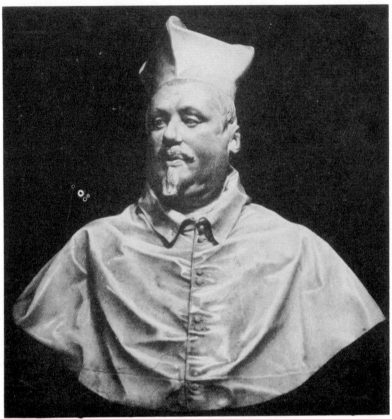

Bernini

which makes the bust baroque, but the fact that the shadow between the lips is regarded as something plastically indeterminate. Although we have here a form modelled fully in the round, it is fundamentally the same type of design as we have already found in Frans Hals and Lievens. For the transformation of the substantial into the unsubstantial which has only a visual reality, hair and eyes are in this case always especially characteristic. The "look" is here obtained by three holes in each eye.

Baroque busts always seem to demand rich drapery. The impression of movement in the face has a far-reaching need of this support. In painting, it is exactly the same, and El Greco would be lost if he could not carry on the movement of his figures in the hurrying drift of the clouds in the sky.

If we wish to find transitions, we might refer to a name like Vittoria. His busts, without being painterly in the ultimate sense of the word, are thoroughly based on the fully resonant effect of light and dark. The development of

sculpture coincides here, too, with that of painting, in so far as the purely painterly style is inaugurated by a treatment in which a richer play of light and shade plays over the basic plastic form. Plasticity is still there, but light becomes very significant on its own account. In such decorative-painterly effects, the eye seems to have been trained to painterly seeing in the imitative sense.

For the full-length figure, we illustrate by a parallel between J. Sansovino * and Puget.* The reproduction is too small for us to obtain a very clear idea of the treatment of detail, yet the contrast of style makes itself felt with the utmost clearness. Firstly, the St. James of Sansovino is an example of classic silhouette effect. Unfortunately, the photo is not taken from the absolutely characteristic front view and hence the rhythm looks somewhat vague. We can see where the mistake lies—in the slab at the feet. The photographer

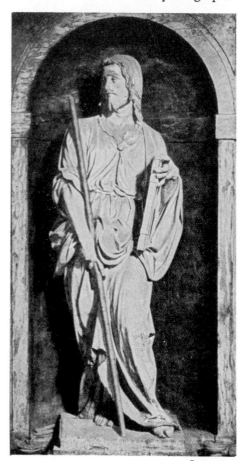

stood too far to the left. The consequences of this mistake make themselves felt everywhere, mostly perhaps in the hand holding the book: the book is so sharply foreshortened that we only see the edge and not the body, and the relation between the hand and the forearm has become so unintelligible that a trained eye must protest. If we take up the right standpoint, the whole thing becomes clear at once, and the clearest view is also the view of complete rhythmic self-sufficiency.

Puget's figure, on the other hand, shows the characteristic negation of contour. Of course, even here, the form is in some way silhouetted against the background, but we are not meant to follow the silhouette. It means nothing with regard to the content it encloses: it looks adventitious, changing from every standpoint without becoming better or worse for such

Sansovino

change The specifically painterly element does not lie in the fact that the line is very restless, but in the fact that it does not grasp and consolidate the form. That is true of the whole as of the detail.

As to the lighting, it is certainly from the outset much more restless than in Sansovino, and we see, too, how in places it quits the form, while in Sansovino light and shade stand completely at the service of intelligibility. The painterly style, however, reveals itself in the fact that light has acquired that life of its own which withdraws the plastic form from the domain of immediate tangibility. The discussion of Bernini's bust might be referred to here. In a different sense from that of classic art, the figure is conceived as an appearance for the eye. The corporeal form does not lose its substantiality, but the stimulus

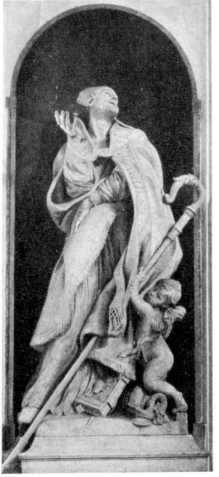

Puget

which it imparts to the organs of touch is no longer the primary factor. That does not prevent the stone, in the treatment of surfaces, from having acquired much greater textural illusion than formerly. And this texture, this distinction of hard and soft, etc., is an illusion for which we have only to thank the eye, and which would immediately elude the exploring hand.

The further motives which increase the impression of movement, the bursting of the tectonic scaffolding, the transposition of composition in the plane into composition in recession, and so on, must be left out of consideration here: for the moment, on the other hand, we might note that the shadow of the niche has, in painterly sculpture, become an integral factor in the effect. It enters into the light-movement of the figure. Thus in baroque drawings we find that no portrait sketch has been thrown so hastily on to the paper as to have no accompanying shadow in the background.

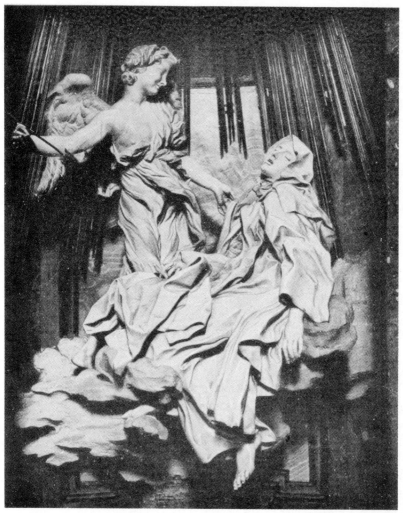

Bernini

It is consistent for a type of sculpture which aims at pictorial effects that it
must feel more attracted to the figure on the wall and in the niche than to the
free-standing figure. In spite of that, it is precisely the baroque—we shall
return to this point—which escapes from the spell of the plane, and thus it is
fundamentally in its interest to limit the possible points of view. For this, it is
just Bernini's masterpieces which are characteristic, especially those which,
after the style of the St. Theresa,* are enclosed in a half-open recess. Cut into
by the enframing half-column and lighted from above by its own source of
light, this group produces a thoroughly pictorial effect, that is, the effect of a

thing which has, in a certain sense, been withdrawn from immediate tangibility. And now, by a painterly handling of form, care is further taken to remove from stone its immediately tangible character. Line as boundary is eliminated and so much movement is introduced into the surfaces that, in the impression of the whole, the quality of tangibility more or less vanishes.

Let us consider as contrast Michelangelo's recumbent figures in the Medici Chapel. These are pure silhouette figures. Even the foreshortened form is taken into the plane, that is, reduced to an expressive silhouette effect. With Bernini, on the other hand, everything is done to prevent the form from speaking by the outline. The total contour of his saint in ecstasy yields a perfectly senseless figure and the drapery is modelled in such a way that it cannot be come at by linear analysis. The line flashes out here and there, but only momentarily. Nothing substantial and tangible. Everything movement and endless change. The impression essentially reduced to the play of light and shade.

Light and shade—Michelangelo makes them speak, and in rich contrasts too, but they still mean for him plastic values. As clearly defined masses, they remain subordinate to the form. In Bernini, on the other hand, they are indeterminate and, as though they no longer belonged to definite forms, they flash, a liberated element, in wild play over surfaces and furrows.

The extent of the concessions which are now made to purely visual appearance is shown by the eminently textural effect of the flesh and the fabrics (the robe of the angel). And the same spirit conceived the clouds, treated illusively, which, apparently hovering free in air, serve as couch for the saint.

It is easy to see the logical consequences for the relief entailed by such premisses and scarcely requires further illustration. It would be foolish to believe that a purely plastic character must always be denied to it because it does not work with bodies in the round. These rough material differences do not matter. Even free-standing figures may be flattened down into a relief without losing their bodily fullness: the effect is the thing that counts, not the sensuous facts.

ARCHITECTURE

General Remarks

The examination of painterly and unpainterly in the tectonic arts is especially interesting in that the concept, here for the first time liberated from confusion with the demands of imitation, can be appreciated as a pure concept

of decoration. Of course, for painting and architecture, the position is not quite the same. Architecture of its very nature cannot become an art of semblance to the same degree as painting, yet the difference is only one of degree and the essential elements of the definition of the painterly can be applied as they stand.

The elementary phenomenon is this—that two totally different architectural effects are produced according to whether we are obliged to perceive the architectural form as something definite, solid, enduring, or as something over which, for all its stability, there plays an apparent, constant movement, that is, change. But let there be no misunderstanding. Of course, all architecture and decoration reckons with certain suggestions of movement; the column rises, in the wall, living forces are at work, the dome swells upwards, and the humblest curve in the decoration has its share of movement, now more languid, now more lively. But in spite of that movement, the picture in classic art is constant, while post-classic art makes it look as though it must change under our eyes. That is the difference between a rococo decoration and a renaissance ornament. A renaissance panel may be designed with as much life as you like, its appearance stays as it is, while ornamentation such as rococo art strews over its surfaces produces the impression that it is in constant change. And the effect in major architecture is the same. Buildings do not run away and a wall remains a wall, but there subsists a very palpable difference between the finished look of classic architecture and the never quite assimilable picture of later art; it is as though the baroque had feared ever to speak the last word.

This impression of the becoming, of the unresting, has various origins—all the later chapters will contribute to its explanation—but here we shall only discuss what may be called painterly[1] in a specific sense, while popular usage calls everything picturesque[1] which is in any way connected with the impression of movement.

It has rightly been said that the effect of a beautifully proportioned room would make itself felt if we were led through it blindfold. Space, being physical, can only be apprehended by physical organs. This spatial effect is a property of all architecture. If painterly interest is added, it is a purely visual element—pictorial, and hence no longer accessible to that most general type of tactile feeling. The perspective of a flight of rooms is painterly not by the architectonic quality of the single room, but by the picture, the visual picture which is yielded by the superimposed forms: the separate form in itself can be felt, but the picture which is born of the sequence of receding forms can only

[1] The original uses "malerisch" in both cases (Tr.).

be seen. So that, whenever "views" are to be reckoned with, we stand on painterly ground.

It goes without saying that classic architecture must be *seen*, and that its tangibility has only an imagined significance. And in the same way we can, of course, look at the building in many ways, foreshortened or not, with or without intersection of the forms, and so on, yet from all standpoints, the tectonic basic form will penetrate as the decisive element, and where this basic form is distorted, we shall feel the fortuitousness of a merely secondary aspect and not be ready to tolerate it long. Conversely, painterly architecture is particularly interested in making its basic form appear in as many and as various pictures as possible. While in the classic style the permanent form is emphasised and the variation of the appearance has beside it no independent value, the composition in the other case is from the outset laid out in "pictures". The more manifold they are, the more they diverge from the objective form, the more painterly the building is considered to be.

In the staircase of a rich rococo chateau, we do not look for the solid, enduring, concrete form of the lay-out, but surrender to the rhythm of the changing views, convinced that these are not fortuitous by-products, but that, in this spectacle of never-ending movement, the true life of the building is expressed.

Bramante's St. Peter's as a circular building with cupolas would also have yielded many views, but those which were painterly in our sense would have been, for the architect and his contemporaries, the meaningless ones. Being was the essential, not the pictures shifted this way or that. In the strict sense, architectonic architecture could acknowledge either no standpoint of the spectator—certain distortions of the form always being present—or all: painterly architecture, on the other hand, always reckons with the beholding subject, and hence does not in the least desire to create buildings which may be viewed from all standpoints, such as Bramante worked out for his St. Peter's; it restricts the space at the spectator's disposal so that it may the more certainly achieve the effects it has at heart.

Although the full front view will always claim for itself a certain exclusivity, we still find now compositions which clearly set out to reduce the significance of this view. This is very clear, for instance, in the Carlo Borromeo Church in Vienna, with its two columns placed in front of the façade, the true value of which is first revealed in the non-frontal views, where the columns lose their equality and the central dome is cut across.

For the same reason it was regarded as no misfortune if a baroque façade was so placed in a street that it was almost impossible to obtain a front view of

it. The Theatiner Church in Munich, a famous example of a twin-towered façade, was only laid free by Ludwig I in the neo-classic period: originally it was wedged in the narrow street. Of necessity, therefore, it always appeared a-symmetrical.

We know that the baroque enriched the form. Figures become more intricate, motives entwine, the order of the parts is more difficult to grasp. In so far as this is connected with the principle of the avoidance of absolute lucidity, we shall have to consider these points later: here the phenomenon will only be treated in so far as the specifically painterly transformation of purely tangible into purely visual values is illustrated. Classic taste works throughout with clear-cut, tangible boundaries; every surface has a definite edge, every solid speaks as a perfectly tangible form; there is nothing there that could not be perfectly apprehended as a body. The baroque neutralises line as boundary, it multiplies edges, and while the form in itself grows intricate and the order more involved, it becomes increasingly difficult for the individual parts to assert their validity as plastic values; a (purely visual) movement is set going over the sum of the forms, independently of the particular viewpoint. The wall vibrates, the space quivers in every corner.

A special warning must be made here against regarding the painterly movement-effect as equivalent to the great mass movement of certain Italian buildings. The dramatic effect of sinuous walls and mighty groups of columns is only a special case. The gentle flicker of a façade in which the projections are hardly noticeable is just as painterly. But what then is the real impetus in this transformation of style? A mere reference to the interest of increased enrichment is not enough, nor is it a question of an intensification of effect on an identical basis: even in the richest baroque, it is not only that more forms are there, but that they are forms of a totally different effect. Obviously we have the same relationship before us as in the development of drawing from Holbein to Van Dyck and Rembrandt. Even in tectonic art, nothing is to settle into tangible lines and surfaces; even in tectonic art, the impression of permanence is to be supplanted by the impression of change; even in tectonic art, form must breathe. That is, apart from all expressional differences, the basic notion of the baroque.

But the impression of movement is only attained when visual appearance supplants concrete reality. That is, as has already been observed, not possible to the same degree in the tectonic arts as in painting: we shall, perhaps, speak of impressionist decoration, but not of impressionist architecture. But, all the same, architecture has means enough at its disposal to provide the painterly contrast to the classic type. It always depends on how much the individual

form complies with the (painterly) total movement. Depreciated line enters more easily into the great play of forms than plastically significant, form-defining contour. Light and shade, which cling to every form, become a painterly element at the moment at which they seem to have an independent import apart from the form. In classic style, they are bound to the form; in the painterly style, they appear unbound and quicken to free life. It is no longer the shadows of the separate pilaster or window-pediment of which we become aware, or, at any rate, not of these only. The shadows link up among themselves, and the plastic form can at times be quite submerged in the total movement which plays over the surfaces. In interiors, this movement of light can be carried on in oppositions of dazzling light and pitch dark, or tremble in merely light tones—the principle remains unchanged. In the one case, we must think of the vigorous plastic movement of Italian church interiors; in the other, of the flickering lightness of a very softly modelled rococo room. If the rococo liked wall-mirrors, that does not only mean that it liked light, but also that it wished to discount the wall as concrete surface by what is apparently impalpable not-surface—the reflecting glass.

The deadly enemy of the painterly is the isolation of the single form. In order that the illusion of movement may be brought about, the forms must approach, entwine, fuse. A piece of furniture of painterly design always requires atmosphere: you cannot set a rococo chest of drawers against any wall—the movement must re-echo. It is the peculiar charm of rococo churches that every altar, every confessional, is merged into the whole. The astonishing extent to which tectonic barriers are broken down in the consistent development of this demand can be realised in supreme examples of painterly movement, as, for instance, the St. John Nepomuk Church by the brothers Asam in Munich.

As soon as classicism reappears, the forms temporarily separate. In the façade of the palace, we can again see window beside window, each separately apprehensible. Semblance has evaporated. The concrete form, solid, enduring, must speak, and that means that the elements of the tangible world again take the lead—line, plane, geometric body. All classic architecture seeks beauty in what is, baroque beauty is the beauty of movement. In the former, "pure" forms have their home, and architects seek to give visible form to the perfection of eternally valid proportions. In the latter, the value of perfected being sinks into insignificance beside the idea of breathing life. The constitution of the body is not indifferent, but the primary demand is that it should have movement; in movement, above all, lies the stimulus of life.

These are radically different conceptions of the world. What has here been set forth on the subject of painterly and unpainterly forms one part of the ex-

pression in which the conception of the world manifested itself. The spirit of the style, however, is equally present in major as in minor arts. A mere vase is enough to illustrate the universal historical opposition. When Holbein★ designs a tankard, it is the plastically determinate figure in absolute perfection, a rococo vase★ is a painterly, indeterminate work: it settles into no tangible outline, and over the surfaces there plays a movement of light which makes their tangibility illusory; the form is not exhausted in *one* aspect, but contains for the spectator something inexhaustible (see reproduction, pp. 242, 243).

However economically we may apply the concepts, the two words painterly and unpainterly are absolutely inadequate to denote all the innumerable transitions in the historical development.

Firstly, scenic and national characters diverge. The painterly essence runs in the veins of the Germanic race, which has never felt at home for long in the neighbourhood of "absolute" architecture. We must go to Italy to get to know the type. That style of building which prevails in later epochs and had its origin in the fifteenth century was purged in the Renaissance period of any painterly by-products and developed into a purely linear style. Bramante, as contrasted with the Quattrocento, set out to base the architectonic effect with increasing consistency on purely concrete effects. But even in the Italy of the Renaissance, there are again differences. Upper Italy, Venice in particular, was always more painterly than Tuscany and Rome, and, whether we will or no, we must apply the notion even within the linear epoch.

In the same way, the baroque transformation into the painterly style fulfilled itself in Italy in a brilliant development, but we must not forget that the ultimate conclusions were only drawn in the north. There the painterly mode of feeling seems to lie in the very soil. Even in the so-called German Renaissance, which yet felt the new forms with reference to their plastic content with so much gravity and emphasis, the painterly effect is often the best. The finished form has too little meaning for the Germanic imagination: over it there must always play the charm of movement. That is why, within the movement style, Germany has produced buildings of an incomparably painterly type. Measured by such standards, Italian baroque still shows traces of the underlying (plastic) feeling, and to the rococo, with its mere scintillations of light, the home of Bramante has only been accessible in a very limited sense.

As regards chronology, the facts cannot, of course, be mastered with two concepts. The development proceeds by imperceptible transitions, and what I call painterly in comparison with an earlier example can appear to me unpainterly with regard to a later. Especially interesting are those cases in which, within a painterly total conception, linear types appear. The Rathaus of

Amsterdam,* with its smooth walls and the naked right angles of its ranges of windows, would appear to be an unsurpassable example of linear art. It was, in fact, born of a classic reaction, but the connection with the painterly pole is not lacking: the principal point is how contemporaries looked at the building, and that we can learn from the many pictures painted from it in the seventeenth century, which all look quite otherwise than when, for instance, a confirmed linearist later takes up the theme. Long rows of uniform windowpanes are not unpainterly in themselves, the only question is how they are seen. One observer sees only the lines and right angles; for the other, the main thing is the surfaces vibrating with a most stimulating effect of light and dark.

Every epoch perceives with its own eyes, and nobody will contest its right to do so, but the historian must ask in each case how a thing demands to be seen in itself. In painting this is easier than in architecture, where there are no limits to arbitrary perception. The stock of reproductions at the disposal of art history is rife with false views and false interpretations of effects. The only thing that can help here is verification by contemporary pictures.

A multiform late Gothic building such as the Town Hall of Louvain must not be so drawn as a modern eye, trained on impressionist lines, sees it (in any case, that gives no scientifically serviceable reproduction), and a late Gothic chest in low relief must not be looked at in the same way as a rococo chest of drawers: both objects are painterly, but the store of contemporary pictures gives the historian plenty of clear indications as to how one type of the painterly is to be distinguished from the other.

The distinction between painterly and unpainterly (or strict) architecture comes out most clearly when painterly taste has had to grapple with a building of the old style, that is, where we have an alteration into the painterly style.

The Ss. Apostoli* church in Rome possesses a fore part which was worked out in Early Renaissance style in two storeys of arcades with pillars below and slim columns above. In the eighteenth century the upper storey was closed in. Though the system was not destroyed, a wall was created which, envisaging throughout the impression of movement, stands in characteristic contrast to the strict character of the ground floor. In so far as this impression of movement is achieved by a-tectonic means (raising of the window pediments above the line of the springing of the arches), or is produced by the motive of the rhythmic articulation (unequal accentuation of the bays by the statues on the balustrade—the central and corner bays are stressed) we leave the matter to itself; nor must the peculiar conformation of the middle window, which projects from the surface—at the edge of our reproduction—preoccupy us here. What is radically painterly is that the forms have here lost through-

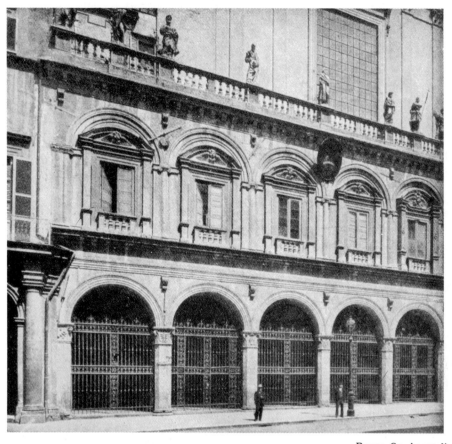

Rome, Ss. Apostoli

out their separateness and tangible concreteness, so that, beside them, the pillars and arches of the lower storey appear as something totally disparate, as the only real plastic values. That does not lie in the stylistic detail—the creating spirit is different. Not the restless movement of the line in itself is the decisive factor (in the breaking of the pediment corners) nor the multiplication of the line itself (in the arches and lintels), but that a movement is created which quivers over the whole. This effect presumes that the spectator is able to disregard the merely tangible character of the architectonic form and is capable of surrendering to the visual spectacle, where semblance interweaves with semblance. The treatment of form assists this reading in every way possible. It is difficult, even impossible, to seize the old column as a plastic form, and the originally simple archivolt is not less withdrawn from immediate tangibility. By the telescoping of the motives—arches and pediments—the

building becomes so intricate in appearance that one is always impelled to apprehend the total movement rather than the single form.

In strict architecture every line looks like an edge and every volume a solid body: in painterly architecture the impression of mass does not cease, but with the notion of tangibility there is combined that illusion of all-pervading movement which is derived just from the non-tangible elements of the impression.

A balustrade in the strict style is the sum of so many balusters which assert themselves as tangible separate bodies in the impression: with a painterly balustrade, on the other hand, it is the shimmer of the total form which is the main factor in the effect.

A renaissance ceiling is a system of clearly defined coffers: in the baroque, even where the design is not confused and the tectonic boundaries not suppressed, it is the movement of the whole at which the artistic intention aims.

What such a movement means on a large scale is made quite convincingly clear by an example such as the show façade of S. Andrea* in Rome. It is unnecessary to reproduce the classic contrast. Here the forms, one by one, like separate waves, are so conveyed into the total undulation that they are completely swamped—a principle which is directly contrary to that of strict architecture. We can disregard the particular dynamic resources which are here applied to aid powerful movement — the projection of the middle, the accumulation of the lines of force, the breaking of cornices and gables. The distinguishing feature in regard to the whole of the Renaissance remains the interplay of forms, so that, independent of the separate bay, independent of the separate forms which fill, frame, and join, an apparent movement is produced which is purely visual in kind. Imagine how much of this façade could be caught in a sketch with mere dabs of the brush, and how, conversely, all classic architecture requires the most definite rendering of proportion and line.

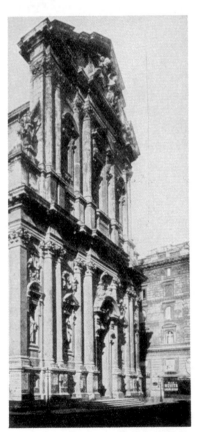

Rome, S. Andrea della Valle

Foreshortening adds its quotum. The effect of painterly movement will make itself felt the more easily if the surface proportions are distorted and the body as a form of appearance is divorced from its real form. Confronted with baroque façades, we always feel impelled to take up our stand to the side. Meanwhile, we must here again refer to the fact that every epoch bears its standard within itself, and that not all views are possible at all times. We are always prone to take things in a still more painterly way than they are meant to be taken, even to force the definitely linear, if it is at all possible, into the painterly. It *is* possible to look at a façade such as the Otto Heinrichsbau of Heidelberg Castle in such a way as to catch the flicker of the surface, but there is no question that, for its creator, this possibility had not much importance.

With the idea of foreshortening, we have attacked the problem of the perspective view. In painterly architecture, as has been pointed out, it plays an essential part. For what has been said up to now, we refer to the example of S. Agnese in Rome (reproduction, p. 17). A church with a central dome and two front towers. The rich array of forms predisposes to a painterly effect, but is not in itself painterly. S. Biagio in Montepulciano is composed of the same elements without being akin in style. What makes the painterly character of the design here is the fact that into the artistic calculation there enters that variation of the aspect which, of course, is never entirely absent, but is, in a handling of form aiming from the outset at visual effects, much more strongly justified than in architecture of pure being. Every reproduction remains inadequate, because even the most startling picture in perspective represents only *one* possibility, and the interest lies just in the inexhaustibility of the possible pictures. While classic architecture seeks its significance in corporeal reality, and only allows the beauty of the aspect to proceed from the architectural organism as its natural result, the visual appearance, in the baroque, plays a determining part in the conception from the beginning: the aspects, not the aspect. The building assumes very different forms, and this variation in the mode of appearance is enjoyed as the interest of movement. The views strive towards each other, and the picture with the foreshortening and overlapping of single parts is as little criticised as an improper by-product as, for instance, the a-symmetrical appearance in perspective of two symmetrical towers. This type of art takes care to set up the building in pictorially fruitful sites for the spectator. That always means a limitation of the points of view. It does not lie in the interests of painterly architecture to set up the building so that the spectator may move all round it, that is, as a tangible object, as was the ideal of classic architecture.

The painterly style finds its climax in interiors. The possibilities of combining the tangible with the charm of the intangible are here most favourable. Only here does the element of the indeterminate, of what cannot be taken in at a glance, reach its full value. Here is the real field for coulisses and perspectives, for rays of light and darkness of depths. The more light there is introduced into the composition as an independent element, the more does architecture become visual-painterly in type.

Not that classic architecture had abandoned the beauty of light and the effect of rich spatial combinations. But there light is subservient to form, and even in the richest perspective view the spatial organism, the real form, is the ultimate aim, not the painterly picture. Bramante's St. Peter's is splendid in its perspective aspects, but we can clearly feel that all the pictorial effect is only a detail in relation to the powerful speech uttered by the masses as bodies. The essence of this architecture is, to a certain extent, what we obtain by bodily experience. But for the baroque, new possibilities are given precisely by the fact that, beside the reality for the body, there exists a reality for the eye. We do not need to think of really illusive buildings, buildings which set out to give an illusion of something different from what is there, but only of the fundamental exploitation of effects which are no longer of a plastic tectonic character. The ultimate intention is to deprive the enclosing wall and covering ceiling of their tangible quality. In that way there arises a very remarkable illusory product which the northern imagination has developed incomparably more "picturesquely" than the south. Startling lights and mysterious depths are not needed to make an interior look picturesque. Even with a lucid plan and perfectly clear lighting the rococo was able to create its *beauty of the impalpable*. Such things are inaccessible to reproduction.

If then, about the year 1800, in the neo-classic period, art again becomes simple, confusion yields to order, and the straight line and right angle are again brought to honour, that has certainly to do with a new homage to simplicity, but at the same time the basis of art as a whole was shifted. More vital than the reorientation of taste towards simplicity was the transformation of feeling from the painterly to the plastic. Once more, line is a tangible value, and every form finds its reaction in the organs of touch. The neo-classic blocks of houses in the Ludwigsstrasse in Munich, with their broad, simple surfaces, are the protest of a new tactile art against the sublimated visual art of the rococo. Architecture once more sought its effects in the pure cube, in the definitely palpable proportion, in the plastically clear form, and the whole art of the painterly fell into contempt as pseudo-art.

II

PLANE AND RECESSION

PAINTING

1. General Remarks

IF we say that a development took place from a plane type into a recessional type, we have said nothing in particular, for it goes without saying that the means of representation of the object in the round and of recession in space were only gradually brought to perfection. The phenomenon we have in mind is that other—that just that stage of art which entered into full possession of the means of representing pictorial space, the sixteenth century, recognised the combination of forms in a plane as a principle, and that this principle of composition in the plane was dropped by the seventeenth century in favour of a definitely recessional type of composition. In the former case, the will to the plane, which orders the picture in strata parallel to the picture plane; in the latter, the inclination to withdraw the plane from the eye, to discount it and make it inapparent, while the forward and backward relations are emphasised, and the spectator is compelled to co-relate in recession.

It seems paradoxical, and yet fully corresponds to the facts—the sixteenth century is more planimetric than the fifteenth. While the undeveloped imagination of the primitives is certainly as a whole bound to the plane, yet continually makes attempts to break its spell, we see art, as soon as it has mastered perspective and spatial depth, consciously and consistently acknowledging the plane as the true form of beholding. It can be neutralised here and there by recessional motives, yet it penetrates the whole as binding basic form. Recessional motives in earlier art look for the most part incoherent, and the horizontal stratification there appears as mere poverty: now, on the other hand, plane and recession have become *one* element, and just because the whole is interspersed with foreshortened forms, we feel that the acquiescence in the plane type is a matter of free choice, and obtain the impression of wealth simplified to the greatest repose and explicitness.

Nobody who comes from the Quattrocentists will forget the impression which Leonardo's *Last Supper* makes in this sense. Although the table with the group of disciples had certainly always been placed parallel to the picture edge, the alignment of the figures and their relation to the picture space here for the first time achieves that wall-like compactness which forces the plane upon us. If then we think of Raphael's *Miraculous Draught of Fishes*,* even there the way in which the figures are disposed in a coherent "relief-like" plane is a totally new impression; and it is the same thing where only single figures are involved, as in the presentment of a reclining Venus by Giorgione or Titian. Everywhere the form is posed in the definitely stated main plane of the picture. We shall not mistake this form of representation even in cases where the plane coherence does not appear continuous, but, to a certain extent, only intermittent, with separate intervals, or where the straight row is deepened to a flat curve within the plane as in Raphael's *Disputa*. Even a composition such as Raphael's *Heliodorus* does not fall out of the schema, although an energetic slanting movement cuts into the picture from the side: the eye is still led back out of the depth and will grasp the foreground groups to left and right as the essential points in one arc.

Yet the classic plane style had its limited period, just like the classic line style, with which, since all line is bound to the plane, it has a natural affinity. There comes a moment when the plane relation slackens and the receding sequence of the picture forms begins to speak, where the contents of the picture can no longer be grasped in plane sections, but the nerve lies in the relation of the foreground to the background parts. That is the style of de-preciated plane. An ideated foreground plane will always be present, but the possibility is no longer allowed to arise that the form unites in a plane. What-ever could operate in this sense—whether in the single figure or in the sum of many figures—is arrested. Even where this effect seems inevitable, as, for instance, where a number of human figures stands along the edge of the stage—care is taken that they do not settle into a row and that the eye is continually forced to form recessional relations.

If we leave out of account the imperfect solutions of the fifteenth century we obtain here two types of representational methods as different as the linear and painterly. Certainly, we can rightly ask whether they are really two styles, each of individual value and neither replaceable by the other, or whether the recessional representation contains only a greater measure of space-creating resources, without being an essentially new mode of representation. Properly understood, the two concepts are complete contrasts which derive from decorative feeling and cannot be understood on the basis of mere imita-

tion. It is not a question of the degree of recession in the space represented, but in what way recession is made effective. Even where the seventeenth century apparently indulges in pure compositions in breadth, a closer comparison must prove the fundamentally different point of departure. The spiral into-the-picture movement which Rubens loves will certainly be sought for in vain in Dutch pictures, yet this system of Rubens' is only *one* type of recessional composition. There need even be no plastic oppositions of foreground and background: Jan Vermeer's *Lady Reading* (Amsterdam), who stands in profile in front of straight back-wall, is chiefly a recessional composition in the seventeenth-century sense by the fact that the eye connects the highest light on the wall with the figure. And if Ruysdael, in his *Distant View of Haarlem** (The Hague), arranges the fields in mere unevenly lighted, horizontal strips, that does not make it a picture of the old plane-sequence, for the reason that the receding disposition of the strips is more strongly emphasised than the individual strip, which the spectator cannot isolate as an object.

This is no matter to be mastered by catchwords or superficial observation. It is easy to see how Rembrandt, as a young man, pays tribute to his time by the rich echelonnement of his figures, but in his master years he abandoned this style, and if he once depicted the story of the *Good Samaritan* with an artificial spiral recession of the figures (etching of 1632), later in the Louvre picture of 1648,* he gave it in a quite simple row. And yet that was no return to old forms of style. Just in the simple composition in strips, the principle of the recession picture becomes doubly clear—everything being done to prevent the series of figures from settling into a row in the plane.

2. THE CHARACTERISTIC MOTIVES

If we attempt to compare the characteristic transformations, the simplest case would be the transposition of the alignment in two-figure scenes into a diagonal recession. This takes place in the story of Adam and Eve, in the Angel's Greeting of the Annunciation, in St. Luke painting the Virgin, and whatever other name the situation may bear. Not that every such picture in the baroque must have the diagonal movement in the disposition of the figures, but it is the prevailing one, and where it is absent care is certainly taken in some other way to prevent the impression of a side-by-side arrangement from arising. On the other hand, there are also examples in which classic art breaks a gap through the plane, but then the essential point is that the spectator feels the gap as a breaking through of the normal plane. It is not necessary that

everything should be extended in one plane, but deviation must be felt as such.

Our first illustration is Palma Vecchio's *Adam and Eve*.* What we meet here as plane-arrangement is by no means the continuation of a primitive type, but the essentially new classic beauty of figures energetically posed in the plane, so that the stratum of space looks uniformly living in all its parts. In Tintoretto,* this relief-like quality is destroyed. The figures have withdrawn into the picture, a diagonal movement goes from Adam to Eve, held by the landscape with the distant light on the horizon. The beauty of the plane has yielded to the beauty of recession, which is always combined with an impression of movement.

Quite analogous is the development of the theme of the painter and his model, a subject known to earlier art as St. Luke and the Virgin. If we wish to draw the comparison here between northern pictures, and at the same

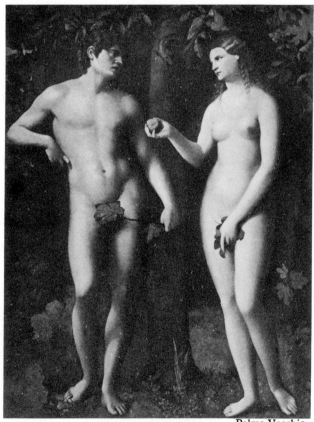

Palma Vecchio

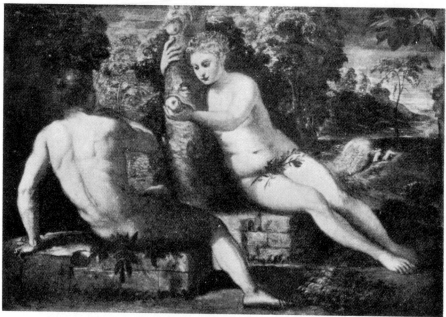

Tintoretto

time take a rather greater interval of time, we can contrast with Vermeer's*
baroque schema the plane schema of a painter of the school of Dirk Bouts,*
where the principle of the stratification of the picture in parallel planes is
carried out—in the figures as in the setting—in absolute purity, although with
some constraint, while for Vermeer, the transposition into recession is the
natural method of treatment. The model is placed far back in the room, but
lives only in relation to the man for whom she poses, and thus, from the outset,
a vigorous into-the-picture movement comes into the scene, materially sup-
ported by the lighting and the perspective. The highest light is placed in the
background, and in the clash of the strongly opposed size values of the girl
and the near curtain with the table and chair, the picture acquires an interest
of a decidedly recessional character. A closing wall parallel to the picture plane
is certainly there, but has no essential importance for visual orientation.

The extent to which it is possible to maintain the confrontation in profile of
two figures and still to overcome the plane can be seen in a picture such as
Rubens' *Meeting of Abraham and Melchizedek.** This confrontation, which the
fifteenth century had formulated only loosely and uncertainly, is so handled
by Rubens that the two main figures stand in rows which open a way into the
picture, by which device the side-by-side motive yields to the recessional
motive. We see Melchizedek holding out his hand, and he stands on the same

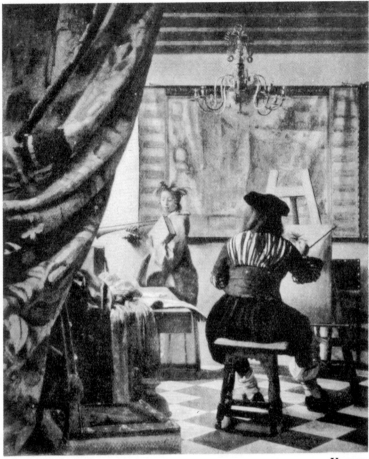

Vermeer

level as Abraham in armour, to whom he turns. There is nothing simpler here than to obtain a relief-like picture. But just this effect is avoided by the epoch, and, the main figures being involved in rows with a decidedly recessional movement, it becomes impossible to relate them in the plane. The architecture of the back wall can no longer counteract these optic facts, even if it had been less rugged and did not open into illuminated breadth.

Quite similar is the case in the picture of Rubens' *Last Communion of St. Francis* (Antwerp). The priest with the host facing the man who kneels before him—how easily can we imagine the scene in Raphael's style! It seems hardly possible that the figures of the man receiving the host and the man bending over him should not unite in a plane picture. Yet when A. Caracci, and after him Domenichino, handled the story, it was already decided that the sequence

Dirk Bouts (School of)

of planes was to be avoided: they undermined the visual union of the main
figures by opening a vista between them into the picture. And Rubens goes
still further; he emphasises the relation between the accessory figures, which
are disposed in rows running into the picture, so that the natural factual
connection between the priest on the left and the dying saint on the right is
counteracted by a completely contrary sequence of form. In comparison with
the classic age, the orientation has completely shifted.

If we are to quote Raphael literally, a specially fine example of the plane-
style is the *Miraculous Draught of Fishes* from the Tapestry Cartoons,★ where
the boats with the six men are combined in a quiet plane-form with a splendid
run of the line from the left to the height of St. Andrew standing, and a highly
effective fall just in front of Christ. Rubens certainly had this picture before

him. He reproduces (Mechlin) all the essentials, the only difference being that he intensifies the movement of the figures. This intensification, however, is not yet the decisive point for the style of the picture. Much more important is the way in which he counteracts the plane and, by the displacement of the boats, still more by the movement introduced from the foreground, disintegrates the old plane picture into strongly emphasised receding sequences. Our reproduction shows the free copy by Van Dyck after Rubens,* which is rather broader in the arrangement.

As a further example of this kind we might refer to Velasquez' *Surrender of Breda*, where again, although the old plane-schema is not abandoned in the arrangement of the main figures, the picture takes on an essentially new appearance by the fact that we are repeatedly impelled to link up foreground and background. This presentment of the handing over of the fortress keys with the meeting of the two main figures in profile, is in principle nothing else than is contained in the handing over of ecclesiastical keys or Christ and St. Peter in *Feed my Lambs*. Yet if we refer to Raphael's composition from the series of tapestries, or even Perugino's frescoes in the Sistine Chapel, we see

Rubens

Raphael

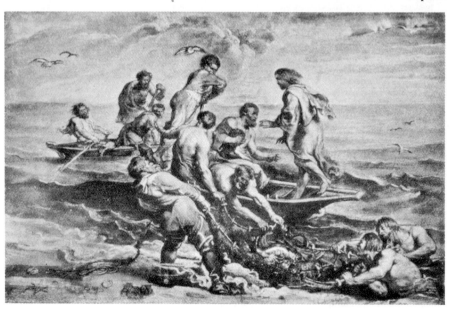

Van Dyck (after Rubens)

at once in Velasquez how little importance that profile meeting now has for the total habitus of the picture. The groups are not extended in a plane; at all points, the recessional relations speak, and where the consolidation of the plane should have taken place, in the motive of the two generals, the danger is averted by the fact that just at this point a vista is opened on to the bright troops in the background.

It is a similar matter with another main picture of Velasquez—*The Spinners*. If we consider only the lay-out, we might think that the seventeenth-century artist had here reproduced the composition of the School of Athens: a foreground with roughly equal important groups on either side, and behind, exactly in the middle, a raised, smaller space. Raphael's picture is a capital example of the plane style—mere horizontal strata one behind the other. In Velasquez a similar impression, as far as the single figures are concerned, is of course excluded by the difference in the drawing, yet even the total composition has with him a different sense: the sunny middle distance corresponds to a unilateral light in the foreground on the right, and thus, from the outset, a light-diagonal is created which dominates the picture.

Every picture has recession, but the recession has a very different effect according to whether the space organises itself into planes or is experienced as a homogeneous recessional movement. In the northern painting of the sixteenth century, it is Patenir* who spreads out his landscape in separate receding bands with unprecedented repose and lucidity. Here, perhaps better than anywhere else, can we learn to realise that a decorative principle is at issue. This space in bands is not an expedient to represent recession, it is the very arrangement in bands which is of itself pleasing. It is the form in which the period enjoyed spatial beauty. The same in architecture.

In the same way colour lies in layers. Colour zones succeed each other in clear, quiet gradations. The co-operation of coloured strata is so important in the total impression of a Patenir landscape that it is hardly worth while to place here a reproduction without colour.

If then later the separation of the colour-gradations of the picture-zones is constantly increased and a system of violent colour perspective made of it, those are phenomena of the transition to the recessional style, quite analogous to the striping of the landscape with powerful oppositions of light. We might refer to the example of Jan Brueghel. The true contrast, however, is only achieved when we can no longer obtain the notion of a series of strips before us, but when recession becomes immediate experience.

That does not necessarily have to be brought about by plastic methods. In lighting, distribution of colour and type of perspective drawing, the baroque

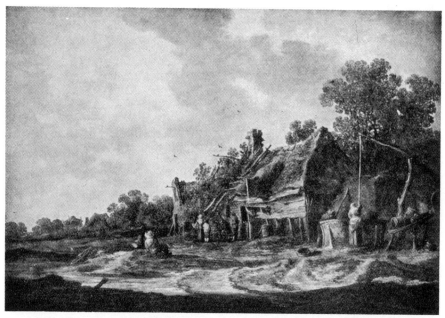

Van Goyen

possesses means of enforcing the recessional movement even if no preparation is made for it with the plastic-spatial motives. When Van Goyen* takes his dunes diagonally into the picture—good, the impression of recession is then directly achieved. And when Hobbema, in the *Avenue at Middelharnis,* makes the road leading into the picture the principal motive, we again say good, that is typical baroque. But, after all, how few are the pictures which have taken these recessional motives as subject! In the wonderful *View of Delft* by Vermeer (The Hague), the houses, the water, and the hither bank are laid out in almost pure strips. Where is the modern element in all that? The picture cannot be properly appreciated in photographs. Only the colour explains fully how the whole achieves its effect so definitely in recession, and how the idea that the composition could be contained in longitudinal strips cannot even arise. Over the shadowed foreground space the eye leaps at once to what lies behind, and the brightly shining lane which at one place leads into the depths of the town would of itself suffice to preclude any resemblance with the pictures of the sixteenth century. Just as little has Ruysdael anything to do with the old style when he makes isolated tongues of light pass over the shadowed land. These are not—as in the masters of the transition—bands of light which coincide with definite forms and divide the space into separate parts: they are lights flitting freely over the picture which can only be apprehended as part of a spatial whole.

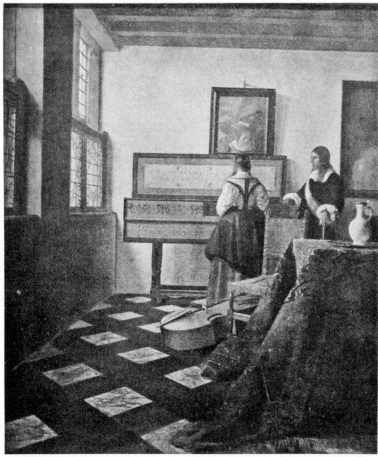

Vermeer

In this connection we should have to place the *exaggerated foreground*.[1] Perspective diminution had always been known, but to set the small beside the big is a long way from compelling the spectator to think the two sizes together in the spatial sense. Leonardo urgently advises painters to convince themselves by holding out their thumbs of how incredibly small the more distant objects appear if they are immediately related to the forms seen close by. He himself took great care as a painter to have nothing to do with such kinds of appearance. The baroque, on the other hand, gladly availed itself of this motive, and by taking up a very near station point, increased the suddenness of perspective reduction.

[1] Jantzen, "Die Raumdarstellung bei kleiner Augendistanz" (*Zeitschrift für Ästhetik und allgemeine Kunstwissenschaft*, iv. 119 ff.).

This is the case with Vermeer's *Music Lesson*.★ The composition seems at first to vary very little from the schema of the sixteenth century. If we think of Dürer's *St. Jerome*★ (see reproductions, p. 48) the room is not dissimilar. The foreshortened wall on the left, the open space to the right, the back wall, of course, parallel to the picture plane, and the ceiling with its rafters also running parallel, apparently still more in the sense of the old style than Dürer's board joints running from front to back. In the planimetric relation of the table and the spinet, which is not essentially disturbed by the slanting chair between, there lies nothing modern. The figures are held completely in the side-by-side relation. If the reproduction contained more light and colour, the stylistically new element in our artist would certainly betray itself; but even here, certain factors make their appearance which absolutely point to baroque style. Above all, it is the series of perspective magnitudes, the striking dimensions of the foreground with reference to the background. This precipitous diminution, which is given by a near station point, will always enforce the recessional movement. The effect is the same in the appearance of the pattern on the floor. That the open space is shown as a corridor with a predominantly recessional movement is a material motive which operates in the same sense. There is, of course, an analogous accentuation of the recessional effect in the colour perspective.

Even so discreet an artist as Jacob Ruysdael is prone to use these "exaggerated" foregrounds to emphasise the recessional relation. It is impossible to conceive a picture in the classic style with a foreground such as we see in *The Castle of Bentheim*.★ Boulders, insignificant in themselves, are invested with an appearance of size which must give rise to a spatial perspective movement. The hill in the background with the castle, though it bears a strong factual accent, looks strikingly small in comparison. We cannot help relating the two scales, that is, reading the picture in recession.

The antithesis to the very near view is the unusually distant view. Then there is so much space interposed between the scene and the spectator that the diminution of equal sizes in the different planes takes place unexpectedly slowly. Good illustrations of this, too, are offered by Vermeer (in the *View of Delft*) and Ruysdael (in the *View of Haarlem*, reproduction, p. 146).

That light and dark, applied as contrasting foils, increase plastic illusion had always been known, and Leonardo requires in particular that care should be taken to place the light forms on dark and the dark on light. But it is a different matter if a dark body introduces itself in front of the light, partially covering it: here the eye seeks the light, yet can only grasp it in its relation to the form set in front of it, in reference to which it must always appear as

Ruysdael

something set back. Transferred to the whole, this yields the important motive of the dark foreground.

 Overlapping and enframing are old possessions of art. But the baroque coulisse and the baroque enframement have a peculiar power to drive things backward which was formerly not sought. Thus it is a peculiarly baroque idea if Jan Steen paints a beauty who, busy with her stockings at the back of the room, appears in the dark frame of the entrance door (Buckingham Palace). Raphael's Stanze pictures have the framework of the archway, but the motive is then not made effective at all in the recessional sense. If, on the other hand, the figure looks from the outset as if it were withdrawn behind an interposed body, that is the same thought which baroque architecture has carried out on a large scale. Bernini's colonnade was only possible on the basis of such a feeling for recession.

3. SUBJECT MATTER

The consideration from the standpoint of formal motives may be completed by a consideration, from the purely iconographic standpoint, of single pictorial themes. Although we cannot in any case hope to make our survey complete, an iconographic counter-examination will at least dispel the suspicion that certain extraordinary cases have been sought out from a one-sided point of view.

The portrait seems to yield least for our concepts, as it deals mainly with a single figure and not with several which could be brought into a relation of alignment or recession. But that does not matter at all. Even in the single figure, the forms can be so disposed that the impression of a plane is produced, and the arrangement of the objects in space is only the beginning, not the end. An arm laid on a balustrade in Holbein is always so used that the definite notion of a foreground plane is created: if Rembrandt repeats the motive, everything can be similar in the objective sense, yet the impression of a plane does not arise and is not meant to arise. The visual accents are so placed that any other combination is more natural to the spectator than the combination in the plane. Cases of pure frontality are to be found in both styles, but Holbein's *Anne of Cleves* looks just like a wall, while Rembrandt avoids this impression even where he does not consciously counteract it, say by an outstretched arm. He uses such violent methods in the youthful pictures, in the desire to be modern: I am thinking of the *Saskia with the Flowers* in the Dresden Gallery. Later there is repose everywhere, yet he has baroque depth. But if we ask how the classic Holbein would have treated the Saskia theme, we might refer to the delightful picture of the *Girl with the Apple* in the Berlin Gallery. It is no Holbein, but is rather akin to the young Moro, yet this planimetric handling of the theme would have been fundamentally approved by Holbein.

For elementary demonstration purposes, the richer themes of narrative, landscape, and genre of course yield more. Single details having already been analysed, we will now take a few cross-sections in the iconographic sense.

Leonardo's *Last Supper* is the first great example of the classic plane style. Matter and form so condition each other in this subject that there is a peculiar interest in seeking just here the contrasting example of the depreciated plane. This can be enforced by a slanting arrangement of the table, and Tintoretto, for instance, attempted it in this way, but it is not necessary to have recourse to such methods. Without abandoning the parallelism of the table and the picture-

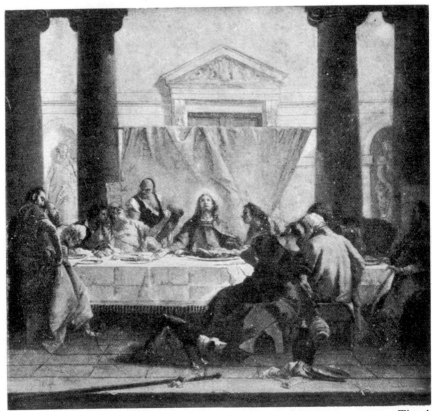

Tiepolo

edge and giving this direction an echo in architecture, Tiepolo composed a *Last Supper** which, while it cannot be compared with Leonardo as a work of art, stylistically presents the absolute opposite. The figures do not unite in the plane and that decides. Christ cannot be detached from the relation to the group of disciples obliquely in front of him who, by their mass and by the coincidence of deep shadow and highest light, have optically the chief accent. Whether we will or no, everything co-operates to draw the eye to this point, and beside the recessional tension between the foreground group and the central figure behind, the plane elements fall quite into the second place. That is something totally different from the isolated Judas figures of primitive art, which appear as sorry appendages, incapable of leading the eye onward. The recessional motive in Tiepolo is, of course, indicated not only once, but has manifold echoes.

Of intermediate links in the history of the development we take only Baroccio,* who provides an illuminating example of how the plane style is

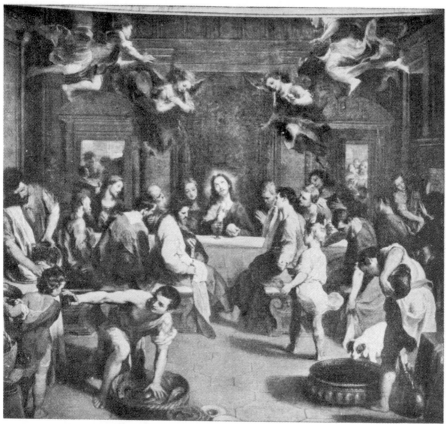

Baroccio

first associated with recession. The picture enters with great energy into recessional movements. From the left front, and still more from the right front, we are led over various points to Christ. If Baroccio has thereby more recession than Leonardo, he is nevertheless akin to him by the fact that the disposition in separate strips of space is clearly preserved.

This distinguishes the Italian from the northern painter of the transition such as Pieter Brueghel.* His *Village Wedding* is in subject matter not unlike the *Last Supper*: a long table with the bride as central figure. Yet the picture has hardly a line in common with Leonardo's picture. The bride is certainly distinguished by the rug hung behind her, but in apparent size she is very small. For the history of style, however, the important point is that she *must* be seen in immediate relation to the great figures of the foreground. The eye seeks her as the ideated central point, and thus for that very reason will unite the perspective small with the perspective big, but in order that we should not

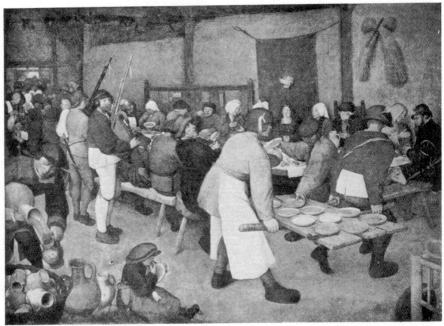

Pieter Brueghel the Elder

avoid this, care is taken to form the relation from foreground to background
by the movement of the seated figure which takes and hands on the dishes
from the tray—a door off its hinges (cf. the similar motive in Baroccio).
Small figures in the further grounds also existed formerly, but they are not
related with the big ones in the foreground. Here there has happened what
Leonardo knew in theory but avoided in practice—the juxtaposition of actu-
ally equal dimensions in very unequal appearance, the new factor lying in the
necessity of seeing them together. Brueghel is not yet Vermeer, but he paved
the way for Vermeer. The motive of the oblique arrangement of the table is
a further element to withdraw the picture from the plane. The filling of the
two corners, on the other hand, re-establishes it.

Quinten Massys'* great *Pietà* of 1511 (Antwerp) is "classic" because the
main figures are all quite distinctly situated in the plane. The body of Christ
lies absolutely parallel to the horizontal base-line of the picture, Magdalene
and Nicodemus complete the picture space to the full breadth of the canvas.
The bodies with their extremities are spread out in a planimetric relief, and
even from the back rows hardly a gesture interrupts this atmosphere of quiet
plane sequence. It is finally assumed by the landscape too.

After what has been said it is hardly necessary here to explain that this

Massys

planimetry is no primitive form. The generation previous to Massys had its great master in Hugo van der Goes. If we take his famous masterpiece, the *Adoration of the Shepherds* in Florence, we immediately see how little preference for the plane these northern Quattrocentists had, how they tried to open up the depth of the picture by moving the figures inwards and placing them one behind the other, and just what a diffuse and brittle effect they produce thereby. In the little Vienna picture* we have the exact parallel in subject matter to Massys' *Pietà*. Even here it is a definite recession, and the corpse is taken obliquely into the picture.

This slanting arrangement, although not the only formulation, is still characteristic. With the sixteenth century it almost completely disappears. If the corpse is still foreshortened, then care is taken in other ways that it does not disturb the "planimetric habitus" of the picture. Dürer who, in his early *Pietàs*, decidedly adheres to a Christ in the plane, later occasionally fore-

shortened the body, the finest example being in the great drawing in Bremen
(L. 117). A capital painterly example is the *Pietà with Donors* by Joos van Cleve
(Master of the Death of Mary)★ in the Louvre. In such cases the foreshortened
form looks just like a gap in a wall: the decisive point is that there is a wall
there at all. The earlier artists do not achieve this effect even when they keep
parallel to the picture edge.

As classic pendant in the south we can take Fra Bartolommeo's *Pietà* of
1517 (Florence, Pitti). Still more subjected to the plane. Still more the style of
the strict relief. Though in perfectly free motion, the figures still hold to-
gether so closely that we imagine we can physically feel the foreground
stratum. The picture achieves thus a peace and repose which hardly a modern
spectator will fail to feel, yet it would be false to say that the picture had been
gathered into this self-contained form simply for the sake of the stillness of the
story of suffering. We must not forget that this mode was general at that time,
and if it cannot be denied that an atmosphere of particularly solemn reserve
was envisaged, the impression for the spectator of that time cannot have been
the same as for us, who bring quite other conditions with us. The crucial

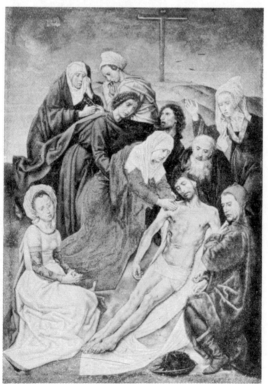

point in the problem, how-
ever, is that the seventeenth
century, even where it sought
repose, could not revert to
this type of presentment.
This is true even of the "arch-
aic" Poussin.

The true baroque trans-
formation of the *Pietà* is to
be found in Rubens in the
masterly example of 1614
(Vienna, see reproduction, p.
123), where the foreshorten-
ing of the corpse is almost
startling. The mere fact of
foreshortening does not make
the picture a baroque picture,
but the recessional elements
in the picture have here been
given so great a weight that
any plane impression of the
renaissance type is abolished,

Van der Goes

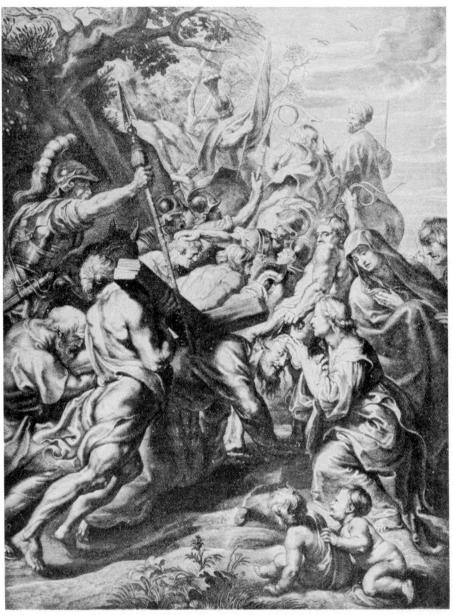

Rubens

and the foreshortened body quite of itself pierces the space with a hitherto unprecedented power.

Recession speaks most intensely when it can reveal itself as movement, hence a real bravura piece of baroque was the transposition of the theme of an agitated crowd from the plane into the third dimension. The *Bearing of the Cross* contains this theme. We have the classic version in the so-called *Spasimo di Sicilia* (Madrid), a picture still dominated by the orderly power of Raphael. The movement evolves from the depth of the picture, but the composition remains firmly held in its plane. The wonderful drawing by Dürer in the Little Passion woodcut which Raphael used for the principal motive is, for all its insignificance of dimensions, a perfectly pure example of classic plane style. And Dürer could take his stand on an existing tradition less than Raphael. Among his predecessors, Schongauer certainly had a remarkably alert feeling for the plane. Yet in any comparison with him, Dürer's art stands out as the first real plane style, and Schongauer's great *Bearing of the Cross* is still little united in the plane.

The baroque antithesis to Raphael and Dürer is here represented by Rubens' *Christ Bearing the Cross* * (engraving by Pontius with a variant anterior to the picture in Brussels). The recessional movement most brilliantly developed, and made still more interesting by an upward movement. The stylistically new factor we are looking for certainly does not lie in the merely material motive of the direction of movement, but, as it is a question of a principle of present-ment, in the way in which the theme is handled, how every recessional element is brought out for the eye and, on the other hand, how everything which could emphasise the plane is repressed.

Just for this reason, Rembrandt and his Dutch contemporaries, without opening up the picture space with plastic means so violently as Rubens, can participate in the baroque principle of recessional presentment: in the de-preciation or concealment of the plane they meet Rubens, but they achieve the interest of the into-the-picture movement more especially with painterly devices.

Even Rembrandt worked originally with a lively recession of the figures—we have already referred above to his etching of the *Good Samaritan*—if later he tells the same story* with an almost completely strip-like evolution of the figures, that implies no reversion to the form of a past century: by the incidence of the lighting, the plane marked by the objects is again disintegrated, or, at any rate, reduced to the status of a secondary motive. It would occur to no-body to read the picture as a relief. We notice only too clearly how the figure stratum bears no relation to the real life-content of the picture.

Rembrandt

The great *Ecce Homo* (etching of 1650) is an analogous case. As is known, the schema of the composition dates back to a Cinquecentist, Lucas van Leyden. A house wall and a terrace before it, seen frontally; people who have taken up their stand side by side in rows on and in front of the terrace—how are we to get a baroque picture out of all that? We learn with Rembrandt that it is not the subject but the treatment which matters. While Lucas van Leyden exhausts himself in mere plane pictures, Rembrandt's drawing is interspersed to such an extent with recessional elements that the spectator certainly sees the degree of actual plane which is present, but will only appreciate it as the more or less fortuitous substratum of a picture totally different in type.

For the Dutch genre painters of the sixteenth century we have plenty of subjects for comparison in the same Lucas van Leyden, in Pieter Aertsen, and Averkamp. Even here, in pictures of *mœurs*, where there was certainly no obligation to any ceremony in the setting, the painters of the sixteenth century adhere closely to the schema of the strict relief. The figures at the edge form a first stratum, now completely carried through the breadth of the picture, now

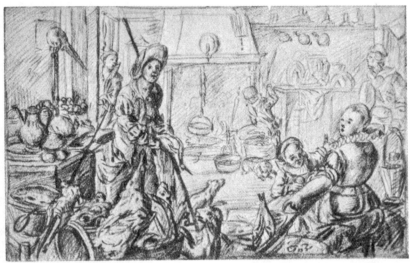

Aertsen

only indicated, and what follows further back is articulated in the same way. Pieter Aertsen handles his interiors thus and, in the somewhat younger Averkamp, the pictures with the skaters are also built up in this way. But gradually the coherence of the plane slackens, the motives decidedly leading from fore to background increase, till at last the picture is so transposed that horizontal relations are no longer possible or are no longer felt to correspond to the meaning of the picture. We must compare a winter landscape by Adrien van de Velde with Averkamp, or a rustic interior by Ostade with a kitchen scene by P. Aertsen.* Most interesting, however, will be the examples in which the artist does not work with the wealth of "picturesque" interiors, but where the back wall of a room, seen full front, simply and clearly closes the scene. It is the favourite theme of Pieter de Hooch. Then it is again typical of this style to deprive the spatial scaffolding of its planimetric stratifications, and to lead the eye on to other ways by light and colour. In Pieter de Hooch's picture of the mother with the child in the cradle * (p. 205) the movement goes diagonally into the picture towards the high light in the entrance door. Although the room is seen frontally, the picture could not be mastered with sections in breadth.

A few contributions to the problem of landscape have been made above to show how Patenir's classic type was translated into the baroque type. It is perhaps not superfluous to return to the subject in order to insist that the two types must be grasped as self-contained powers in their whole historical significance. It must have been recognised that the spatial form which Patenir

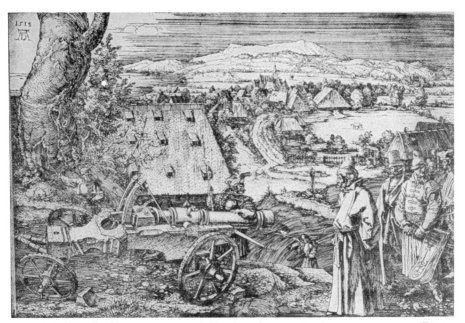

Dürer

produces is identical with what Dürer, for instance, gives in the *Landscape with the Cannon*★ and that Titian,★ the greatest landscape painter of the Renaissance, coincides completely with Patenir in the strip schema.

What the unhistorical spectator feels in Dürer as constraint—the parallel disposition of foreground, middle distance, and background—is precisely the application of a very clear period ideal to the particular problem of landscape. The ground must be thus definitely organised in strata, the village must present itself thus planimetrically within its zone. Certainly Titian apprehended nature more freely and greatly, but—this is especially clear in his drawings—his conception is throughout sustained by the same taste for the plane.

However different, on the other hand, Rubens and Rembrandt may seem to us, they agree perfectly in their transposition of spatial presentment. The recessional movement dominates and nothing settles into strips. Roads leading inwards, foreshortened avenues happened earlier, but they never dominated the picture. Now it is on just such motives that the accent lies. The recession of forms is the chief thing, not their co-relation from left and right. Concrete objects can even be totally absent, and then the new art really comes into its own, then it is the general depth of the space which the spectator is called upon to apprehend in one breath as a unified whole.

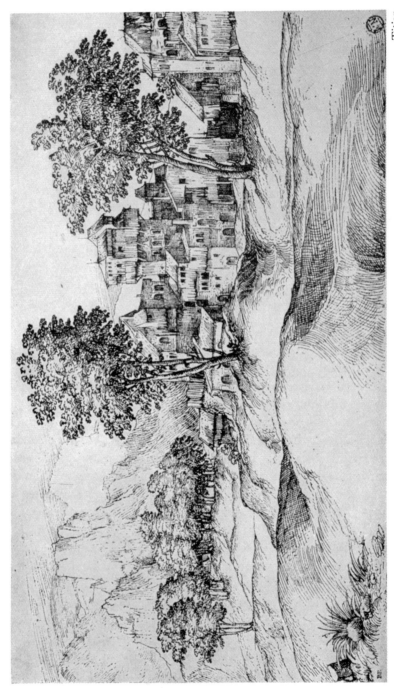

Titian

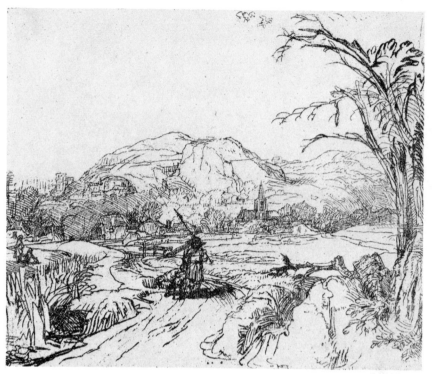

Rembrandt

The more clearly the opposition of the types is recognised, the more interesting does the history of the transition become. Even the generation following Dürer—the Hirschvogels and Lautensacks—broke with the ideal of the plane. In the Netherlands, Pieter Brueghel the Elder was here, too, the innovator of genius who points away from Patenir directly to Rubens. We cannot refrain from reproducing his *Huntsmen in the Snow* * as final illustration to this section. It can be a revelation of both extremes. On the right, in the middle distance and background, the picture has many elements which recall the old style, but with the mighty motive of the trees which lead from the left over the brow of the hill to the houses down below—already very small in perspective—a decisive step into the new age is made. Penetrating from bottom to top, filling the picture to the middle, they create a recessional movement which affects even the refractory elements. The troop of huntsmen with the dogs runs in the same direction of movement, and underlines the force of the row of the trees. Houses and hill ranges towards the edge join in the movement.

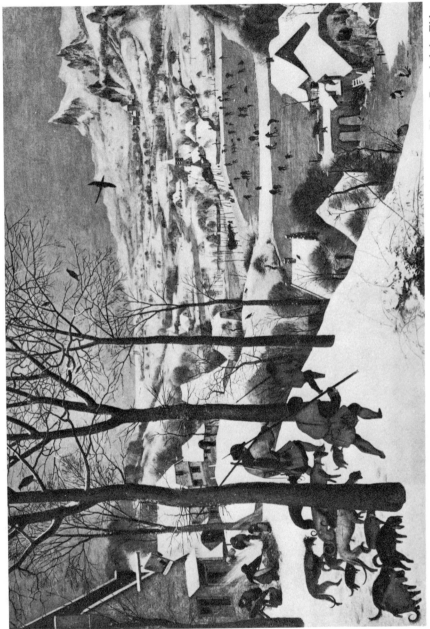

Pieter Brueghel the Elder

4. Historical and National Characteristics

The way in which, about the year 1500, the will to plane breaks through everywhere is a most remarkable spectacle. The more art overcame the constraint of primitive beholding which, with the clearest desire to get free of the mere plane, still remained firmly held in it by one foot, the more art became capable of handling with perfect surety the resources of foreshortening and spatial recession, the more decidedly does the desire make itself felt for pictures which have assembled their content in a clear plane. This classic plane looks quite different from the primitive plane, not only because the relation of the parts is more deeply felt, but because it is interspersed with contrasting motives. Only by the foreshortened motives leading into the picture does the character of what is extended and united in the plane reach its full significance. The plane does not demand that everything should be adjusted to one plane, but main forms must lie in a common plane. The plane must continually make itself felt as the underlying form. There is no picture of the fifteenth century which, as a whole, is so resolutely planimetric as Raphael's *Sistine Madonna*, and it is again a characteristic of the classic style how, within the whole, Raphael's child, foreshortened as it is, is firmly posed in the plane.

The primitives tried rather to overcome the plane than to develop it.

If the three archangels are represented, a Quattrocentist like Botticini* gives them in a very well-known picture in a slanting row: the High Renaissance (Caroto*) sets them in a straight line. It may be that the oblique order was felt to be the more lively form for a walking group—in any case, the sixteenth century felt the need of giving another version of the subject.

Straight rows, of course, always appear, but later artists would have criticised a composition like Botticelli's *Primavera* as too thin, too loose: it lacks the succinct finish which the classics achieve even where the figures follow each other at long intervals, even where a whole side is left open.

In their desire for recession and their dread of looking flat, earlier artists were apt to place striking elements in the picture in a slanting position, especially tectonic elements which were easily foreshortened. We might recall the somewhat obtrusive effect of the sarcophagus in Resurrections. The Master of the Hofer Altar (Munich) quite ruins the naïveté of his full-face main figure by this shrill line. An Italian like Ghirlandaio, with the same slanting form, introduces superfluous agitation into his *Adoration of the Shepherds* (Florence, Accademia), although in other works he actively prepared the way for the classic style with purposeful stratification of his figures.

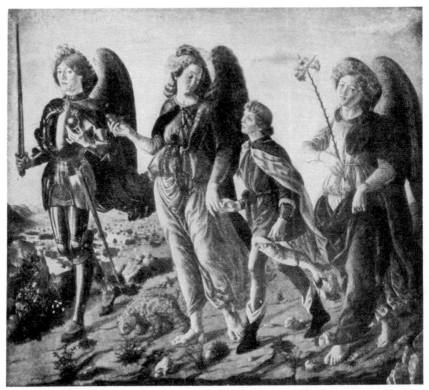

Botticini

Attempts to create direct recessional movements, for instance, to develop a procession of human figures from the background, are not at all rare in the fifteenth century, but they look premature, because the connection between the foreground and background figures is not made clear. Typical example —the procession of figures in Schongauer's copper engraving of the *Adoration of the Magi*. Akin the motive in the *Presentation of the Virgin*, by the Master of the Life of Mary (Munich), where the Virgin, walking into the background, has lost all connection with the figures of the foreground.

An illuminating example of the simple case of the picture space enlivened at various depth intervals, without definite movement to or from the background, is to be found in the *Birth of the Virgin** by the same Master in Munich; the plane coherence is here almost entirely destroyed. If, on the other hand, in a subject presenting the same problem, an artist of the sixteenth century, the Master of the Death of Mary,* has reduced the deathbed and the group in the room to a perfectly reposeful plane sequence, this does not only imply a better understanding of perspective, which has worked wonders here,

but it is the new—decorative—feeling for the plane without which perspective would not have helped much.[1]

The restlessly disintegrated birth picture of the northern primitives is, however, interesting too as contrast to the contemporary art of Italy. We can clearly see here what the Italian instinct for the plane means. In comparison with the Flemings, and still more in comparison with the North Germans, the Italians of the fifteenth century appear remarkably conservative. With their clear spatial feeling they risk much less. It is as if they had not wished to uproot the flower before it had bloomed of itself. Yet this expression does not quite meet the case. They do not hold back from fear but take to the plane gladly and intentionally. The strictly stratified rows in the sacred pictures of

[1] In the reproduction we certainly feel the painful lack of the ordering power of the colour.

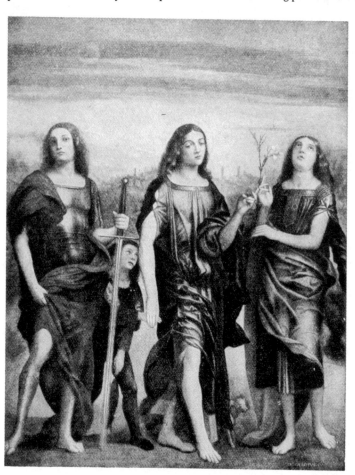

Caroto

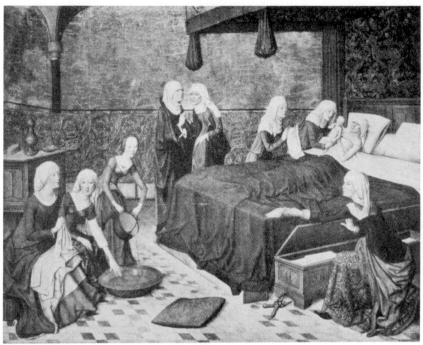

Master of the Life of Mary

Ghirlandaio and Carpaccio are not the clumsy products of a feeling still constrained, but the premonition of a new beauty.

It is exactly the same in the drawing of the single figure. A plate such as Pollaiuolo's engraving of the fighting men with its almost purely planimetric arrangement of the bodies, which was unusual even in Florence, would be quite unthinkable in the north. This drawing certainly lacks that perfect freedom which makes the plane appear a matter of course, yet such cases must not be judged as wilful archaism but as the prophecy of the coming classic style.

We have undertaken here to discuss concepts and not to record history, but it is indispensable to have some knowledge of the preliminary stages if we wish to get the right impression of the classic plane style. In the south, where the plane seems to have its true home, we must learn to feel varying degrees of plane effect; in the north, we must have seen the contrary powers at work. But now, in the sixteenth century, an accomplished feeling for the plane seems victoriously to dominate the whole domain of representation. It is everywhere —in Titian's and Patenir's landscape, in Dürer's and Raphael's sacred story— even the single enframed figure suddenly begins resolutely to pose itself in the plane. A *Sebastian* by Liberale da Verona is held in the plane quite otherwise

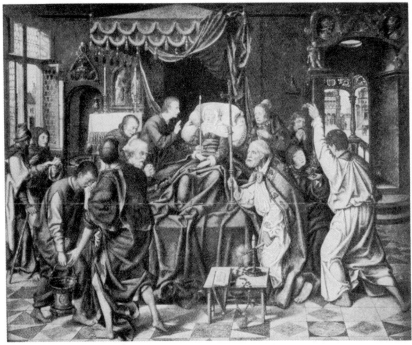

Master of the Death of Mary

than a *Sebastian* by Botticelli, which in comparison, can easily appear a little insecure; not until Titian and Cariani does the drawing of a recumbent female nude seem to have become a real plane picture, although the primitives (Botticelli, Piero di Cosimo, etc.) had already attacked the problem in quite a similar way. One and the same motive—a full-front crucifix—still looks somewhat threadbare in the weft in the fifteenth century, while the sixteenth was able to give it the character of a plane-picture with self-contained and emphatic effect. A splendid example of this is Grünewald's great Golgotha on the Isenheimer altar where, in a way till then unprecedented, the Crucified is combined with the attendant figures in the impression of a uniformly living plane.

The process of the decomposition of this classic plane moves quite parallel to the process of the depreciation of line. The historian who one day writes this history will have to pause at the same names as are important in the development of the painterly style. Here, too, Correggio stands as predecessor of the baroque among the Cinquecentists. In Venice it is Tintoretto who contributed powerfully to the destruction of the ideal of plane, and in El Greco there is hardly a trace of it left. Reactionaries to line, such as Poussin, are also reactionaries to plane. And yet who could mistake in Poussin, for all his "classic" intentions, the man of the seventeenth century?

As in the history of the painterly, plastic recessional motives precede the merely visual, and in this process the north may always claim to have had the start of the south.

There is no question that the nations diverge from the very outset. There are peculiarities of national imagination which remain constant throughout all change. Italy always possessed a stronger instinct for the plane than the Germanic north, where it runs in the very blood to plough up the depths. It is undeniable that the classic Italian plane has a parallel north of the Alps; on the other hand, it is also noticeable that the pure plane was soon felt there as a constraint and was not long tolerated. But the conclusions which northern baroque drew from the principle of recession could only be followed from afar by the south.

SCULPTURE

1. General Remarks

We can demonstrate the history of sculpture as a history of the development of the figure. An initial constraint is thrown off, limbs stir and spread, the body as a whole begins to move. But such a history of objective themes does not quite coincide with what we understand as the development of style. We mean, there is a self-restriction to the plane that does not mean a suppression of the wealth of movement, but only another arrangement of the forms, and, on the other hand, there is a conscious disintegration of the stressed plane in the sense of an emphatic recessional movement. This arrangement of forms is certainly favoured by rich complexes of movement, but can also combine with quite simple motives.

Line and plane style obviously correspond. Just as the fifteenth century, in a general way, envisaged line, it is also in a general way a century of the plane, only that the notion was not developed to the limits of its power. Artists adhere to the plane, but rather unconsciously, and cases constantly occur where the plane is abandoned without special notice being taken of the fact. Characteristic is Verocchio's group of *Doubting Thomas*: the group stands in a niche, but one of the disciple's legs remains outside.

With the sixteenth century, however, the feeling for the plane begins to be a serious matter. Consciously and consistently, the forms are assembled in one stratum. Plastic wealth has increased, oppositions of direction are more marked, only now do the bodies look as if they had become free in the joints, but the whole work has sobered down into a pure plane picture. That is classic style with its well-defined silhouettes.

Yet this classic plane did not last long. Soon it seemed as if things were being entrammelled if they were subjected to the pure plane: the silhouettes are dissolved and the eye is led around and about the edges: the proportion of foreshortened form is increased and by means of overlapping, intersecting motives, strongly speaking relations from front to rear are given: in short, artists intentionally avoid allowing the impression of a plane to arise, even if the plane actually exists. In this way Bernini works. Principal examples: the tomb of Urban VIII. in St. Peter's and (still more strikingly) the tomb of Alexander VII.,* also in St. Peter's. Compared with these, Michelangelo's Medici tombs look absolutely disc-like. It is just in the progress of the earlier to the later work of Bernini that we can learn to know the real mentality of this style. The principal plane still more powerfully furrowed, the foremost figures seen essentially from the narrow side. To the rear, half-length figures. Even the old motive of prayer with raised hands (in the Pope) which seem unquestionably to demand representation in profile, subjected here to the foreshortened view.

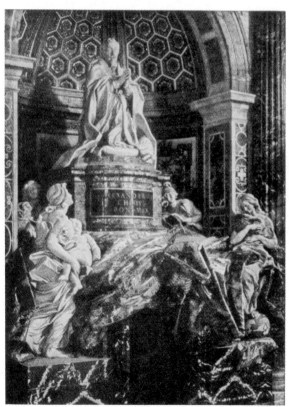

How far the old plane-style is impaired must become the clearer from these examples, in that fundamentally we still have in them the type of the mural tomb. Certainly the flat niche is transformed into a deep one and the chief figure approaches us on a bulging pedestal; but even the figures standing together in one plane are so handled that there is hardly any reciprocal feeling between them: we see the side-by-side arrangement, and threads even pass from one side to the other, but into this weft the interest of the inwards-leading

Bernini

motives is woven, and the master of baroque must have been highly satisfied to find a door in the middle which, far from forming a horizontal link in the manner of the earlier sarcophagus, slits the interval vertically, whereby a new recessional form is opened: from the darkness of the shadow darts forth death, raising the heavy drapery.

We might think that the baroque had rather eschewed mural compositions, since of their very nature they offered a certain resistance to the liberation from the plane. But it is exactly the other way about. The baroque arranges the figures in rows, orders them in niches: it has the greatest interest in insisting upon a spatial orientation. Only in the plane, in the negation of the plane, does recession become palpable. The all-the-way-round, free-standing group is not typical of the baroque. It certainly avoids the impression of strict frontality, as though the figure had a decisive main direction and required to be seen in this direction. Its recession always implies the view from different angles. It would seem to the baroque a sin against life if sculpture were to settle into a definite plane. It does not only look to one side but possesses a much greater area of radiation.

We must here quote Adolf Hildebrand, who required the plane not in the name of a special style, but in the name of art. His *Problem der Form* has become the catechism of a large new school in Germany. Only when the body in the round, says Hildebrand, for all its convexity, has been translated into a picture to be apprehended in a plane has it become visible in the artistic sense. Where a figure has not been so far worked out that it has assembled its contents in a plane picture, where, that is to say, the spectator who wishes to assimilate it is compelled to move round it and must, in separate acts of movement, collect the total picture, then art has moved not a step beyond nature. The service which the artist must render to the eye with his work by uniting in a coherent picture the dispersed elements of the natural appearance has not been rendered.

In this theory there seems to be no place for Bernini and baroque sculpture. Yet we are unjust to Hildebrand if we (as has been done) regard him only as the advocate of his own art. His protest is directed against the dilettantism which knows nothing of the principle of the demand for the plane. But Bernini—to use one name as representative of a whole species—had already had his plane period, and what he gives as negation of the plane thus has quite a different meaning from what is to be found in a mode of art which still cannot distinguish between plane and not-plane.

There is no doubt that the baroque at times over-reached itself and became unpleasing, just because no coherent pictures are achieved. In these cases

Hildebrand's criticism is well directed, but we must not try to extend it to the whole of post-renaissance art. There is also faultless baroque—and that is not when it affects archaism, but when it is quite itself. Following on a perfectly general development of seeing, sculpture found a style which envisages something different from the Renaissance and for which the old terms of the renaissance aesthetic no longer suffice. There is an art which knows the plane, but does not let it speak distinctly in the impression.

Thus, to characterise the baroque, we must not confront just any figure such as Bernini's David with the sling with a full-face figure such as Michelangelo's classic David (the so-called *Apollo*, Bargello). Certainly the two works present a sharp contrast, but in this contrast the baroque appears in a false light. Bernini's David is a youthful work, and the multiplicity of its directions is achieved at the cost of every satisfying aspect. Here we are really "rushed round the figure", for there is always something lacking which we feel impelled to seek. Bernini felt that himself, and his maturer works are kept in a much more assembled style, more—not entirely—unified in one aspect. The work looks quieter, but still retains a certain indeterminateness.

If primitive style is unconsciously a plane style and classic consciously so, we can call the art of baroque consciously a-planimetric. It repudiates the obligation to the compelling frontality of the work, because only in this freedom did the semblance of living movement seem to it accessible. Sculpture is always round, and nobody is going to believe that classic figures were looked at only from one side; but from whichever side they are looked at the front view makes itself felt as the norm, and we feel its significance even when it is not precisely before our eyes. If we call the baroque a-planimetric, we do not mean that chaos had broken out, and that all ordering in particular directions had ceased. We only mean that the blocklike coherence in the plane is as little desired as the settling of the figure into a definite silhouette. But the requirement that the different views should yield pictures exhausting the subject-matter can, with certain modifications, continue to remain in force. The measure of what artists regard as indispensable for the exposition of form is not always the same.

2. EXAMPLES

The concepts which serve as titles to our chapters work, of course, together —they are the different roots of one plant or, otherwise expressed, it is in each case one and the same thing, but seen from a different standpoint. Thus in the analysis of recessional compositions we meet elements which must be called components of the painterly. The replacement of one silhouette, which

coincides with the actual form, by painterly aspects, in which thing and appearance separate, has already been discussed in painterly sculpture and architecture. The essential is not that such aspects *may* be yielded fortuitously, but that from the outset, they enter into the artistic calculation, and that they are numerous and offer themselves as it were spontaneously to the spectator. This transformation is throughout bound up with the development from plane to recession.

This can be well illustrated in the history of the equestrian monument.

Donatello's *Gattemelata* and Verocchio's *Colleoni* are both set up in such a way that the pure side-view is emphasised. In the first case, the horse stands at right angles to the church in the alignment of the front wall; in the second, it runs parallel to the longitudinal axis, at some distance to the side: in both cases the site prepares for perception in a plane, and the work confirms the rightness of such a perception by presenting so completely clear and self-sufficing a picture. We have not seen the *Colleoni* if we do not know the full side-view. Further, it is the view from the church, the right-hand side of the statue on which the picture is based, for only in that view does the whole become clear, the marshal's baton and the bridle-hand and, though the head is turned to the left, it is not lost.[1] Owing to the height of the pedestal perspective distortion will, of course, at once take place, but the main view penetrates triumphantly. And that is the only one that counts. Nobody will be so foolish as to maintain that the old sculptors really envisaged a single view, for then it would have been superfluous to create a work in the round: we must enjoy the roundness by moving round it, but there is a resting-place for the spectator, and in this case it is the view of the greatest breadth.

There is no essential change even in Giovan Bologna's *Grand Dukes* in Florence, although, with stricter tectonic feeling, each is placed in the central axis of the square, and hence is more evenly bathed in space. The figure evolves in quiet breadth aspects, the danger of perspective distortion being diminished by the lowering of the pedestal. But a new element is that by the orientation of the monuments, the foreshortened view is justified beside the broad view. The sculptor clearly reckons with a spectator moving towards the horsemen.

Michelangelo had worked thus in the erection of *Marcus Aurelius* on the Capitol: standing in the middle of the square, on a low pedestal, the figure can be comfortably taken in from the side, but to the spectator mounting the broad state stairway to the Capitoline Hill, the horse turns full face. And this

[1] Unfortunately the photographs offered for sale are all taken badly, with insufferable concealments and an atrocious distortion of the rhythm in the horse's legs.

view does not look adventitious: the late antique figure was disposed to that end. Can this already be called baroque? The beginning obviously lies here. The markedly recessional effect of the square would in any case compel us to discount the broad view of the horsemen in favour of the half or three-quarters view.

The pure baroque type is shown in Schlüter's *Grosser Kurfürst* on the Lange Brücke in Berlin. He certainly stands at right angles to the causeway, but here it is no longer possible to come at the horse from the flank. From every standpoint the figure looks foreshortened, and its beauty lies precisely in the fact that, for the spectator walking across the bridge, a wealth of charming views unfolds, each of which is equally significant. The type of foreshortening is complicated by the close range. It was not intended otherwise: the foreshortened picture is more interesting than the unforeshortened one. In what way the building up of the forms in the monument envisages this mode of appearance does not require to be discussed in detail here: it is enough to say that what appeared to the primitives a necessary evil, and what the classics avoided as far as possible—the visual distortion of the form—has here been consciously adopted as an artistic device.

As a similar case we can take the group of the antique horse-tamers on the Quirinal which, arranged together with an obelisk and (later) completed by a basin to form a fountain, forms one of the most characteristic pictures of baroque Rome. The two colossal figures of the advancing youths, whose relation to their horses need not preoccupy us here, move obliquely forward from the central obelisk—that is, they subtend an obtuse angle between them. This angle is opened towards the main approach to the square, and the important fact for the history of style is that the main figures appear foreshortened in the main view, an effect which is the more surprising in that, of their very nature, they possess very definite frontal planes. Everything is done to prevent this frontality from making itself felt, and the picture from settling.

But was the all-the-way-round composition with figures standing diagonally to the centre not thoroughly current even in renaissance art? The great difference is that the horse-tamers of the Quirinal are not an all-the-way-round composition, in which each figure demands its own standpoint from the spectator, but that they require to be seen together as *one* picture.

As in architecture the simple central block visible on all sides is no baroque motive, so in sculpture, simple all-the-way-round groupings are not. The baroque has an interest in definite orientation, just because it partly neutralises the orientation with counteracting effects. That the interest of the conquered plane may be achieved, a plane must first be there. Bernini's fountain with the

four world rivers does not face all four points of the compass equally, but has a projecting and a receding front, the figures are combined in pairs, yet in such a way that they take in the corner too. Plane and not-plane interact.

Schlüter has treated in the same way the captives on the pedestal of his *Grosser Kurfürst*. It *looks* as if they were moving uniformly in a diagonal from the pedestal; as a matter of fact the foremost and rearmost figures are connected, even in the literal sense, with chains. The other schema is the renaissance schema. The figures stand thus in the *Tugendbrunnen* in Nuremberg or in the *Herculesbrunnen* in Augsburg. We might take as Italian example Landini's well-known "*Tortoise*" fountain in Rome, with the four boys stretching up their hands to the animals (added later) of the upper basin.

The orientation can be indicated by very slight means. If, in a fountain with central outlay, an obelisk in the middle is only a little on the broad side, it is already there. And just in the same way, with a group of figures, or even a single figure, by the handling, the effect can be shifted at will to one side or the other.

The converse occurs in flat or mural compositions. While the baroque intersperses the centralised composition of the Renaissance with plane in order to bring out its recessions, it must, of course, within a given plane motive, provide for recessional effects in such a way that the impression of a plane cannot even arise. That is the case even with the single figure. Bernini's recumbent *Beata Albertona** lies completely in a plane parallel to the wall, but

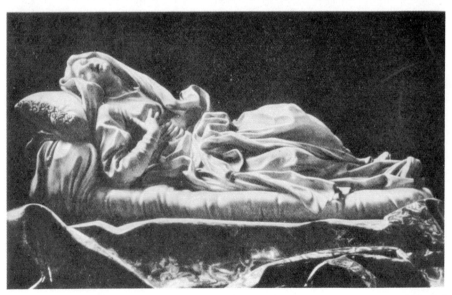

Bernini

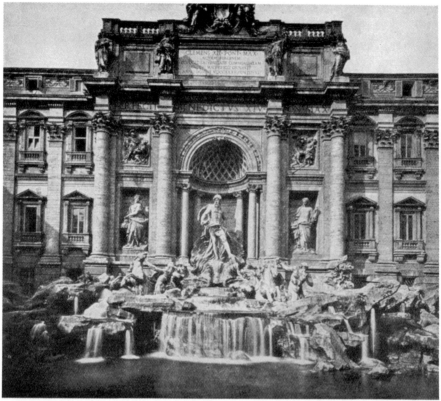

Rome, Fontana Trevi

the form is so furrowed that the plane has become inapparent. How the plani-
metric character of a mural tomb is neutralised has already been demonstrated
in the works of Bernini. A magnificent example on the largest scale is the
baroque mural fountain such as we have in the *Fontana Trevi*.* Given is a wall,
the height of the house, and in front of it a deep basin. That the basin bellies
outwards is a first motive which deviates from the plane sequence of the re-
naissance type, but the essential point lies in that world of forms which press
forward with the water in all directions from the middle of the wall. The
Neptune of the central niche has been completely liberated from the plane,
and belongs to the torrent of radiating forms in the basin. The chief figures—
the sea-horses—are seen in foreshortening and from different angles. The idea
is not allowed to enter our head that there is somewhere a main view. Every
view is complete, and yet urges to a constant change of standpoint. The beauty
of the composition lies in its inexhaustibility.

But if we look about for the beginnings of the disintegration of the plane a

reference to the late Michelangelo would not be out of place. In the Julius tomb, he has made Moses project so far that we *must* regard the figure no longer as a figure in "relief", but as a free-standing figure visible from many sides which cannot be contained in a plane.

With that, we arrive at the general relationship of figure and niche. The primitives treat it as variable: now the figure is housed in the niche, now it advances out of it. For the classics, the normal method is to withdraw all sculpture into the depths of the wall. The figure is then nothing but a piece of wall come to life. That was changing, as we have seen, even in Michelangelo's time, and with Bernini, it is soon a matter of course that the plastic filling the niche should advance out of it. This is the case, for instance, with the single figures of Magdalene and St. Jerome in the Cathedral of Siena, and the tomb of Alexander VII.,* far from restricting itself to the space scooped out of the wall, breaks forward as far as the line of the enframing half-columns placed before it, even projecting beyond them in places. Of course, a-tectonic tendencies play their part here, but the desire to break away from the plane cannot be mistaken. It is not quite an error if this very tomb of Alexander has been described as a free-standing tomb pushed into a niche (Sobotka).

But there is another way of overcoming the plane, and that is to develop the niche into a real three-dimensional space, as Bernini did in his *St. Theresa.** Here the ground plan is oval and opens—like a burst fig—forwards, not along the full breadth, but in such a way that it is overlapped at the sides. The niche forms a recess, in which the figures can move apparently freely, and however limited the possibilities are, the spectator is challenged to take up his stand at various points. The Apostle niches in the Lateran are handled in the same way. For the composition of high altars, the principle is of immeasurable importance.

From this point it was only a step, and a short step, to making the plastic figures look withdrawn and distant behind an independent architectural enframement with their own source of light, as was the case in the *St. Theresa.* The empty space is then taken as a factor into the composition. Bernini had an effect of this kind in mind in his *Constantine* (underneath the Scala Regia in the Vatican): it could only be seen from the portico of St. Peter's, through the final arch. But this arch is now walled up, and we can only get an idea of Bernini's intention by an inferior equestrian figure of Charlemagne [1]). Altar building is involved here too, and Northern baroque in particular contains fine examples. Cf. the high altar of Weltenburg.

[1] The similar project for a full-length figure of Philip IV. in the portico of S. Maria Maggiore was also not carried out. Cf. Fraschetti, *Bernini*, p. 412.

But with neo-classicism, the whole thing was soon at an end. Neo-classicism brings line, and with it, the plane. All appearance is once more perfectly steadied. Overlapping and recessional effects are regarded as illusions of the senses, incompatible with the gravity of "true" art.

ARCHITECTURE

The transference to architecture of the concepts plane and recession seems to meet with some difficulties. Architecture is always dependent on recession, and planimetric architecture sounds dangerously like nonsense. On the other hand, even if we admit that a building as a body is subject to the same conditions as a plastic figure, we should have to say that a tectonic structure, which usually provides a frame and background for sculpture itself, could never, even to provide a comparison, so far depart from frontality as baroque sculpture does. And yet examples which justify our concepts are not far to seek. What else is it but a deviation from frontality when the posts of the porch of a villa no longer look forwards but turn towards each other? With what other words can we describe the process which the altar passes through in which a purely frontal construction becomes more and more interspersed with recessional elements until, in the end, in rich baroque churches, there stand enclosures which draw the essence of their interest from the recession of the forms? And if we analyse the plan of a baroque staircase and terrace, such as the Spanish Steps in Rome, not to speak of any other detail, the spatial recession is brought out merely by the multiple orientation of the steps in such a way that the classically strict lay-out with straight flights looks flat beside it. The system of flights and ramps which Bramante planned for the court of the Vatican could offer the Cinquecentist contrast. In its place, we might compare the neo-classic straight-walled lay-out of the Pincio Terraces with the Spanish Steps. Both give form to space, but in the one case the plane speaks, in the other, the depth.

In other words, the objective existence of solids and voids contains in itself no indication of style. Italian classic art possesses a perfectly well-developed feeling for volume, but it forms volume in a different spirit from the baroque. It seeks stratification in planes, and all depth is here a consequence of such plane sequences, while the baroque from the outset avoids the impression of the planimetric and seeks the real essence of the effect, the salt of the work, in the intensity of the perspectives in depth.

We must not be confused if we meet the circular building in the "plane style". Certainly, it seems to contain in a special measure the invitation to walk

round it, yet no recessional effect is produced thereby, because it yields the same picture from all sides, and however distinctly the entrance side may be defined, there is no marked relation between front and back. It is here that the baroque begins. Wherever it takes up the circular building, it replaces the equality of the sides by an inequality which states the direction and creates a front and back. The pavilion in the Hofgarten in Munich is no longer a pure circular composition. Even the flattened cylinder is not rare. But for church building on a large scale there is a binding rule to place in front of the cupola a façade with corner towers, in relation to which the cupola looks set back, and by which the spectator, at every change of standpoint, can read the spatial relationship. Bernini had a perfectly logical object in view when, on the front side of the cupola of the Pantheon, he added such turrets, the so-called "Asses' Ears", which became notorious and were removed in the nineteenth century.

Further, "plane-like" is not intended to mean that the building as a body should have no projections. The Cancelleria★ or the Villa Farnesina are perfect instances of the classic plane style; in the first case, there are slight corner projections, in the other, the building, on both fronts, projects on two axes, yet in each case we get the impression of plane sequences. And this impression would not change if there were semicircles in the ground-plan and not right angles. How far has the baroque transformed this relationship? In so far as it opposes the receding parts to the projecting parts as something totally disparate. In the Villa Farnesina there is the same series of bays with windows in the main block as in the wings: in the Palazzo Barberini or in the Casino of the Villa Borghese★ they are surfaces of quite a different type, and the spectator must necessarily unite together projections and recessions and seek in the recessional development the special idea of the building. This motive reached great importance especially in the north. Château grounds in horse-shoe form, that is, with an open court of honour, are all conceived in such a way that the relation between the advancing wings and the main façade *must* be grasped. This relation is based on a difference of situation in space which of itself would not look recessional in the baroque sense and is conceivable as lay-out at any time, but by the particular handling of form the recessional tension is enforced.

As regards church interiors, it was, of course, not left to the baroque to discover the interest of recessional perspectives. The all-round building can rightly be claimed as the ideal form of the High Renaissance, yet just as certainly there were always longitudinal naves, and the line of movement towards the high altar is so utterly the essence of these buildings that it is quite impossible to believe that it had not been felt. Yet when a baroque

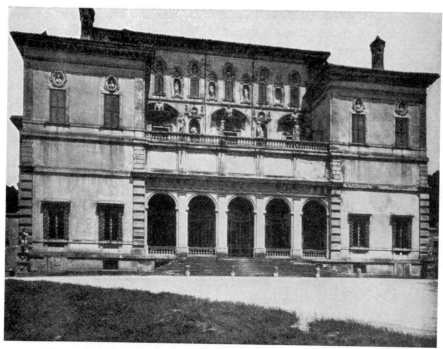

Rome, Villa Borghese

artist draws such a church in longitudinal perspective, he does not feel this recessional movement in itself a satisfying motive: by means of light he creates more speaking relations from front to rear, he places caesurae along the stretch; in short, the spatial facts are artificially accentuated to produce a more intense recessional effect. And that is exactly what happens in the new architecture. It is no mere chance that the type of Italian baroque church with its totally new effect of lighting from the great dome at the rear did not exist earlier. It is no mere chance that architecture did not earlier use the motive of the projecting coulisse—that is, of overlapping—and that punctuations are only now set on the longitudinal axis which do not divide the nave into separate units of space, but are intended to make the inward movement uniform and compelling. Nothing is less baroque than a series of self-contained compartments of space, in the style of S. Giustina in Padua, but on the other hand, the series of uniform vaults of a Gothic church would also have seemed unattractive to this style. How, in case of need, it knew how to get over the difficulty we can learn, say, from the history of the Frauenkirche in Munich, where, by the introduction of a transverse construction in the central nave, the Benno arch, recessional interest in the baroque sense was first brought out.

It is the same notion if uniform flights of steps are now interrupted by

landings. This serves enrichment, it is said: certainly, but it is just by this punctuation that the recessional aspect of the staircase is made interesting by caesurae. Compare Bernini's Scala Regia in the Vatican,* with its characteristic fall of light. That the motive was determined by material necessity does not prejudice its importance from the point of view of style. And what the same Bernini did in the niche of his *St. Theresa**—namely, to advance the enframing columns in front of the niche space, so that the niche always looks overlapped—is also repeated in major architecture. We arrive at forms of chapels and chancels which, the entrance being narrowed, are from every point of view overlapped by this enframement. And in consistent extension of the principle, the main room first becomes visible in the framework of an anteroom.

It is the same feeling which, in the baroque, regulates the relation of building and site.

Wherever it was possible, baroque architecture provided for a forecourt. The most perfect example is Bernini's court in front of St. Peter's in Rome. And even if this gigantic undertaking is unique in the world, we can find the same impulse in a host of minor creations. The decisive point is that building and site enter into a compulsory relationship, that the one cannot be conceived without the other, and as this court is an *entrance* court this relation is of course recessional.

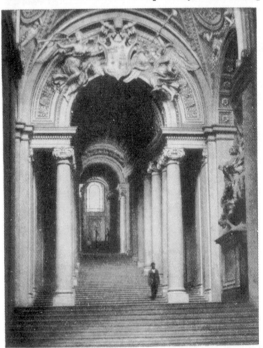

Rome, Scala Regia, Vatican, Bernini

Owing to Bernini's colonnade, St. Peter's appears from the outset as something set back in space, the colonnade is an enframing coulisse. It marks a foreground, and the space thus enclosed is still felt even when it is behind us and we stand before the façade alone.

A renaissance square, such as the fine Piazza della Santa Annunziata in Florence, does not allow the same impression to arise. Although it is clearly conceived as a unit,

deeper than broad, leading towards the church, the spatial relation remains
indeterminate.

The art of recession is never fully contained in the purely frontal view. It
urges to sideways views, in interiors as in exteriors.

Naturally, it was never possible to prohibit the eye from looking at a classical
building more or less cornerwise, but the building does not demand it. If this
brings about an increase of interest, that is not prepared for from within, and
the pure frontal aspect will always make itself felt as the one lying in the nature
of the thing. A baroque building, on the other hand, even when there is no
doubt as to where its principal face stands, always plays with the impulse to
movement. It reckons from the outset with a series of pictures, and that is due
to the fact that beauty no longer resides in purely planimetric values and that
recessional motives only become fully effective by the change of standpoint.

A design such as that of the Carlo Borromeo church in Vienna, with the two
free columns in front of the façade, looks worst in its geometric elevation.
Doubtless the intersections of the cupola by the columns were intended,
these first occur in the half-side view, and the configuration renews itself at
every step.

That is also the sense of those corner towers which, kept low, often flank
the dome in circular churches. We might recall S. Agnese* in Rome, where,
space being limited, a wealth of charming pictures arises for the spectator
moving through the Piazza Navona. The Cinquecentist twin towers of S.
Biagio in Montepulciano, on the other hand, were clearly not conceived with
this (painterly-pictorial) intention.

The erection of the obelisk in the square in front of St. Peter's in Rome is
also a baroque arrangement. Certainly it primarily fixes the middle of the
square, but it also takes account of the axis of the church. Now we can imagine
that the needle simply remains invisible if it coincides with the middle of the
church façade; that proves that this view was simply no longer regarded as the
normal one. But more forcible is the following consideration: according to
Bernini's plan the entrance part of the colonnade, now open, should also have
been closed in, at least partially, by a central portion which would have left
broad approaches open on both sides. But these approaches are, of course,
laid out obliquely to the church facade, that is, the first view was *of necessity*
a side view. Compare the approach drives to châteaux such as Nymphenburg:
they are held to the side, a water-piece lies in the main axis. Here, too, archi-
tectural painting provides the parallel examples.

The baroque does not intend the body of the building to settle into definite
views. By rounding off the corners, it obtains oblique planes which lead the

eye on. Whether we take up our stand in the front or at the side, there are always foreshortened details in the picture. The principle is quite general in furniture: the rectangular cupboard with self-contained front receives bevelled corners which play into the front, the chest with self-contained decoration of front and sides becomes, in its more modern form as chest of drawers, a body which forthwith develops the corners into independent, diagonally-running planes, and while it seems a matter of course that the console table should look straight ahead and *only* straight ahead, we now see everywhere the interplay of front and diagonal orientation—the legs turn half sideways. Where the human figure underlies the form, we could say, literally, the table does not look straight ahead, but sideways: the essential point, however, is not the diagonality in itself, but its interplay with frontality, the fact that we can *quite* take in the object from no side—or, to repeat the expression, that the body does not settle into definite aspects.

The bevelling of the corners and their ornamentation with figures does not, in itself, mean baroque, but when the diagonal plane is combined in *one* motive with the frontal plane, we stand on baroque ground.

What is true of furniture is true, though not to the same extent, of major architecture. We must not forget that a piece of furniture always has behind it the wall of the room, which states the direction; the edifice must of itself create direction.

If, in the Spanish Steps, the steps, from the beginning, look sideways, and later repeatedly change their direction, the intention is to keep the spatial appearance indeterminate, but that is only possible because the stairway receives its definite orientation from the surroundings.

In church towers it often happens that the corners are cut off, but the tower is only part of the whole; and the splaying of the whole body of the building— for instance in palaces—is not frequent even where the alignment is absolutely established.

If the posts of a window pediment or the columns flanking a house porch depart from the natural frontal position and turn to or away from each other, or even if a whole wall breaks up and vertical and horizontal elements appear at all sorts of angles, these are also thoroughly characteristic cases which must arise from the underlying principle, but still, even within the baroque, denote the exceptional and the striking.

Even surface decoration is transformed by the baroque into depth.

Classic art feels the beauty of the plane, and enjoys a decoration which remains planimetric in all its parts, whether it is ornamentation filling a panel or the mere distribution of panels.

Michelangelo's Sistine ceiling, for all its ponderous plasticity, is still a purely planimetric decoration: the ceiling of the Farnese gallery, on the other hand, by the Caracci, is no longer exhausted in pure plane values. The plane in itself has little importance: it only becomes interesting by superimposed forms. Forms are covered and cut across, and hence there arises the interest of recession.

It had already happened that the painting of vaulting had broken a hole through the ceiling, but in that case it is a hole in the otherwise quite coherent form of the ceiling. Baroque vault painting characterises itself as baroque by exploiting the interest of recession in its illusory spatial depths. Correggio had the first premonition of this beauty, in the midst of the High Renaissance, yet only in the baroque have the true conclusions been drawn from the new attitude.

For classic feeling, a wall is articulated in panels which, differing in height and breadth, present a harmony on the basis of a purely planimetric juxtaposition. If the same panels no longer lie in one plane, interest is at once diverted, they would no longer mean the same thing. The plane proportions do not become indifferent, but beside the movement of projections and recessions, they can no longer assert themselves as the primary factor in the effect.

For the baroque, there is no interesting mural decoration without depth. What was already discussed in the chapter on painterly movement can also be considered from this point of view. No painterly patch effect can quite dispense with the element of recession. Whoever it was who had to carry out the alterations to the old Grottenhof in Munich—whether Cuvilliés or someone else—it seemed to the architect indispensable to draw out a central projection to take the deadness from the plane.

Classic architecture also knew the projection, and used it on occasions, but in quite another sense and with quite a different effect. The corner projections of the Cancelleria are piers which we can also imagine separated from the main surface: in the façade of the Hof in Munich, we should not know where to make the section. The projection has its roots in the surface, from which it cannot be separated without vital injury to the body. In this way the projecting central portion of the Palazzo Barberini is to be understood, and, still more typical, because less noticeable, the famous pilaster façade of the Palazzo Odescalchi* in Rome which advances slightly in front of the unarticulated wings. The actual measure of the recession is of no importance here. The treatment of the main body and wings is of such a kind that the impression of a plane running through the whole remains quite subordinate to the dominant recessional motive. In the same way, even the modest dwelling-house was able

Canaletto

to deprive the wall of its sheer plane character by quite trivial projections, until, about 1800, a new generation arises which pays full tribute to the plane and rejects any interest which makes an apparent movement play about the simple tectonic relations: this had also to be set forth in the chapter on the painterly.

Now comes, too, that decoration of the Empire which replaces with absolute flatness the recessional interest of rococo decoration. Whether and how far it was antique forms which the new style used is neither here nor there beside the fundamental fact that they signified a new proclamation of plane beauty, of the same plane beauty as had already existed in the Renaissance, and then had had to yield to the increasing desire for recessional effects.

However far a panel of the Cinquecento may progress beyond the thinner and more transparent design of the Quattrocento in the power of its relief and its wealth of shadow effects, this is not yet an absolute contrast of style. That comes only at the moment at which the impression of plane is undermined. Nor can we forthwith speak of the ruin of art. Admitted that the quality of the decorative feeling was, on the average, superior earlier, as a principle, the other standpoint is possible too. And whoever cannot enjoy the dramatic effect of baroque is, after all, amply compensated by the grace of northern rococo.

A particularly illuminating field of observation lies in the iron work of garden and church railings, grave-crosses and inn-signs, where we are tempted to regard the flat models as invincible and where, for all that, by every possible device, a kind of beauty is realised which lies outside of pure plane. The more brilliant the achievements here, the more striking is the contrast when the

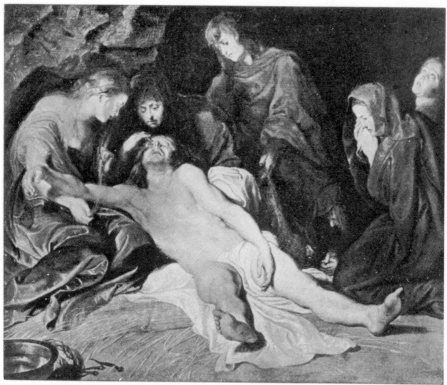

Rubens

new classicism again brings in the supremacy of plane and hence of line as
resolutely as if no other possibility were conceivable.

III

CLOSED AND OPEN FORM
(Tectonic and A-tectonic)

PAINTING

1. General Remarks

EVERY work of art has form, is an organism. Its most essential feature is the character of inevitability—that nothing could be changed or moved from its place, but that all must be as it is.

Yet if, in this *qualitative* sense, we can say of a Ruysdael landscape, as of a composition by Raphael, that it is an absolutely self-contained thing, the difference remains that this quality of inevitability has been achieved in each case on a different basis: in the Italian Cinquecento, a tectonic style was developed to its ultimate perfection, in the Dutch style of the seventeenth century it was the free, a-tectonic style which existed for Ruysdael as the only possible form of presentment.

It would be well if there were a special word to distinguish the closed composition in the qualitative sense from the mere groundwork of a style of presentment tectonic in type, such as we have in the sixteenth century, and can contrast with the a-tectonic of the seventeenth. In spite of the undesirable ambiguity, the concepts closed and open form have been adopted in the title, because, being so general, they define the phenomenon better than tectonic and a-tectonic, and again are more exact than rough synonyms such as strict and free, regular and irregular, and so on.

What is meant is a style of composition which, with more or less tectonic means, makes of the picture a self-contained entity, pointing everywhere back to itself, while, conversely, the style of open form everywhere points out beyond itself and purposely looks limitless, although, of course, secret limits continue to exist, and make it possible for the picture to be self-contained in the aesthetic sense.

Someone may perhaps object: the tectonic style is always the ceremonial

124

style, and will always be adopted when an impressive effect is aimed at. We may reply that certainly the clear revelation of law tends to entail the ceremonial effect, but the point at issue here is that it was *impossible* for the seventeenth century, even when envisaging the same atmosphere, to revert to the forms of the Cinquecento.

In a general way we must not picture to ourselves the notion of closed composition only with the recollection of the highest productions of strict form, such as the School of Athens or the Sistine Madonna. It must not be forgotten that such compositions represent, even within their epoch, a specially severe tectonic type, and that beside them a freer form always occurs, without geometric backbone, which must be equally regarded as "closed composition" in our sense—Raphael's *Miraculous Draught of Fishes*,* for instance, or Andrea del Sarto's *Birth of the Virgin* in Florence. We must take a broad view of the notion, so broad that there is room in it too for the northern pictures which, even in the sixteenth century, tend rather to the free side, and yet as a whole clearly distinguish themselves from the style of the following century. And if perhaps Dürer in his *Melancholia* would like intentionally to depart from the impression of closed form for the sake of *stimmung*, the kinship with contemporary art is for all that closer than the kinship with the productions of the style of open form.

What is peculiar to all pictures of the sixteenth century is that the vertical and horizontal are not only present as directions, but that they are made to dominate the picture. The seventeenth century avoids allowing these elementary oppositions to predominate. Even when they really occur in all their purity, they lose their tectonic force.

In the sixteenth century the picture elements group themselves round a central axis or, if this does not exist, so as to produce a perfect balance of the two halves of the picture which, though not easily definable, makes itself clearly felt when contrasted with the freer order of the seventeenth century. It is a contrast such as is defined in mechanics by stable and unstable equilibrium. But the representative art of the baroque has the most decided aversion from stabilisation about a middle axis. Pure symmetries disappear, or are made inapparent by all kinds of disturbances of balance.

It was natural to the sixteenth century to take its direction, in filling its picture, from the given surface. Although no definite expression is envisaged thereby, the contents of the picture are disposed within the frame in such a way that one thing seems to be there for the sake of the other. Edge lines and corner angles are felt to be binding and re-echo in the composition. In the seventeenth century the filling has lost touch with the frame. Everything is

done to avoid the impression that this composition was invented just for this surface. Although a hidden congruity of course continues to play its part, the whole is meant to look more like a piece cut haphazard out of the visible world.

The diagonal itself, as the main direction of the baroque, is an undermining of the tectonics of the picture in that it either negates or at least obscures the rectangularity of the picture space. To aim at the not self-contained, the adventitious, however, leads further to the abandonment of the so-called "pure" aspects of definite full face and definite profile. Classic art loved them in their simple strength, and loved to work them out as oppositions: the baroque avoids allowing things to settle into these primitive aspects. Where they still occur, it seems as if they do so more casually than intentionally. No accent lies on them.

But ultimately the general tendency is to produce the picture no longer as a self-existing piece of the world, but as a passing show, which the spectator may enjoy only for a moment. The final question is not one of full-face and profile, vertical and horizontal, tectonic and a-tectonic, but whether the figure, the total picture as a visible form, looks *intentional* or not. The pursuit of the passing moment in the pictorial conception of the seventeenth century is also a factor in "open composition".

2. The Principal Motives

Let us try to analyse these leading concepts more in detail.

1. Classic art is an art of definite horizontal and vertical directions. The elements are manifested in their full clearness and sharpness. Whether it is a portrait or a figure, a sacred picture or a landscape, the picture is always dominated in all its parts by the opposition of vertical and horizontal. All deviations are measured by the standard of the pure primitive form.

In contrast to this, the baroque inclines, not to suppress these elements, but to conceal their obvious opposition. Should the tectonic scaffolding appear all too clearly, it is felt as rigid and refractory to the idea of a living reality.

The pre-classic century was an unconsciously tectonic epoch. We feel everywhere the web of verticals and horizontals, but the epoch rather tended to work itself free of these meshes. It is remarkable how little these primitives felt the desire for a definite effect of directions. Even where a vertical appears in all its purity, it does not speak with emphasis.

If, then, we attribute to the sixteenth century a strong tectonic feeling, that does not mean that every figure—to use a popular expression—must look as

if it had swallowed a poker, but in the totality of the picture, the vertical lives as dominant, and the opposing direction speaks just as clearly. The oppositions of direction look comprehensible and resolute, even where the extreme case of meeting at right angles does not occur. It is typical how firmly a group of heads with different angles of inclination is presented by the Cinquecentists, and how then the relationship is led more and more into the a-tectonic and incommensurable.

And thus classic art does not use the full face and profile aspects as the only ones, but they are there and make themselves felt as the standard. The important point is not how large a percentage of pure full face portraits existed in the sixteenth century, but that the full face could be natural for Holbein and unnatural for Rubens.

This elimination of geometry naturally alters the appearance of art in all spheres. For the classic Grünewald, the light which surrounds his resurrected Christ was naturally a circle: even when envisaging the same impressive atmosphere, Rembrandt could not have reverted to this form without looking archaic. Living beauty no longer resides in the limited, but in the limitless form.

The same may be demonstrated in the history of colour harmony. Pure oppositions of colour come at the very moment at which pure oppositions of direction make their appearance. The fifteenth century does not yet know them. Only gradually, parallel to the process of the bracing up of the tectonic line-scheme, colours come out which, as complements, enhance each other and give the picture a firm colour basis. With the development into baroque the force of immediate oppositions breaks down here too. Pure oppositions of colour still occur, but the picture is not built up on them.

2. Even in the sixteenth century, symmetry was not the general form of composition, but it easily came about, and where it was not palpably worked out, we still find a distinct balance of the two halves of the picture. The seventeenth century transposed this stable balance into an unstable balance, the two halves of the picture become dissimilar, and the baroque only feels pure symmetry as natural within the limited sphere of architectonic form. In painting it is completely overcome.

When we speak of symmetry, we think first of all of the solemnity of the effect: wherever a more monumental appearance is aimed at, the need of symmetry will be felt, while it remains undesirable to a secular state of mind. Doubtless it was always understood in this sense as an expressional motive, yet a difference of epoch there is. The sixteenth century could also subject the freely moving scene to symmetry without danger of deadness: the seventeenth

century limits the form to the actual elements of the representation. But what is more important, even then the presentment remains a-tectonic: liberated from the common basis with architecture, painting does not incorporate symmetry in itself, but gives it only as it is actually seen and distorted in this way or that in the aspect. Symmetrical arrangements may be represented, the picture is not symmetrically built up.

In Rubens' Ildefonso Altar (Vienna), the holy women are certainly grouped in pairs beside the Virgin, but the whole scene is foreshortened, and hence the regular becomes apparently irregular.

Rembrandt did not wish to dispense with the symmetrical arrangement in the *Supper at Emmaus*★ (Louvre), and Christ sits exactly in the middle of the great niche in the back wall, but the axis of the niche does not coincide with the axis of the picture, which is broader to the right than to the left.

How strongly feeling revolts against pure symmetry may be seen in those unilateral enlargements which the baroque here and there delighted to patch on to bilaterally constructed pictures to make them more living. Picture galleries are not poor in such examples.[1] We quote here the still more remarkable case of a baroque relief copy of Raphael's *Disputa*,★ where the copyist has simply made one half shorter than the other, in spite of the fact that the classic composition seems to live precisely in virtue of the absolute bilateralism of the parts.

Even here the Cinquecento could not take over the schema as a perfected heritage from its predecessor. Strict conformity to law is not a quality of primitive, but only of classic art. In the Quattrocento, law is only loosely applied, or, where it appears strictly, only achieves a loose effect. There is symmetry and symmetry.

Not until Leonardo's *Last Supper*, by the isolation of the one central figure and the contrasted handling of the groups to right and left, did the symmetrical form first become living. The earlier painters either do not allow Christ to appear at all as central figure, or at least do not let him take full effect as such. And so it is in the north too. In Dirk Bouts' *Last Supper* in Louvain, Christ certainly sits in the middle, and the middle of the table is the middle of the picture too, but the arrangement lacks tectonic force.

In other cases, however, pure symmetry is not even aimed at. Botticelli's *Primavera* is only apparently a symmetrical picture, the central figure does not stand in the middle, and the same is true of Roger van der Weyden's *Adoration of the Magi* (Munich). These are intermediate forms which, in the

[1] Cf. Munich Pinakothek, 169: Hemessen, *Wechsler* (1536), with a great Christ figure patched on in the seventeenth century.

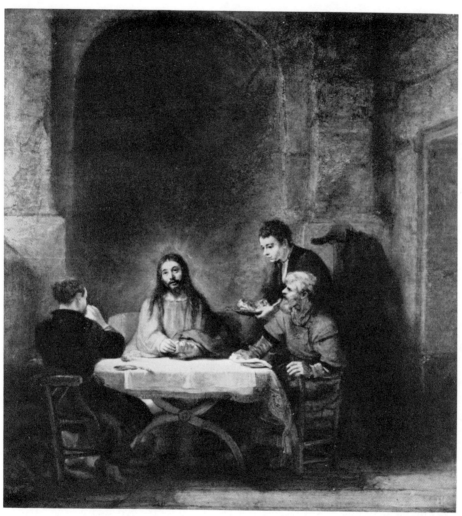

Rembrandt

Relief Copy of Raphael's *Disputa*

same way as the later definite a-symmetry, are intended to enhance the impression of living movement.

Even in compositions without a developed centre, the bilateral relation is more strongly felt in the sixteenth century than formerly. There seems to be nothing simpler and, for primitive feeling, more natural than the juxtaposition of two equivalent figures, and yet pictures such as Massys' *Geldwägers* in the Louvre have no parallels in archaic art. The *Virgin with St. Bernard*, by the Master of the Life of Mary (Cologne), shows the difference; for classic taste there always remains here a residue of inequality.

The baroque, however, consciously emphasises one side, and thus, since the really unbalanced is no longer art, creates the relation of oscillating balance. We must compare double portraits by Van Dyck with similar pictures by Holbein or Raphael. Always, often with quite unobtrusive devices, the balance of the picture is upset, even where we have not two portrait heads, but perhaps two saints, as in the *Two Sts. John*, by Van Dyck (Berlin), where there ought certainly to be no difference in actual value.

Every direction in the sixteenth century has its counter-direction, every light, every colour its compensation. The baroque delights in the predominance

of one direction. Colour and light, however, are so distributed that no relation
of satisfaction, but a relation of tension, results.

Even classic art tolerates a diagonal movement in the picture. But if Raphael
in the *Heliodorus* cuts diagonally into the depth of the picture on one side, on
the other he comes diagonally out of the depth again. The later art makes a
motive of the unilateral movement. And in the same way the incidence of light
is shifted so as to upset the balance. We can recognise the classic picture from
far off by the way in which the lights are evenly distributed over the picture-
space, as when, for instance in a portrait, the high light of the head is balanced
by the high light of the hands. The baroque reckons otherwise. Without
creating an impression of disturbance, it can throw its light to one side only,
merely for the sake of living tension. Balanced modes of distribution seem
dead to it. Van Goyen's quiet river scene with the view of Dordrecht (Amster-
dam), where the highest light sits absolutely at one edge, receives thus a dis-
position of light which would have been inaccessible to the sixteenth century,
even if it had sought the expression of passionate excitement.

As examples of the system of shifted balance in colouring, we might mention
cases such as Rubens' *Andromeda* ★ in Berlin, where a brilliant mass of carmine
—the discarded cloak—is placed low in the right-hand corner, or Rubens'
Bath of Susanna (Berlin), with the reverberating cherry-red dress at the
extreme right-hand edge: here the excentric arrangement is palpable. But
even in less striking arrangements, we can feel that the baroque intentionally
avoids the satisfying impression of classic art.

3. In the tectonic style, the filling relates to the given space, in the a-tectonic
the relationship between space and filling is apparently adventitious.

Whether the space be rectangular or round, we find the classic epoch
following the principle that given conditions rule the personal will, that is,
the whole is made to look as if this filling were just made for this frame, and
vice versa. Parallel lines lead up to the close and fix the figures at the edge.
Whether we have trees accompanying a head or architectonic forms—in any
case, the portrait now appears more firmly anchored in the ground of the
given space than formerly, when these relations were only loosely felt. There
are Crucifixions in which advantage is taken of the beams of the Cross to estab-
lish the figure within the frame. Every landscape will tend to cling to the edge
by single trees. Whoever comes from the primitives cannot fail to be struck by
the way in which, in the widespread landscape of Patenir, the horizontals and
verticals make themselves felt as something related to the tectonics of the plane.

In contrast to this, the landscapes of Ruysdael, for all their purposeful
construction, are still essentially conditioned by the will to alienate the picture

from the frame, to prevent it looking as if it were governed by the frame. The picture is freed from the tectonic relationship, or only allows it to be felt as something secretly working on within it. The trees still grow towards the sky, yet artists avoid letting the harmony with the vertical of the frame become noticeable. How much has Hobbema's *Avenue at Middelharnis* lost its contact with the edge lines!

If earlier art works so much with architectonic backgrounds, one reason is that in this world of forms it possessed material related to the tectonic plane. The baroque certainly did not abandon architecture, but it tends to break down its impressiveness by draperies and so on: the column as vertical is not intended to enter into relation with the vertical of the frame.

It is the same with the human figure. Its tectonic content is as far as possible concealed. Extremely secessionist paintings of the transition, such as Tintoretto's unruly *Three Graces*, who disport themselves in the corner of the picture, are absolutely meant to be judged from this standpoint.

The problem of the recognition or denial of the frame touches the further question—how far the motive becomes visible within the frame or is cut into by it. Even the baroque cannot quite avoid the natural demand for complete visibility, but it avoids any obvious coincidence of picture-space and picture-content. We must distinguish—even classic art could not manage without cutting at the edge, and yet the picture looks complete because it informs the spectator on all essential points and only such things are cut into as bear no accent. Later artists seek the appearance of violent intersection, but in reality even they sacrifice nothing really essential (that would always look unpleasing).

In Dürer's *St. Jerome* engraving,* the space to the right is open and a few slight intersections occur, but as a whole the picture looks thoroughly self-contained: we have an enframing side pillar to the left, and the step in the foreground runs parallel to the lower picture edge: the two animals, fully visible, exactly fit into the breadth of the canvas, and in the upper right-hand corner hangs the pumpkin, also fully visible, filling the corner and bringing the whole to a close. Compare with this Pieter Janssens'* interior in the Munich Pinakothek: the scene (reversed) is quite similar, one side left open. But everything is translated into the a-tectonic. There is no rafter to coincide with the edge of the picture and the picture-space: the ceiling remains partially cut across. There is no pillar at the side, the corner is not fully visible, and on the other side is a chair with a garment thrown over it also quite sharply cut into. Where the pumpkin hung, half a window runs against the corner of the picture, and—in passing—instead of the quiet parallel line of the two animals

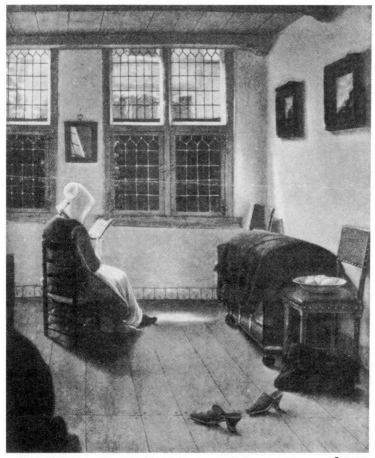

Janssens

there lie two slippers thrown down anyhow in the foreground. For all its
intersections and discrepancies, however, the picture does not look limitless.
The space enclosed apparently haphazard is still quite at rest in itself.

4. If in Leonardo's *Last Supper* Christ sits as the stressed central figure
between symmetrical side groups, that is a tectonic arrangement of which
we have already spoken. But it is something different and new if Christ at the
same time is brought into harmony with the accompanying architectural
forms. He does not only sit in the middle of the space, but His figure coincides
so exactly with the high light of the central door that an enhanced effect—a
kind of halo—is thereby achieved for Him. Such a support of the figures by
their environment is, of course, equally desired by the baroque: what is not
desired is that this coincidence of forms should look obvious and intentional.

Leonardo's motive is no isolated one. In a significant place, the *School of Athens*, Raphael repeated it. All the same, even for the Italian High Renaissance, it was not the *sine qua non*. Freer dispositions are not only allowed, but form the majority. The only important point for us is that the arrangement was once possible at all, while later it was no longer possible. Rubens, as typical representative of Italianate baroque in the north, bears this out. He moves the picture to the side, and this divergence of the axes is not now felt as a departure from the stricter form, as in the sixteenth century, but simply as the natural thing. The other arrangement would look insufferably "sought for" (cf. *Abraham and Melchizedek*, p. 80).

Later on, we can see how Rembrandt repeatedly strove to avail himself of the advantages of Italian classic art as regards the monumental effect. But even if his Christ in his *Supper at Emmaus** sits centrally in the picture, the perfect congruence between figure and niche is still upset, the figure is swamped in the exaggerated space. And when, in another case—the great *Ecce Homo* in the oblong form (etching)—he constructs, with clear reference to Italian models, a symmetrical architecture whose mighty breath bears the movement of the little figures, once again the most interesting point is that, in spite of all, he is able to cast the semblance of hazard over this tectonic composition.

5. The final notion of tectonic style is to be sought in a regularity which can only be partially apprehended as geometry, but which speaks very clearly from the line, lighting, perspective gradations, etc., as an underlying law. The a-tectonic style does not fall into lawlessness, but the order on which it is based is so much freer that we may well speak of a general contrast of law and freedom.

As regards the line, the contrast between a drawing by Dürer and one by Rembrandt has already been described, but the regularity of the line-movement in the first case and the almost indefinable movement of the line in the second cannot be directly deduced from the notions linear and painterly: we must also have considered the picture from the point of view of tectonic and a-tectonic style. And if the painterly foliage in the picture is worked out with patches instead of with determinate forms, that also has something to say here. The patch is, in itself, not everything. In the distribution of the patches a totally different, freer rhythm prevails than in all the line-patterns of classic tree-drawing, where we cannot escape the impression of a binding law.

When Mabuse, in the *Danae* of 1527 (Munich), paints the golden rain, it is a tectonically stylised rain in which not only the single drops are little straight strokes, but the whole maintains a uniform order. Though no geometric configuration arises, it looks essentially different from any baroque

series of drops. Compare, for instance, the falling water of the brimming fountain basin in Rubens, *Diana and Nymphs surprised by Satyrs* (Berlin).

In the same way, the lights in a head by Velasquez have not only the indeterminate forms of the painterly style, but they dance among themselves more freely than in any distribution of light of the classic epoch. Law is there, or there would be no rhythm, but the law belongs to another species.

And we can thus extend the consideration to all the elements of the picture. The space represented in renaissance art is, as we know, graduated by rule. "Although the things confronting the eye", says Leonardo, "as they gradually recede, touch each other in uninterrupted contact, nevertheless I shall make my rule (of distance) from 20 to 20 ells, just as the musicians, although the tones unite in one whole, have set a few gradations from tone to tone." [1] The definite measurements which Leonardo gives do not need to be binding, yet in the planimetric stratifications even of the northern pictures of the sixteenth century, there rules a palpable law of sequence. On the other hand, such a motive as the exaggerated foreground is first possible when beauty was no longer sought in proportions, but when artists were capable of enjoying the interest of abrupt rhythm. Naturally, even then there is an underlying law, but that law is not an immediately obvious proportionateness, and hence operates as free order.

The style of closed composition is an architectural style. It builds, as nature builds, and seeks in nature what is akin to it. The preference for the primitive forms of the vertical and horizontal goes together with the need for limit, order, law. Never was the symmetry of the human figure more strongly felt, never the opposition of horizontal and vertical and self-contained proportion more forcibly sensed than then. At all points the style strives to grasp the firm and enduring elements of form. Nature is a cosmos and beauty is revealed law. [2]

In a-tectonic style the interest in the constructed and self-contained declines. The picture ceases to be an architecture. In the figure the architectonic factors are the secondary ones. The significant element of form is not the scaffolding, but the breath of life which brings flux and movement into the rigid form. In the one case, the values of being, in the other, the value of change. In the one case, beauty resides in the determinate, in the other, in the indeterminate.

Again we meet notions which reveal, behind artistic categories, different conceptions of the world.

[1] Cf. Leonardo, *Trattato della pittura*.
[2] Cf. L. B. Alberti, *De re aedificatoria*, lib. ix. *passim*.

Van Orley

3. SUBJECT MATTER

The spectator coming from the fifteenth century feels the aplomb of the portraits of the classic masters as something new. The development of the determining oppositions of form, the posing of the head in the vertical, the co-operation of accessory forms giving tectonic support — symmetrical trees and so on—everything works to the same end. If we take Barend van Orley's *Carandolet**** as an example, we shall easily be convinced of how profoundly the conception is conditioned by the ideal of a firm tectonic framework, and how the parallel lines of mouth, eyes, chin, and collar-bone are stressed and thrown into relief by the clearly opposing directions of the vertical. The horizontal is underlined by the cap and repeated by the resting arm and the dado of the wall. The upright forms are sustained by the high lines of the wainscot. Throughout we feel the affinity of figure and tectonic groundwork. The whole is so fitted into the picture-space that it looks immutably fixed. This impression asserts itself even when the head is not drawn full face, but the upright position remains the standard, and on the basis of such a conception we understand that pure frontality could be felt, not as something sought for, but as a natural form. Dürer's *Portrait of the Artist* in Munich is, as a pure full-face picture, not only a confession of faith in his own name, but in the name of the new tectonic art. Holbein, Aldegrever, Bruyn—all followed him.

To the firmly compact type of the sixteenth century we oppose the baroque type in Rubens' *Dr. Thulden.** The first thing which leaps to the eye as contrast is certainly the lack of *tenue*. Yet we must be on our guard against judging the two pictures expressionally by the same standard, as though they had expressed the character of their model by the same means. The whole basis of picture construction has shifted. The system of horizontals and verticals

is not exactly done away
with, but it is intentionally
made inapparent. There
is no attempt to bring out
the strictly geometric rela-
tions—the form plays over
them. In the drawing of
the head the tectonic-sym-
metrical element is sup-
pressed. The picture-space
is still rectangular, but the
figure bears no relation to
the axial system, and even in
the background little is done
to adjust the form to the
frame. On the contrary, the
artist seeks to create the im-
pression that the frame and
content have nothing to do
with each other. The move-
ment runs diagonally.

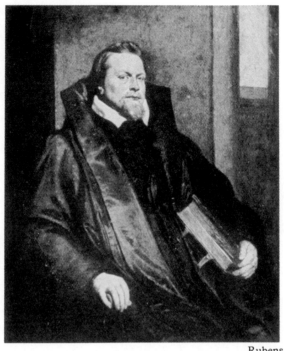

Rubens

It is natural that the front aspect should be avoided, but the vertical is
unavoidable. Even in the baroque there are "upright" people. But, strange
to say, the vertical has lost its tectonic significance. However clearly it may
be marked, it no longer enters into the system of the whole. Compare the half-
figure of Titian's *Bella* in the Pitti Palace with Van Dyck's *Luigia Tassis* in
the Liechtenstein gallery: in the first case, the figure lives within a tectonic
whole from which it draws and to which it imparts strength: in the other,
the figure is alienated from the tectonic basis. The one figure looks fixed, the
other mobile.

In the same way the history of the male standing figure from the sixteenth
century on is the history of a progressive slackening of the relation between
frame and content. When Terborch poses his single figures in empty space,
the relation of the axis of the figure to the axis of the frame seems to have
completely evaporated.

From the portrait we pass to the picture of a seated *Magdalene* by Scorel,*
where the artist was certainly not bound to a definite attitude, but felt it, at
that epoch, a matter of course that horizontal and vertical should determine
the tenor of the picture. To the vertical of the figure responds the vertical of

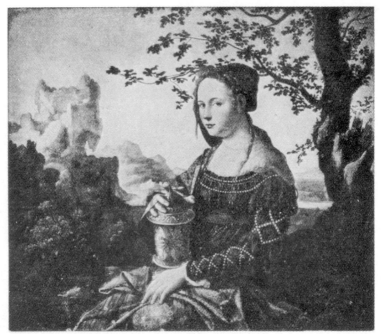

Scorel

tree and rock. The sitting motive in itself contains the opposing horizontal direction: it is repeated in the landscape and in the twigs of the tree. Not only do these right angles fix the appearance of the picture, they impart to it quite a specially self-contained character. The repetition of analogous relations increases considerably the impression that picture surface and content belong to each other.

If we compare with this Scorel a Rubens, who has repeatedly handled the theme of the female seated figure as Magdalene, we arrive at the same differences as in the portrait of Dr. Thulden already discussed. But if we pass from the Netherlands to Italy, even a Guido Reni*—although he is rather to be reckoned with the conservatives—shows the softening of the habitus of the picture into the a-tectonic. The rectangularity of the picture-space as active, form-defining principle is already essentially negated. The main current runs diagonally, and even if the distribution of the masses does not far depart from renaissance bilateralism, the recollection of Titian would suffice to bring home to us the baroque character of this Magdalene. The abandoned pose of the figure is not the decisive factor. Certainly the spiritual version of the motive diverges from the mode of the sixteenth century, but strength would now be developed on an a-tectonic basis just as much as pliancy.

No nation has expressed the tectonic style in the nude so convincingly as Italy. Here we might say that the style had grown out of the contemplation of the body, and that justice could not be done to the splendid growth of the human form unless it is beheld *sub specie architecturae.* We shall continue to believe so until we have seen what an artist such as Rubens or Rembrandt has made of the subject with another mode of contemplation and how, even in this form, nature seems to have manifested nothing but herself.

We illustrate with the modest but clear example of Franciabigio.* Compared with Quattrocentist forms—say with Lorenzo di Credi's *Venus* reproduced above (p. 3)—it looks as if, in this picture, art had first discovered the straight line. In both cases we have a perfectly upright standing figure, but the vertical has achieved in the sixteenth century a new sense. Symmetry does not always

mean symmetry—just as little does the concept of the straight line always have the same worth. There is a strict and a free interpretation. Independently of all differences of quality in the imitative sense, Franciabigio has that definitely tectonic character which determines the arrangement within the picture-space just as much as the representation of the formal structure within the body itself. The figure is reduced to a schema so that, as in the single head, the parts of the form work against each other in elementary oppositions and the picture as a whole is governed throughout by tectonic forces.

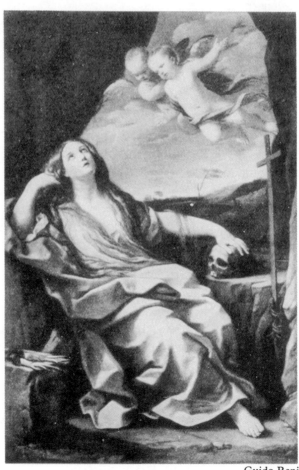

Guido Reni

Picture axis and figure axis strengthen each other. And when one arm is raised, and the female figure reflects itself in the mussel shell, there is created an—ideated—horizontal which again powerfully reinforces the effect of the vertical. In such a conception of the figure the architectural setting (niche with steps) will always look quite natural. From the same impulse, even if not with the same technical severity, Dürer, Cranach, Orley in the north painted their pictures of Venus and Lucrece, the significance of which for the history of the development must be judged in the first instance according to the tectonics of the pictorial conception.

Later, when Rubens takes up the theme, we are astonished at how rapidly and naturally the pictures shed their tectonic character. The great *Andromeda* ★ with her arms bound above her in no way avoids the vertical, but the vertical no longer works tectonically. The rectangle of the picture space no longer seems related to the figure by its lines. The distances of the figure from the

frame no longer count as constituent pictorial values. The body, even though it appears full front, does not take its frontality from the picture-space. Pure oppositions of direction are neutralised, and in the body the tectonic element speaks only secretly and, as it were, out of the depths. The emphasis in the effect has passed to the opposite side.

The stately show-picture—the picture of saints in the church above all—always seemed to be dependent on the tectonic order. Yet even if, in the seventeenth century, symmetry continues to be worked out, this type of composition is no longer compulsory in the building up of the picture. The arrangement of the figures may be meant to be symmetrical, the picture does not look so. If a symmetrical group is shown in foreshortening—as the baroque is prone to do—no symmetry appears in the picture. But if foreshortening is abandoned, this style has other resources at its disposal to make the spectator aware

Franciabigio that the spirit of the presentment is not

tectonic, even if the artist has, to a certain extent, admitted symmetry. Rubens' work contains very obvious examples of such symmetric-asymmetric compositions. But even quite trivial displacements of position and balance are enough to prevent the impression of tectonic order from arising.

When Raphael painted his *Parnassus* and the *School of Athens*, he could take his stand on a conviction that, for assemblies of such exalted atmosphere, the right thing was the strict schema of stressed middle. Poussin in his *Parnassus* (Madrid) followed him in that, yet, for all his admiration of Raphael he, as an artist of the seventeenth century, still gave his time what it demanded; by quite inapparent devices, the symmetry was transposed into the a-tectonic.

Dutch art passed through an analogous development with the corporate military picture. Rembrandt's *Night Watch* has its Cinquecentist ancestors in purely tectonic-symmetrical pictures. We cannot, of course, assert that Rembrandt's picture is the break-up of an old symmetry-schema: his point of departure does not lie on that line at all. But it is a fact that for this portrait problem the symmetrical composition (central figure and equal distribution of heads on both sides) was once felt to be the appropriate form of representation, while the eighteenth century, even at its stiffest and most pompous moments, could simply no longer recognise it as something living.

Thus in the sacred picture, too, the baroque rejected the schema. Even in classic art the bilateral arrangement had never been a general form in which the event was represented—it is possible to compose tectonically without stress on the middle axis—but it appears very frequently, and in every case seems to have the advantage of impressiveness. Now when Rubens treats the *Assumption** (p. 162), he certainly envisages the impressive no less than Titian in the *Assunta*, yet what was a matter of course in the sixteenth century — to raise the main figure up the middle axis

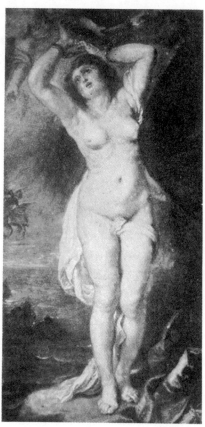

Rubens

Rubens

of the picture—was already unbearable for Rubens. He lays aside the classic vertical and gives the movement a slanting run. In the same way he has shifted the tectonic axis of the *Last Judgment* as he found it in Michelangelo into the a-tectonic.

To repeat: the bilateral composition is only an isolated enhancement of the tectonic. It *is* possible to give such a version of the *Adoration of the Magi*. Leonardo did so, and there are famous pictures in south and north which follow this type (cf. the Cesare da Sesto in Naples and the Master of the Death of Mary in Dresden), but it is possible to compose excentrally and yet not fall into the a-tectonic. The north preferred this form (cf. Hans von

Kulmbach's *Adoration of the Magi* in the Berlin Museum), but it is thoroughly familiar to the Cinquecento too. Raphael's cartoons reckon equally with both possibilities. What here looks relatively free appears thoroughly bound as soon as a comparison with baroque relaxation becomes possible.

We have an excellent example of how the rustic-idyllic scene, too, is penetrated by the tectonic spirit in Isenbrant's *Rest on the Flight*.* From all sides the tectonic effect of the middle figure is prepared for. The arrangement on the axis alone does not do it, the vertical is reinforced from the sides and continued in the background, and by the formation of the terrain and the picture zones, care is taken to make the opposing direction felt too. However unassuming and modest its motive, the little picture thereby becomes a member of the great family to which the *School of Athens* belongs. But

the schema is general, even where the middle axis is unstressed, as when Barend van Orley* handles the same subject. Here the figures are moved to one side without the balance being upset. Naturally, much depends on the tree. It does not stand in the middle, but for all that, we perceive very clearly where the middle lies: the trunk is no mathematical vertical, but we feel that it is related to the line of the picture frame: the whole growth goes into the picture-space. That alone determines the style.

It is just in landscape that we clearly

Isenbrant

see that it is the degree of significance assigned to the geometric values in the picture which chiefly decides as to its tectonic character. Landscapes of the sixteenth century are all laid out on verticals and horizontals in a way which, for all "naturalism", allows the inward relationship to the architectonic work to be perfectly felt. The stabilisation of the balance of the masses, the aplomb of the filling of the picture-space, completes the impression. Let us, for the sake of clearness, demonstrate by means of an example which is no pure landscape, but just on that account shows the stamp of the tectonic the more clearly, Patenir's *Baptism of Christ* * (reproduction, p. 145).

First of all, the picture is an excellent example of the plane style. Christ in one plane with the Baptist, whose arm does not quit the plane; the tree at the edge is included in the same zone. A (brown) cloak forms the transition. Mere

breadth forms in parallel sequence throughout all planes. Christ gives the keynote.

But the arrangement of the picture can just as well be considered under the heading of the tectonic. We shall then start with the absolute verticality of Christ and see how this direction is brought out by oppositions. The tree is thoroughly felt in its relation to the picture edge, from which it draws strength just as, on the other hand, it establishes the close of the picture. In the same way, the horizontality of the landscape zones conforms to the base line of the picture. Later pictures never allow this

Van Orley impression to arise. The

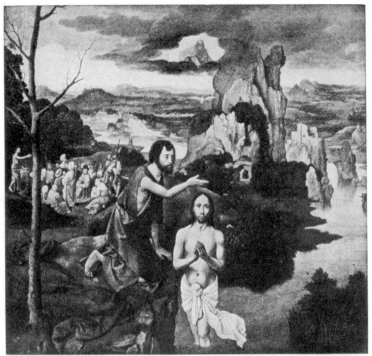

Patenir

forms collide with the frame, the picture-space looks adventitious, and the axial system remains unstressed. There need be no recourse to violent methods. In the frequently mentioned *View of Haarlem*,* Ruysdael gives the flat fields with a quiet, low horizon. It seems inevitable that this one very expressive line should operate as a tectonic value. Yet the impression is quite different: we feel only the limitless extent of space, and the picture is the characteristic model for that beauty of the infinite which the baroque was first capable of apprehending.

4. HISTORICAL AND NATIONAL CHARACTERISTICS

To realise the full historical significance of this specially complex pair of concepts it is essential to get rid of the idea that the primitive stage of art was the really tectonically bound stage. Certainly there exist tectonic limits for the primitives, but after all that has been said, it must be realised that art only became strict when it had achieved perfect freedom. Earlier painting possesses nothing which could be compared in tectonic content with Leonardo's *Last Supper* or Raphael's *Miraculous Draught of Fishes*.* A head by Dirk Bouts*

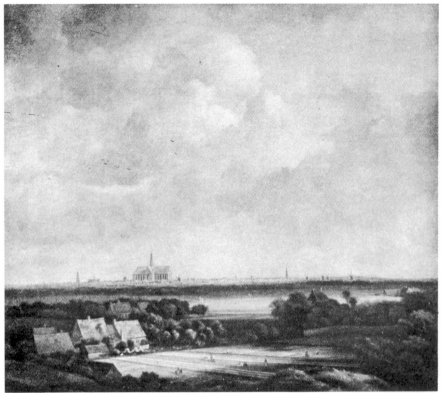

Ruysdael

is, as architecture, loosely felt as compared with the firm structure in Massys or Orley.* The masterpiece of Roger van der Weyden, the *Dreikönigsaltar* in Munich, has something insecure and variable in its directions compared with the simply lucid axial system of the sixteenth century, and the colour lacks the self-contained character because it does not reckon with mutually balancing elementary oppositions. And even in the next generation, how far removed is Schongauer from the full tectonic effect of the classics! We have the feeling that nothing is properly secured. Vertical and horizontal do not grip each other. The front view remains without emphasis, the symmetry looks weak, and the relation between picture-space and picture-filling still looks casual. To bear this out we might mention Schongauer's *Baptism of Christ*, which should be taken together with Wolf Traut's classic composition (Germanisches Museum, Nuremberg): with the main figure, full face, worked out absolutely centrally, it gives the type of the sixteenth century in a specially strict version, which the north did not long retain.

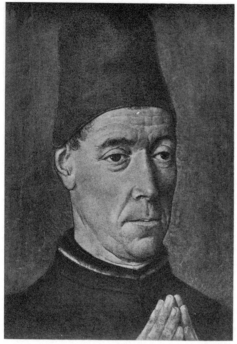

Bouts

While in Italian art the most self-contained form is felt to be the most living, Germanic art, without even embarking on ultimate formulations, immediately presses into freer forms. Altdorfer surprises us here and there with a feeling so free that he hardly seems to fit into an historical order. Yet even he did not fall out of his epoch. If the *Virgin's Birth* in the Munich Pinakothek looks as if it had negated all tectonics, merely the way in which the circle of angels sits in the picture, and the central arrangement of the angel with the censer, would frustrate any attempt to smuggle it into a later context.

In Italy it was, as is well known, Correggio who very early broke with the renaissance form. He does not play with isolated displacements behind which we can still feel a determining tectonic system, as Veronese did, but, inwardly and fundamentally, his type is a-tectonic. All the same, these are first beginnings, and it would be wrong to measure him from the outset, as a Lombard, by the standard of Florentino-Roman models. The whole of Upper Italy reserved its own judgment as to strict and free.

A history of the tectonic style cannot be written without going into the difference of nationality and scenery. The north, as has been said, felt less tectonically than Italy. Direction and "rule" easily appear life-destroying to

the north. Northern beauty is not a beauty of the self-contained and self-limited, but of the boundless and infinite.

SCULPTURE

It goes without saying that the plastic figure as such is subject to no other conditions than the painted figure. The problem of tectonic and a-tectonic has first a special application to sculpture as a problem of placing or, to put it otherwise, as a problem of the relation to architecture.

There is no free-standing figure which has not its roots in architecture. The pedestal, the relation to the wall, the direction in space—all these are architectonic points. Now there happens something similar to what we observed in the relation of picture content to picture frame in painting. After a period of mutual recognition, the elements begin to become estranged. The figure frees itself from the niche. It will not acknowledge the wall behind it as a binding force, and the less the tectonic axes are recognisable in the figure the more strained are the relations to every kind of architectural background.

We refer to the illustrations on pp. 59-60. Puget's figure lacks vertical and horizontal and thus presses out of the architectural system of the niche, but the niche-space is not respected either. The edge is cut into and the foreground plane is pierced. But contradictory is not arbitrary. The a-tectonic element here first makes itself felt by having a contrasting element to stand out on, and so far the baroque urge to freedom is a different thing from the lax composition of the primitives who do not know what they are doing. When Desiderio, in the Marsuppini tomb in Florence, pushes a few armorial figures against the foot of the pilasters, without really anchoring them in the construction, that is a sign of still undeveloped feeling, but the way in which the baroque cuts across the members of the building with sculpture is conscious negation of tectonic constraints. In Bernini's church of S. Andrea by the Quirinal, the patron saint soars into free space out of the segmental gable. We can say that that is a natural consequence of the representation of movement, yet the century, even in quite quiescent motives, no longer suffers the tectonically simplified and the harmony of the figure with the architectural order. It is, for all that, no contradiction if it is just this a-tectonic plastic which cannot free itself from architecture.

That the renaissance figure is so resolutely posed in the plane can also be understood as a tectonic motive, just as the baroque contortion of the figure, which twists free of the niche, must correspond to a-tectonic taste. Where figures are set up in a row, whether on an altar or along a wall, it is a rule that

they stand at an angle to the main plane. It is part of the charm of a rococo church that sculpture has acquired a flower-like freedom.

Neo-classicism first leads back to the tectonic. To disregard all other manifestations, when Klenze arranged the throne-room of the Munich Residenz, and Schwanthaler modelled the ancestors of the royal house, there could be no doubt that the figures had to be aligned with the columns. The analogous problem in the imperial room of Ottobeuer was so solved by the rococo that the figures turn towards each other in pairs, and thus assert the principle of their independence from the wall-surface without ceasing to be mural figures.

ARCHITECTURE

Painting *can*, architecture *must*, be tectonic. Painting only develops its own peculiar values where it emancipates itself from the tectonic: for architecture, the abolishment of the tectonic scaffolding would be equivalent to self-destruction. What in painting belongs of its nature to tectonics is only the frame, but the development proceeds in such a way that the picture parts company with the frame: architecture is specifically tectonic and only decoration seems to be able to comport itself more freely.

Nevertheless, the weakening of tectonics, as the history of representative art shows, was accompanied by analogous processes in architecture. While it seems far-fetched to speak of a-tectonic architecture, the notion "open" composition as opposed to "closed" composition may be used without objection.

The forms of manifestation of just this concept are very manifold. The survey will become easier if they are separated into groups.

Firstly, the tectonic style is the style of strict arrangement and clear adherence to rule: the a-tectonic, on the other hand, is the style of more or less concealed adherence to rule and of free arrangement. In the former case, the vital nerve in every effect is the inevitability of the organisation, absolute immutability. In the latter, art plays with the semblance of the lawless. It plays, for in the aesthetic sense, of course, form is bound by necessity in all art, but the baroque tends to conceal the rule, loosens the frames and joints, introduces dissonance, and, in decoration, verges on the impression of the casual.

Further, everything belongs to the tectonic style which operates in the sense of limitation and completeness, while a-tectonic style opens the closed form—that is, translates perfect into less perfect proportion: the finished figure is replaced by the apparently unfinished, the limited by the limitless.

Instead of an impression of repose, there arises an impression of tension and movement.

With that is connected—and this is the third point—the transformation of the rigid form into the flowing form. Not that the straight line and right angle are eliminated: it is enough that here and there a frieze bulges, that an angle bends into a curve, to produce the idea that a will to a-tectonic freedom was there from the outset and only awaited its opportunity. For renaissance feeling, the strictly geometric element is beginning and end, equally important for ground-plan and elevation: in the baroque, we can soon feel that it is the beginning but not the end. There is a similar process here as in nature in the progress from crystal formations to the forms of the organic world. The real domain in which forms attain the freedom of vegetable growth is, of course, not major architecture, but furniture liberated from the wall.

Changes of this kind are hardly thinkable without a transformation in the conception of material. Material seems everywhere to have become softer. It has not only become more pliable in the hands of the craftsman, but is itself imbued with a manifold impulse to form. That is certainly the case in all architecture regarded as art, and is its own special condition, but in contrast to the primitively limited expressions of tectonic architecture proper, we meet here a wealth and mobility in the creation of form which compels us once more to apply the metaphor of organic and inorganic growth. It is not only that the triangular form of a gable softens down into a flowing curve, the wall itself winds in and out like a living snake.

While we thus prepare to define the separate points more exactly, it may not be superfluous to repeat that a permanent apparatus of form is, of course, the fundamental condition of the process. The a-tectonic quality of Italian baroque is determined by the fact that there live on in this style the forms which the Renaissance had known for generations. If Italy had at that time experienced the invasion of a new world of forms (as occasionally happened in Germany) the mood of the epoch might have been the same, but architecture as its expression would not have developed the same motives. It is the same in the north with late Gothic. Late Gothic produced quite analogous phenomena of form-creation and form-combination. But we must be on our guard against wishing to explain them merely by the spirit of the time: they became possible because Gothic had been so long on the move and had so many generations behind it. The a-tectonic character is here too bound to a *late style*.

Northern late Gothic stretches, as we know, into the sixteenth century. We can see from this that the development in south and north does not quite

coincide in time. But even in content it does not quite coincide, in that a much stricter conception of closed form is natural to Italy, and the transposition of the law-observing into the apparently lawless there remained just as far behind northern possibilities as the conception of form almost as a free vegetable growth.

On the basis of its special values, the Italian High Renaissance realised the same ideal of the absolutely self-contained form as perhaps High Gothic did with quite a different point of departure. The style is crystallised in formations which bear the stamp of absolute inevitability, in which every part, in its place and in its shape, looks unchangeable and immovable. The primitives had the premonition of this beauty but did not see it clearly. The Florentine mural tombs of the Quattrocento, in the style of Desiderio or Antonio Rossellino, all look a little insecure: the individual figure is not firmly anchored. Here an angel floats on the surface of the wall, there a herald stands beside the foot of the corner column, both without convincing the spectator that only this form was possible here and no other. With the sixteenth century, that ceases. The total form is everywhere so organised that no trace of wilfulness remains. We might contrast with the Florentine examples just mentioned the Roman ecclesiastical tombs of A. Sansovino in S. Maria del Popolo, a type to which even the less tectonically conceived landscapes such as those of Venice immediately react. Revealed law is the highest form of life.

For the baroque too, beauty, of course, is necessity, but it plays with the charm of the adventitious. For the baroque too, the detail is enhanced and conditioned by the whole, but it must not look intentional. Who can speak of constraint in the creations of renaissance art? Everything fits into the whole and yet lives of itself. But perceptible rule is unbearable in the later epoch. On the basis of a more or less concealed order there is an effort to achieve that impression of freedom which alone seems to guarantee life. Bernini's tombs are particularly bold examples of such liberated compositions, although the symmetrical scheme is retained. The relaxation of the impression of rule is, however, unmistakable even in tamer works.

In the Urban tomb, Bernini sprinkled here and there a few bees, the heraldic device of the Pope, as casual spots. It is certainly only a small motive and does not weaken the tectonic basis of the construction, but yet how inconceivable was this playing with the casual in the High Renaissance!

In major architecture, the possibilities of the a-tectonic are, of course, more limited, but the fundamental fact remains that Bramante's beauty is the beauty of revealed law, and Bernini's beauty the beauty of a more concealed law. What the law-observing is cannot be said in a word. It consists in the harmony

of the forms, in a general uniformity of proportions; it consists in oppositions clearly worked out and mutually supporting; it consists in an articulation so strict that every element seems self-contained; it consists in a definite order in the sequence of the forms. And at all points the procedure of the baroque is the same; not to allow disorder to usurp order, but to transform the impression of the strictly bound into the impression of the freer. The a-tectonic always mirrors itself in the tradition of the tectonic. Everything depends on the point of departure. The relaxation of law has only a meaning for the artist for whom law was once nature.

A single example. In the Palazzo Odescalchi * (reproduction, p. 190) Bernini gives a colossal order with pilasters running through two storeys. In itself, that is nothing extraordinary. Palladio at any rate has the same thing. Yet the two great ranges of superposed windows which, as horizontal motive, cut across the rows of pilasters without transitional member, is an arrangement which was of necessity felt to be a-tectonic once classic feeling had at all points required clear articulation and clear distinctions of the parts.

In the Palazzo de Montecitorio, Bernini uses the cornice-band (in connection with two-storey pilasters), but the cornice does not look tectonic, nor does it act as articulation in the older sense, because it runs dead against the pilasters without being in any way supported. Here, in a motive of this kind, unobtrusive and not even new, we realise still more the relativity of all effects: it only attains its real significance because Bernini in Rome could not escape Bramante.

More radical changes occur in the domain of proportions. The proportions of the classic Renaissance were of such a kind that one and the same proportion is repeated on different scales—plane and solid proportions. That is why everything "sits" so well. The baroque avoids this clear relationship and seeks to overcome the impression of the completely finished by means of a more hidden harmony. In the proportions themselves, however, the tense, the unsatisfied, gradually supplants fully harmonised repose.

In contrast to Gothic, the Renaissance had always conceived beauty as a kind of satiety. It is not the satiety of dullness, but that relation between energy and repose which we feel to be an enduring state. The baroque abolishes this satiety. Proportions tend to become more restless, surface and content no longer coincide; in short, everything happens which for us produces the effect of an art of passionate tension. Yet we must not forget that the baroque did not only produce theatrical church buildings, but that by the side of this there is an architecture of the less extreme moods of life. What is here described is not an intensification of expressional resources lavished by

the new art in moments of high excitement, but the way in which, in perfectly peaceful moments, the concept of the tectonic was transposed. We have landscapes of the a-tectonic style which breathe the deepest peace; in the same way there is an a-tectonic architecture which is meant to produce no other than a peaceful and happy effect. Yet even for this, the old schemata have become useless. The living, taken quite generally, has now another form.

Thus it is comprehensible if forms with a definitely enduring character tend to die out. The oval does not completely supplant the circle; yet where the circle still appears, for instance in the ground plan, it has lost in the treatment its uniform satiety. As regards rectangular proportions, the relation of the *linea aurea* is pre-eminently effective in the sense of the self-contained: everything is done to prevent just this effect from coming about. The pentagon of Caprarola (Vignola) is a perfectly restful figure, but when the façade of the Palazzo di Montecitorio (Bernini) breaks into five planes, it does so at angles which are not easily apprehensible, and are hence apparently mobile. Pöppelmann applies the same motive in the great Zwinger pavilions. Also late Gothic knew it (Rouen, St. Maclou).

Analogous to the process already observed in pictorial art, is the process by which, in decoration, the content parts company with the given surface, while for renaissance art the perfect coincidence of both elements was the basis of beauty. The principle remains identical where solid relations are concerned. When Bernini had to erect his great tabernacle (with the four twisted columns) in St. Peter's, everybody realised that the problem was primarily one of proportions. Bernini declared that he owed the successful solution to a chance inspiration (*caso*). He meant by that that he could not appeal to any rule, but one is tempted to complete the remark by saying that he was aiming at that beauty of the form which looks adventitious.

If the baroque transforms the rigid into the flowing form that is also a motive which it has in common with late Gothic, only that the softening is carried further. We have already remarked how little we can attribute to the epoch the intention to bring *all* form into flux. The interesting thing is the transition, how the free form disengages itself from the rigid. Even a few consoles, in plant-like freedom, at the cornice are enough to convince the spectator of a more general will to the a-tectonic: conversely, in the most perfect examples of free form in the rococo, the contrast with exterior architecture is absolutely necessary if we are to obtain the real effect of the interiors with their rounded corners and their almost imperceptible transitions of wall into ceiling.

Certainly, even with exterior architecture of this type, we are bound to

realise that the whole nature of the architectonic body has changed. The limits of the separate species of forms have been effaced. Formerly the wall was absolutely distinct from what was not wall; now it can happen that the courses of the masonry run straight into a porch—perhaps with a quarter-circle ground-plan. The transitions from the heavier and more bound to the freer and more differentiated forms are many and subtle. Substance seems to have become more living, and the contrast between the actual members of the form is no longer brought out with the same sharpness. Thus it is possible that, in rococo interiors, a pilaster evaporates to a mere shadow, a mere breath on the surface of the wall.

The baroque, however, makes friends with the purely naturalistic form too: not for its own sake, but as a contrast, into which or out of which the tectonic elements may develop. Naturalistic stone is admitted. Naturalistic drapery finds extensive use. And a naturalistic curtain of flowers which moves quite freely over the surface of the form can, in the extreme cases, replace the old pilaster decoration with stylised foliage.

This is, of course, the doom of all arrangements with stressed centre and bilateral development.

Here, too, it is interesting to compare the analogous phenomena of late Gothic (naturalistic tracery, endless, running patterns in the panels).

Everybody knows that rococo decoration was replaced by a new style of strict tectonics. With that, the inward coherence of the motives is confirmed: the forms of revealed law reappear, regular distribution again replaces free rhythmic sequence, stone becomes hard, and the pilaster regains the articulating force it had lost since Bernini.

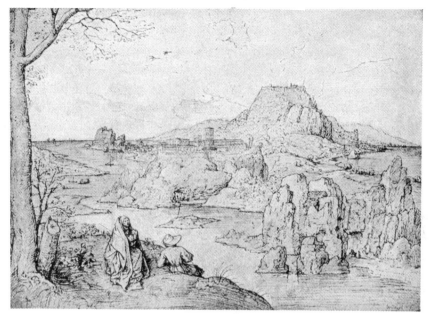

P. Brueghel the Elder

IV

MULTIPLICITY AND UNITY
(Multiple Unity and Unified Unity)

PAINTING

1. General Remarks

THE principle of closed form of itself presumes the conception of the picture as a unity. Only when the sum of the forms is felt as one whole can this whole be thought as ordered by law, and it is then indifferent whether a tectonic middle is worked out or a freer order reigns.

This feeling for unity develops only gradually. There is not a definite moment in the history of art at which we could say—now it has come: here too we must reckon with purely relative values.

A head is a total form which the Florentine Quattrocentists, like the early Dutch artists, felt as such—that is, as a whole. If, however, we take as comparison a head by Raphael or Quinten Massys, we feel we are confronted by another attitude, and if we seek to comprehend the contrast, it is ultimately the contrast of seeing in detail and seeing as a whole. Not that the former

could mean that sorry accumulation of details over which the reiterated corrections of the art master try to help the pupil—such qualitative comparisons do not even come into consideration here—yet the fact remains that, in comparison with the classics of the sixteenth century, these old heads always preoccupy us more in the detail and seem to possess a lesser degree of coherence, while in the other case, in any detail, we at once become aware of the whole. We cannot see the eye without realising the larger form of the socket, the way it is set between forehead, nose, and cheekbone, and to the horizontal of the pair of eyes and of the mouth the vertical of the nose at once responds: the form has a power to awaken vision and to compel us to a united perception of the manifold which must affect even a dense spectator. He wakes up and suddenly feels quite a new fellow.

And the same difference obtains between a pictorial composition of the fifteenth and sixteenth centuries. In the former, the dispersed; in the latter, the unified: in the former, now the poverty of the isolated, now the inextricable confusion of the too much; in the latter, an organised whole, in which every part speaks for itself and is comprehensible, yet makes itself felt in its coherence with the whole as a member of a total form.

In establishing these differences between the classic and the pre-classic period, we first obtain the basis for our real subject. Yet here we at once feel the painful lack of distinguishing vocabulary: at the very moment at which we name unity of composition as an essential feature of Cinquecento art, we have to say that it is precisely the epoch of Raphael which we wish to oppose as an age of multiplicity to later art and its tendency to unity. And this time we have no progress from the poorer to the richer form, but two different types which each represent an ultimate form. The sixteenth century is not discredited by the seventeenth, for it is not here a question of a qualitative difference but of something totally new.

A head by Rubens is not better, seen as a whole, than a head by Dürer or Massys, but that independent working-out of the separate parts is abolished which, in the latter case, makes the total form appear as a (relative) multiplicity. The Seicentists envisage a definite main motive, to which they subordinate everything else. No longer do the separate elements of the organism, conditioning each other and holding each other in harmony, take effect in the picture, but out of the whole, reduced to a unified stream, individual forms arise as the absolute dominants, yet in such a way that even these dominant forms signify for the eye nothing separable, nothing that could be isolated.

The relationship can be elucidated most satisfactorily in the composite sacred picture.

One of the richest motives of the biblical picture-cycle is the *Descent from the Cross*, an event which sets many hands in movement and contains powerful psychological contrasts. We have the classic version of the theme in Daniele da Volterra's picture in the Trinità dei Monti in Rome. This has always been admired for the way in which the figures are developed as absolutely independent parts, and yet so work together that each seems governed by the whole. That is precisely renaissance articulation. When later Rubens, as spokesman of the baroque, treats the same subject in an early work, the first point in which he departs from the classic type is the welding of the figures into a homogeneous mass, from which the individual figure can hardly be detached. He makes a mighty stream, reinforced by devices of lighting, pass slanting through the picture from the top. It sets in with the white cloth falling from the transverse beam; the body of Christ lies in the same course, and the movement pours into the bay of many figures which crowd round to receive the falling body. No longer, as in Daniele da Volterra, is the fainting Virgin a secondary centre of interest detached from the main event. She stands, and is completely absorbed, in the mass round the Cross. If we wish to denote the

change in the other figures by a general expression, we can only say that each has abdicated part of its independence to the general interest. On principle, the baroque no longer reckons with a multiplicity of co-ordinate units, harmoniously interdependent, but with an absolute unity in which the individual part has lost its individual rights. But thereby the main motive is stressed with a hitherto unprecedented force.

It must not be objected that these are less differences of development than differences of

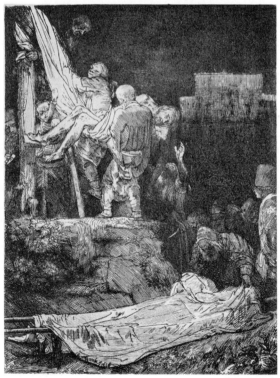

Rembrandt

national taste. Certainly, Italy has always had a preference for the clear component part, but the difference persists too in any comparison of the Italian Seicento with the Italian Cinquecento or in the comparison between Rembrandt and Dürer in the north. Although the northern imagination, as contrasted with Italy, aimed rather at the interweaving of the members, a *Deposition* by Dürer, compared with Rembrandt,* provides the absolutely pronounced opposition of a composition with independent figures to a composition with dependent figures. Rembrandt focusses the story on the motive of two lights—a strong, steep one at the top left-hand corner, and a weak, horizontal one at the bottom right. With that, everything that matters is indicated. The corpse, only partially visible, is being let down, and is to be laid out on the winding-sheet lying on the ground. The "down" of the deposition is reduced to its briefest expression.

Thus there stand opposed the multiple unity of the sixteenth century and the unified unity of the seventeenth: in other words, the articulated system of forms of classic art and the (endless) flow of the baroque. And, as is evident from previous examples, two elements interact in this baroque unity—the cessation of the independent functioning of the individual forms and the development of a dominating total motive. This can be achieved plastically, as in Rubens, or by means of more painterly values, as in Rembrandt. The example of the *Deposition* is only characteristic of an isolated case: unity fulfils itself in many ways. There is a unity of colour as well as of lighting, and a unity of the composition of figures as of the conception of form in a single head or body.

That is the most interesting point: the decorative schema becomes a mode of apprehension of nature. It is not only that Rembrandt's pictures are built up on a different system from Dürer's, things are seen differently. Multiplicity and unity are, so to speak, vessels in which the content of reality is caught and takes form. We must not assume that just any decorative system was clapped over the world's eyes: matter plays its part too. People not only see differently, they see *different things*. But all the so-called imitation of nature has only an artistic significance when it is inspired by decorative instincts and produces in its turn decorative works. That the concept of a multiple beauty and of a unified beauty also exists, apart from any imitative content, is borne out by architecture.

The two types stand side by side as independent values, and it does not meet the case if we conceive the later form only as an enhancement of the former. It goes without saying that baroque art was convinced that it had first found truth and that renaissance art had only been a preliminary form, but

the historian judges otherwise. Nature can be interpreted in more than one way. And therefore it came about that it was just in the name of nature that, at the end of the eighteenth century, the baroque formula was ousted and again replaced by the classic.

2. The Principal Motives

The subject of this chapter, therefore, is the relation of the part to the whole —namely, that classic art achieves its unity by making the parts independent as free members, and that the baroque abolishes the uniform independence of the parts in favour of a more unified total motive. In the former case, co-ordination of the accents; in the latter, subordination.

All our previous categories have led up to this unity. The painterly is the deliverance of the forms from their isolation; the principle of recession is no other than the replacement of the sequence of separate planes by a uniform recessional movement, and a-tectonic taste dissolves the rigid structure of geometric relations into flux. We cannot avoid partly repeating familiar matter: the essential viewpoint of the consideration is all the same new.

It does not happen of itself and from the outset that the parts function as free members of an organism. Among the primitives, the impression is checked because the component parts either remain too dispersed or look confused and

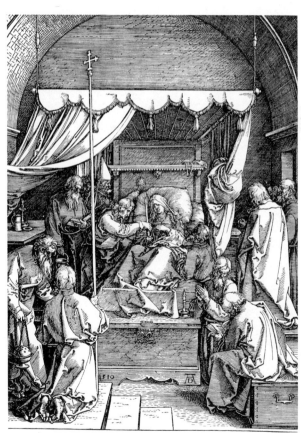

Dürer

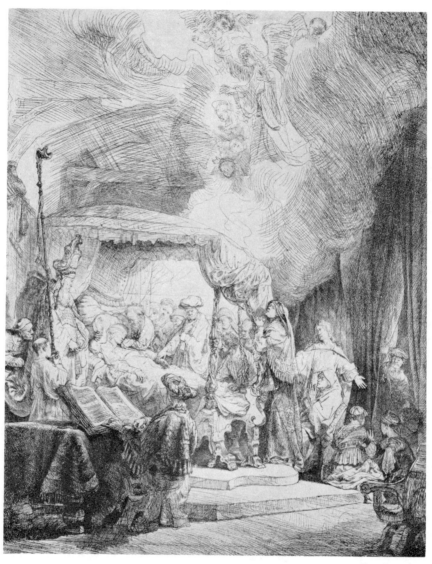

Rembrandt

unclear. Only where the single detail seems a necessary part of the whole do we speak of organic articulation, and only where the component part, bound up in the whole, is still felt as an independently functioning member, has the notion of freedom and independence a sense. That is the classic system of forms of the sixteenth century, and it makes no difference, as we have said, whether we understand by a whole a single head or a composite sacred picture.

Dürer's impressive woodcut of the *Virgin's Death*★ (1510) outstrips all previous work in that the parts form a system in which each in its place appears determined by the whole and yet looks perfectly independent. The picture is an excellent example of a tectonic composition—the whole reduced to clear geometric oppositions—but, beside that, this relationship of (relative) co-ordination of independent values should always be regarded as something new. We call it the principle of multiple unity.

The baroque would have avoided or concealed the meeting of pure horizontals and verticals. We should no longer have the impression of an *articulated* whole: the component parts, whether the bed canopy or one of the apostles, would have been fused into a total movement dominating the picture. If we recall the example of Rembrandt's etching of the *Virgin's Death*,★ we shall realise how very welcome to the baroque was the motive of the upward streaming clouds. The play of contrasts does not cease, but it keeps more hidden. The arrangement of obvious side-by-side and clear opposite are replaced by a single weft. Pure oppositions are broken. The finite, the isolable, disappear. From form to form, paths and bridges open over which the movement hastens on unchecked. But from such a stream, unified in the baroque sense, there arises here and there a motive so strongly stressed that it focusses the eye upon it as the lens does the light rays. Of this kind, in drawing, are those spots of most expressive form which, similarly to the culminating points of light and colour, of which we shall speak presently, fundamentally separate baroque from classic art. In classic art, even accentuation; in the baroque, one main effect. These motives which bear the main accent are not pieces which could be broken out of the whole, but only the final surges of a general movement.

The characteristic examples of unified movement in the composite figure picture are given by Rubens. At all points, the transposition of the style of multiplicity and separation into the assembled and flowing with the suppression of independent separate values. The *Assumption*★ is not only a baroque work because Titian's classic system—the main figure opposed as vertical to the horizontal form of the group of the apostles—has been transformed

into a general diagonal movement, but because the parts can no longer be isolated. The circle of light and angels which fills the centre of Titian's *Assunta* still re-echoes in Rubens, but it only receives an aesthetic sense in the context of the whole. However regrettable it is that copyists should offer Titian's central figure alone for sale, a certain possibility of doing so still exists: with Rubens, such an idea could present itself to nobody. In Titian's picture, the apostle motives to left and right mutually balance—the one looking up and the other with upstretched arms. In Rubens, only one side speaks, the other is, as far as content is concerned, reduced to insignificance, a suppression which makes the unilateral right-hand accent much more intense.

A second case—Rubens' *Bearing of the Cross* ★ (reproduction, p. 93), which has already been compared with Raphael's *Spasimo*. An example of the transposition of plane into recession, but also an example of the transposition of articulated multiplicity into unarticulated unity. In the *Spasimo*, the soldier, Christ, and the women—three separate, equally accented motives; in Rubens, the same, as regards subject matter, but the motives kneaded together, and foreground and background carried into each other in a uniform drift of movement, without caesura. Tree and mountain work together with the figures and the lighting completes the effect.

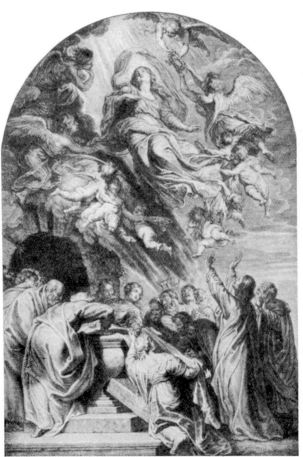

Rubens

Everything is one. But out of the stream the wave rises here and there with surpassing force. Where the herculean soldier rams his shoulder under the cross, so much strength is concentrated that the balance of the picture might seem menaced—not the man as a separate motive, but the whole complex of form and light determines the effect—these are the characteristic nodal points of the new style.

To give unified movement, art need not necessarily have at its disposal plastic resources such as are contained in these compositions of Rubens. It needs no procession of moving human figures: unity can be enforced merely by lighting.

The sixteenth century also distinguishes between main and secondary light, but—we refer to the impression of a black and white plate such as Dürer's *Virgin's Death*—it is still an even weft which is created by the lights adhering to the plastic form. Pictures of the seventeenth century, on the other hand, readily cast their light on one point, or, at any rate, concentrate it in a few spots of highest light which then form an easily apprehended configuration between them. But that is only half the matter. The highest light or the highest lights of baroque art proceed from a general unification of the light-movement. Quite otherwise than previously, the lights and darks roll on in a common stream, and where the light swells to a final height, just there it emerges from the great total movement. This focussing on individual points is only a derivative of the primary tendency to unity, in contrast to which classic lighting will always be felt as multiple and separating.

It must be a pre-eminently baroque theme if, in a closed space, the light flows from one source only. Ostade's *Studio*,★ referred to above (p. 49), gives a clear example of this. Yet the baroque character is not merely a question of subject: in his *St. Jerome*★ engraving, Dürer, as we know, drew quite different conclusions from a similar situation. But we will leave such special cases out of the question and base our analysis on a plate with a less salient quality of lighting. Let us take Rembrandt's etching of *Christ Preaching*.★

The most striking visual fact here is that a whole mass of conglomerated highest light lies on the wall at Christ's feet. This dominating light stands in the closest relation to the other lights. It cannot be isolated as an individual thing, as is possible with Dürer, nor does it coincide with a plastic form: on the contrary, the light glides over the form, it plays with the objects. All the tectonic elements thereby become less obvious and the figures on the stage are, in the strangest way, dragged apart and reassembled as if not they but the light were the element of reality in the picture. A diagonal of light passes from the left foreground over the middle through the archway into the background,

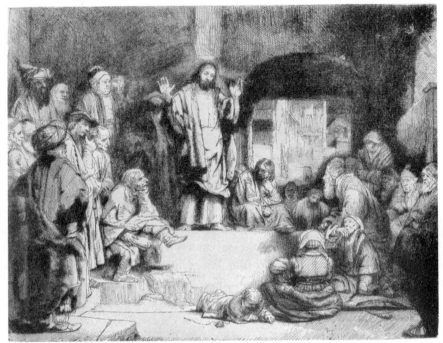

Rembrandt

yet what meaning does such a statement have beside the subtle quiver of light and dark throughout the whole space, that rhythm by means of which Rembrandt, more than any other, imparts to his scenes a compelling unity of life?

Other unifying factors are, of course, at work here too. We disregard what does not belong to the subject. An essential reason why the story is presented with such impressive emphasis lies in the fact that the style also uses distinctness and indistinctness to intensify the effect, that it does not speak with uniform clearness at all points, but makes places of most speaking form emerge from a groundwork of mute or less speaking form.

The development of colour offers an analogous spectacle. In place of the "bright" colouring of the primitives with their juxtaposition of colour without systematic connection, there comes in the sixteenth selection and unity, that is, a harmony in which the colours mutually balance in pure oppositions. The system is perfectly obvious. Every colour plays its part with reference to the whole. We can feel how, like an indispensable pillar, it bears and holds together the building. The principle may be developed with more or less consistency, the fact remains that the classic epoch, as an epoch of fundamentally multiple colouring, is very clearly to be distinguished from the following period with its aiming at tonal relations. Whenever we pass from the Cinquecentist room in a

gallery to the baroque, the surprise we feel is that clear, obvious juxtaposition ceases and that colours seem to rest on a common ground in which they sometimes sink into almost complete monochrome, in which, however, if they stand out clearly, they remain mysteriously moored. We can, even in the sixteenth century, denote single artists as masters of tone and attribute to individual schools a generally tonal style; that does not hinder the fact that, even in such cases, the "painterly" century introduces an enhancement which should be distinguished by a word of its own.

Tonal monochrome is only a transitional form. Artists soon learned to use tonality and colour simultaneously, and in so doing, to intensify individual colours in such a way that, similarly to the highest lights, as spots of strongest colouring they radically reshape the whole physiognomy of painting in the seventeenth century. Instead of uniformly distributed colour, we now have the single spot of colour—it can be a chord of two or three colours—which unconditionally dominates the picture. The picture is, as we say, pitched in a definite hue. With that is connected a partial negation of colouring. Just as the drawing abandons uniform clearness, so it promotes the focussing of colour effect to make the pure colour proceed from the dullness of half or no colour. It breaks out, not as a thing which happens once, or can be isolated, but as one long prepared. The colourists of the seventeenth century handled this "becoming" of colour in various ways, but there is always this distinction from the classic system of coloured composition, that the classic age to a certain extent builds with finished units, while in the baroque the colour comes and goes and comes again, there louder, here lower, and the whole is not to be apprehended save through the idea of an all-pervading general movement. In this sense, the foreword to the great Berlin picture catalogue states that the mode of description of colour tried to adapt itself to the course of the development. "From the detailed notation of colour, there was a gradual transition to a description envisaging the whole of the colouristic impression."

But it is a further consequence of baroque unity that a single colour can stand out as a solitary accent. The classic system does not know the possibility of casting an isolated red into the scene as Rembrandt does in his *Susanna* in Berlin. The complementary green is not absent, but works only softly, from the depths. Co-ordination and balance are no longer aimed at, the colour is meant to look solitary. We have the parallel in design: baroque art first found room for the interest of the solitary form—a tree, a tower, a human being.

And so, from the consideration of detail, we come back to the general principle. The theory of variable accents, which we have here developed, would be inconceivable unless art could show the same differences of type as

Dirk Vellert

regards content. A characteristic of the multiple unity of the sixteenth century is that the separate things in the picture are felt to be relatively equal in material value. The narrative certainly distinguishes between main and secondary figures. We can see—in contrast to the narration of the primitives— from far off where the crucial point of the event lies, but for all that, what have come into being are creations of that relative unity which to the baroque looked like multiplicity. All the accessory figures still have their own existence. The spectator will not forget the whole in the details, but the detail can be seen for itself. This can be well demonstrated by Dirk Vellert's* drawing (1524), showing the child Saul coming to the High Priest. The man who created this work was not one of the pioneer spirits of the sixteenth century, but he was not a backward one either. On the contrary, the representation, articulated through and through, is purely classic in style. Yet every figure has its own centre of interest. The main motive certainly stands out, yet not so that the secondary figures find no room to live their own lives. The architectonic element too is so handled that it must claim some interest for itself. It is still classic art, and not to be confused with the scattered multiplicity of the primitives: everything has its clear relation to the whole, but how ruth-

lessly would an artist of the seventeenth century have cut down the scene to the points of vital interest! We do not speak of qualitative differences, but even the conception of the main motive lacks, for modern taste, the character of a real event.

The sixteenth century, even where it is quite unified, renders the situation broadly, the seventeenth concentrates it on the moment. But only in this way does the historical picture really speak. We make the same experience in the portrait. For Holbein, the cloak is as valuable as the man. The psychic situation is not timeless, yet cannot be understood as the fixation of a moment of freely flowing life.

Classic art does not know the notion of the momentary, the poignant, or of the climax in the most general sense: it has a leisurely, broad quality. And though its point of departure is absolutely the whole, it does not reckon with first impressions. The baroque conception has shifted in both directions.

3. SUBJECT MATTER

It is not easy to make clear in words how, in a definitely given whole such as a head, the conception can be in the one case multiple, in the other unified. After all, the forms remain unchanged and even the classic type blends them into a unified whole. But any comparison will show how in Holbein* the forms stand side by side as in-dependent and relatively co-ordinated values, while in Frans Hals or Velasquez* certain groups of forms take the lead, the whole is subordinated to a definite motive of movement or expression, and in this combina-tion the details can no longer assert an existence of their own in the old sense. It is not only painterly, unified vision con-trasted with the linear limitation of the separate part: in classic art the forms, as it were, are thrust against each other, and, by the emphasis laid upon their immanent contrasts, attain a

Holbein (Detail)

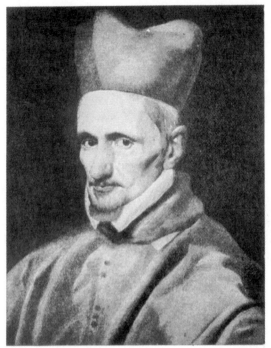

Velasquez

maximum of independent effect, while in the baroque, with the toning down of tectonic values, the single form too has lost something of its independence and separate significance. But that is not the whole of the matter. Whatever methods are resorted to, the significant accent of the separate parts within the whole must be apprehended; for instance, how strongly the form of a cheek stands out beside nose, eye, and mouth. Beside the one type of relatively pure co-ordination, there are infinitely many modes of sub-ordination.

It may help to make the matter clear if we recall the dressing of a head as regards hair and headgear, where the notions of multiplicity and unity have a decorative significance. We might have spoken of this in the preceding chapter. The connection with tectonic and a-tectonic is very close. The classic sixteenth century was the first to provide the conscious opposition to the vertical of the face in flat hats and caps which take up the horizontal of the forehead, and in the simple fall of the hair a contrasting frame is given to all the horizontal elements in the head. The costume of the seventeenth century could not accept this system. No matter how much fashions may change, there can be seen throughout all variants of the baroque an impulse to a more unified movement. Not only in the directions, but in the handling of surfaces, separation and opposition are less aimed at than relation and unity.

This becomes still clearer in the representation of the whole body. Here it is a question of forms poised in freely mobile joints, and hence the possibilities of tense or relaxed effects have much play. An epitome of renaissance beauty is Titian's reclining *Bella*,* which took up Giorgione's type. Nothing but clearly defined limbs organised in a harmony in which the separate tone can still be distinctly heard as such. Every joint finds clear expression, and every portion

between the joints is a self-sufficing form. Who is going to speak here of progress in anatomic verisimilitude? The whole naturalistic, material content of the picture sinks into insignificance beside the realisation of a definite notion of beauty which presided over the conception. If ever musical comparisons are in place, it is in this harmony of beautiful forms.

The baroque has another goal. It does not seek articulated beauty, joints are felt less distinctly, contemplation demands the spectacle of movement. That does not need to be the dramatic Italian swing of the body which inspired Rubens in his youth: even Velasquez, who will have nothing to do with Italian Barocco, has this movement. How different is the underlying feeling in his recumbent *Venus*★ from that in Titian! A body still more delicately built, yet the effect is not based on the juxtaposition of separate forms, but rather on the whole as a whole, subjected to a leading motive, and the uniform accentuation of the members as isolated parts surrendered. We can express the relationship differently: we might say that the accent is concentrated in single places, the form focussed on single points—every definition comes to the same thing. It must be assumed from the outset that the system of the body is differently felt—that is, less "systematically". For the beauty of the classic style, the uniformly clear visibility of all the parts is the *sine qua non*: the baroque can dispense with it, as Velasquez' example shows.

These are not differences of climate and nation. Raphael and Dürer represented the body in the same way as Titian, and Rubens and Rembrandt go together with Velasquez. Even where Rembrandt envisages nothing but lucidity, as in the etching of the seated youth where he deals in such detail with articulation in the nude, he can no longer use the accents of the sixteenth century. From such examples an illuminating light may fall, too, on the treatment of the single head.

But if we turn to the picture as a whole we shall be able to recognise, even in these simple problems, the fundamental quality of classic art, the isolability of the individual figure within the picture, as the natural consequence of classic design. We can cut such a figure out: it will certainly appear less to its advantage than in its old setting, but it does not collapse. The very existence of the baroque figure, on the other hand, is bound to the other motives in the picture. Even the single portrait head is inextricably woven into the movement of the background, be it only the movement of light and dark. This is still truer of a composition such as Velasquez' *Venus*. While Titian's beautiful figure possesses a rhythm in itself alone, in Velasquez the figure is only completed by what is added to it in the picture. And the more necessary this completion is, the more perfect is the unity of the baroque work.

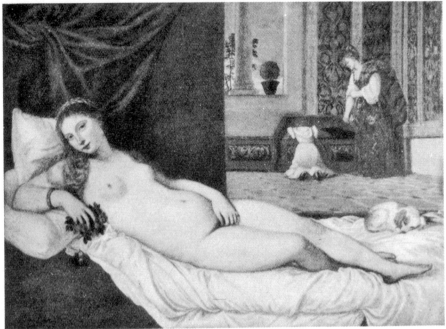

Titian

For the composite picture we may first turn to the Dutch portrait group
for illuminating developments. The military pictures of the sixteenth century,
tectonically constructed, are totalities with nothing but co-ordinated values.
The Captain may be more important than the others, yet the whole remains a
juxtaposition of equally stressed figures. The extreme contrast to this type is
given in Rembrandt's version of the theme in his *Night Watch*. Here we find
single figures, even groups of figures reduced almost to unrecognisability; but
just on that account, the few intelligible motives leap to the eye as dominants
with all the more force. The same happens, with a smaller number of figures,
in the *Regentenstücke*. How the young Rembrandt, in the *Anatomy* of 1632,
demolishes the old scheme of co-ordination and subjects the whole company to
one light and *one* movement is an unforgettable impression, and everyone will
feel this procedure to be characteristic of the new style. But the surprise here
lies in the fact that Rembrandt did not abide by this solution. The *Staal-
meesters** of 1661 is quite different. The theme—five gentlemen and the
servant. But of the gentlemen, each is as important as the others. There is no
trace here of the somewhat spasmodic concentration of the *Anatomy*, but a
loose row of equal members. No artificially concentrated light, but light and
dark freely dispersed over the whole picture-space. Is that a reversion to an

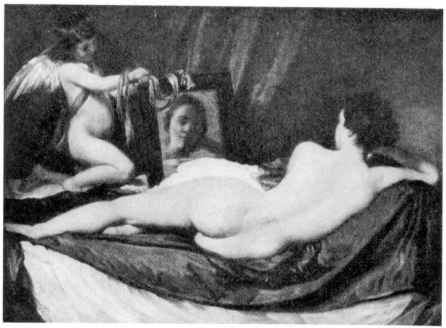

Velasquez

archaic manner? Certainly not. The unity here lies in the absolutely compelling coherence of the movement of the whole. It has rightly been said that the key to the total motive lies in the outstretched hand of the speaker (Jantzen). With the inevitability of a natural gesture, the row of five great figures unfolds. No head could be posed differently, no arm lie otherwise. Each seems to act for itself, but only the coherence of the whole gives the individual action sense and significance. Naturally, it is not the figures alone which make up the composition. The unity is uniformly sustained by light and colour. Of great importance is the high light on the table-cloth, which no photograph has yet been able to bring out. So that here, too, we come back to the baroque require-ment that the figure should be so fused into the whole picture that the unity *can* only be apprehended in the sum of colour and light and form.

In considering these elements of form in the narrower sense, we must not overlook how far the new economy of spiritual accents aided the achievement of unity. It plays its part in the *Anatomy* as in the *Staalmeesters*. More out-wardly in the former case, more inwardly in the latter, the spiritual content of the picture is gathered into a unified motive such as is quite absent from the older portrait group with its juxtaposition of independent heads. In that juxta-position there is nothing particularly behind the times, as if art, in respect

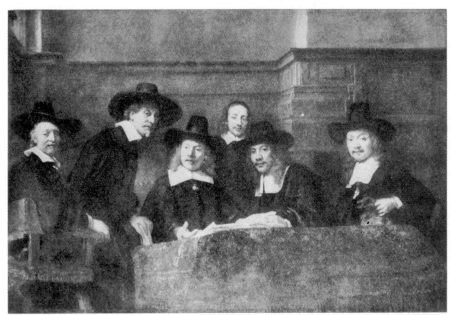

Rembrandt

precisely of this problem, were bound to primitive formulas: rather it corresponds perfectly to the notion of co-ordinated accents, which was even retained where greater freedom was possible, as in the genre picture.

Hieronymus Bosch's *Carnival* ★ is such a picture of the old style, not only as regards the arrangement of the figures, but as regards the distribution of interest. No dispersal of interest, such as can happen among the primitives; on the contrary, everything unified in feeling and effective as a whole, yet a series of motives each of which claims uniform interest for itself. That is intolerable to the baroque. Ostade ★ works with a considerably larger cast, but the notion of unity is applied more boldly. From the tangle of the whole, the group of the three standing figures emerges, the highest wave in the undulation of the picture. Not detached from the total movement, yet a major motive which immediately brings rhythm into the scene. Although everything is expressive, this group obviously bears the liveliest expressional accent. The babel of voices here rises to intelligible speech.

That does not prevent the mere indistinguishable hum of street or market from being represented too, occasionally. Then all the motives are deprived of something of their significance, and the unity is then the mass effect, something totally different from the coexistence of independent parts in older art.

With such aims, of course, the sacred picture necessarily changed its face

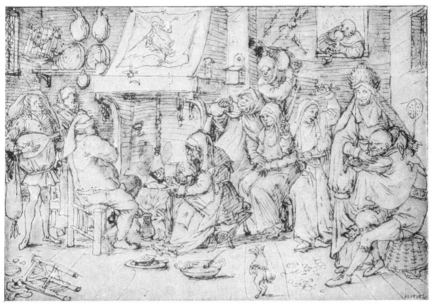

Hieronymus Bosch

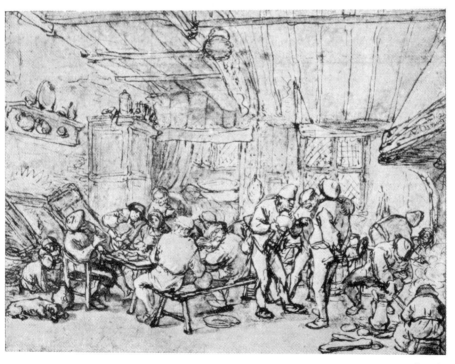

Ostade

the most. The concept of unified narration was already established in the sixteenth century, but it was the baroque which first felt the tension of the moment, and only from that time on did the dramatic narration exist.

Leonardo's *Last Supper* is, as far as the story goes, a unified picture. A definite moment is seized for representation, and the parts played by the individual actors determined by that moment. Christ has spoken and lingers in a gesture which can last some time. Meanwhile, among His hearers, His speech takes effect differently according to their temperament and intelligence. There can be no doubt as to what He has said: the excitement of the disciples and the resigned gesture of the Master—both point to the announcement of the betrayal. In the same need for spiritual unity everything has been removed from the scene which could merely entertain or distract. Only what can fulfil the exigencies of the subject is offered to the imagination—the motive of the covered table and the closed room. Nothing is there for itself: everything subserves the whole.

We know what an innovation such a procedure meant at that time. The notion of unified narration is certainly not lacking among the primitives, but the treatment is uncertain and, in the loading of the story with motives which do not belong to it and must divert interest to themselves, everything is regarded as permissible.

Yet what can be regarded as progress beyond the classic version? Is there any possibility of surpassing this unity? The answer lies in the reference to the transformation which we have already observed in the portrait and the genre picture, *i.e.* the abolition of the co-ordination of values, the development of a main motive which dominates all others visually and spiritually, a bolder grasp of the purely momentary. Leonardo's *Last Supper*, although it is conceived as a unity, still offers the spectator so many points of interest in comparison with later narrations that it looks thoroughly multiple. It may seem blasphemy to many to refer here to Tiepolo's *Last Supper* (reproduction, p. 88), but we can all the same see there how the development moves: not thirteen heads, all meant to be seen uniformly: only a few stand out of the mass, the others are repressed or completely veiled. Therefore what is really visible speaks with double energy throughout the whole picture. It is the same relationship as we tried to make clear at the beginning in the parallel of Dürer's and Rembrandt's *Deposition*. It is a pity that Tiepolo has no more to say to us.

This convergence of the picture on single striking effects is necessarily bound up with a more acute concentration on the momentary. The classic story of the sixteenth century has still, in comparison with later art, a static

element, something envisaging the more enduring, or, better expressed, it still reckons with a broad moment, while now the moment of time contracts and the representation really grasps only the brief consummation of the action.

We can refer in comparison to the story of the Old Testament Susanna. The older form of the story is not really the molesting of the woman, but the way in which the elders watch their victim from afar or hasten towards her. Only gradually, with the intensification of dramatic feeling, comes the moment at which the enemy has leaped on Susanna as she bathes and is whispering his lascivious words into her ear. And in the same way, the dramatic scene of Samson overpowered by the Philistines only gradually developed out of the schema of the sleeper who, lying peacefully in Delilah's lap, is bereft by her of his hair.

Such fundamental changes of interpretation can certainly never be explained on the basis of a single concept. What is new in the sense of this chapter denotes part of the phenomenon, but not the whole. We close the series of these examples with the subject of landscape, and so return to the analysis of visual forms.

A Dürer or Patenir landscape is distinguishable from any of Rubens' landscapes by the fitting together of independently developed details, in which we certainly feel a total calculation, yet, in spite of all gradation, cannot arrive at the impression of a definitely leading motive. Only gradually do the separating barriers weaken, foreground and background flow into each other, one motive in the picture receives the decisive predominance. Even the Nuremberg artists of Dürer's school, the Hirschvogels and Lautensacks, construct differently: in Pieter Brueghel's splendid winter landscape (see reproduction, p. 100) the row of trees cuts into the picture from the left with driving power, the problem of the accents in the picture suddenly takes on a new aspect. Then comes unification by means of great bands of light and shade, such as are familiar from the work of Jan Brueghel; Elsheimer promotes the development from another side with the unity of long ranges of trees and hills carried diagonally through the picture, such as re-echo in the "topographical diagonal" of Van Goyen's dune landscapes. In short, when Rubens drew his conclusions a schema was yielded which, forming the opposite pole to Dürer, can best be illustrated by the *Mechlin Hay Harvest*.*

A flat meadow landscape, opened into the background by a crooked road. By means of the accessory carts and animals, the recessional movement is intensified, while the harvesters departing sideways establish the foreground plane. The curve of the road runs parallel to the drift of the clouds which

Rubens

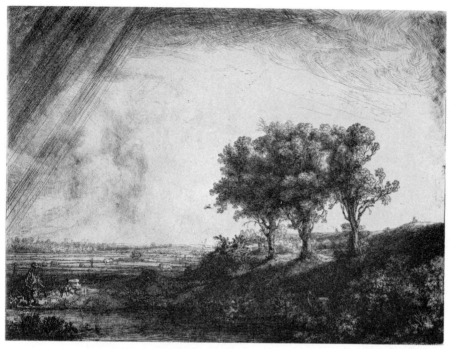

Rembrandt

rise, in high light, from the left edge. There, in the background, the picture "sits", as painters say. The light of the sky and the bright meadows (darkened in the photograph) draws the eye at once into the depths of the background. No further trace of distribution in separate zones. No tree which could be regarded as an independent element outside of the total movement of form and light.

When Rembrandt, in the most popular of his etchings, the landscape with the three oaks,* concentrates the accent still more on one point, he certainly achieves a new and important effect, but fundamentally it is the same style. Such a predominance of one motive in the picture was quite unprecedented. The trees alone are certainly not the point, but the hidden opposition of the verticals to the wide spread of the plain. But the trees bear the main emphasis. Everything is subordinated to them, down to the movements of the atmosphere: the sky weaves a halo round the oaks; they stand like victors. Thus we may recall, in Claude Lorrain, isolated splendid trees which, just because of their unprecedented isolation, look so new in the picture. And when nothing at all is there save a distant landscape with a high sky above, then it is the force of the one line of the horizon which can give the landscape its baroque

Schongauer

character. Or the spatial relationship between sky and earth, when the mighty mass of air fills the picture-space with oppressive power.

That is, within the concept of unified unity, the notion which made it possible that now, and now only, the greatness of the sea could find its representation too.

4. HISTORICAL AND NATIONAL CHARACTERISTICS

Anyone who compares a sacred picture by Dürer with one by Schongauer—for instance, *Christ Taken Prisoner* * in the Great Passion woodcut with the same plate in Schongauer's series of engravings*—will always feel a fresh surprise at the lucidity and comprehensibility of his story. We then say that the composition is better thought out and the story more completely cut down

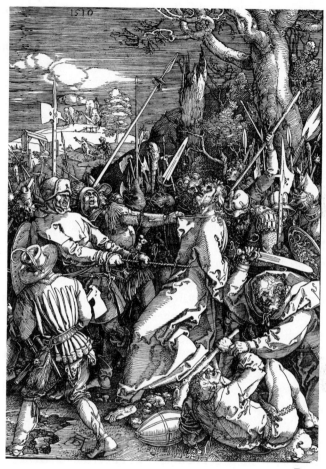

Dürer

to its essentials, but our first business here is by no means the qualitative difference between individual achievements but different representational forms which, extending far beyond the individual case, were binding for the whole mode of artistic thought. We return once more to the characteristics of the pre-renaissance stage, the fundamentals having been indicated at the beginning.

Certainly, Dürer's compositions can claim greater clarity of appearance. Christ, as diagonal form, dominates the whole picture, and at the very first glance brings home the motive of violence. The men dragging Him forwards, by the contrast of the opposing direction, emphasise the force of this diagonal. But the theme of Peter and Malchus, as a mere episode, remains subordinate to the main theme. It forms one of the (symmetrical) corner fillings. In

Schongauer, there is still no distinction between main and secondary. He has not yet the clear system of directions and counter-directions. In places the figures can seem tangled and matted; conversely, other details can look all too detached and loose. The whole relatively monotonous in comparison with the oppositions which fill the compositions of the renaissance style.

The Italian primitives, being Italians, are superior to Schongauer in simplicity and transparency—that is why they seemed poor to the Germans—but even here Quattrocento and Cinquecento are separated by the same disparity in the organisation which, being less differentiated, is less independent in its component parts. We refer to well-known examples, such as Bellini's *Transfiguration* (Naples) and Raphael's *Transfiguration*. In Bellini, three perfectly equivalent standing figures side by side, Christ between Moses and Elias, and at their feet again three equivalent crouching figures, the disciples. In Raphael, on the other hand, not only are the dispersed elements gathered into one great form, but within this form the single detail is placed in more lively opposition. Christ raised as main figure above the accessory figures (now turned towards Him), the disciples in a more decided relation of dependence; everything coherent, and yet every motive apparently freely developed. The increase in objective clarity which the Renaissance obtained from this articulation and creation of oppositions is a chapter for itself. Here it would be preferable to take the principle first on a decorative basis. And, on the other hand, its efficacy is clearly demonstrated in the purely representative pictures of saints as in the stories.

What else is it but co-ordination without contrast, multiplicity without genuine unity, which makes Botticelli's or Cima's arrangements look brittle and thin as soon as we think of examples by Fra Bartolommeo or Titian? Only when the whole was reduced to a unified system could a feeling for the differentiation of the parts awake, and only within a strictly constituted unity could the component part develop to independent effect.

While this process can be easily followed in the representative altar-piece, and no longer causes surprise, it is observations of such a kind which first make the history of the design of bodies and heads comprehensible too. The articulation of the torso, as given by the High Renaissance, is absolutely identical with what the composition of the figure picture achieved on a large scale—unity, system, development of oppositions which, the more obviously they relate to each other, the more they are felt as parts of integral importance. And this development, too, if we leave out of account general differences of nationality, is the same in south and north. Verocchio's drawing of the nude stands in exactly the same relationship to Michelangelo's as a drawing by

Hugo van der Goes to Dürer, or, otherwise expressed, that body of Christ in Verocchio's *Baptism* (Florence, Accademia) stands stylistically on the same level as the nude of Adam in the *Temptation* of Hugo van der Goes ⋆ (Vienna): for all its naturalistic delicacy, the same lack of articulation and conscious manipulation of oppositional effects. If then in Dürer's *Adam and Eve*, or in Palma Vecchio's painting reproduced above (p. 76), the great formal oppositions separate as if of themselves, and the body gives the effect of a clear system, that is not "progress in the apprehension of nature" but a formulation of natural impressions on a new decorative basis. And even where we must speak of antique influences, the adoption of the antique schema first became possible when the condition of a corresponding decorative feeling was fulfilled.

In heads, the relationship is clearer in so far as here, without artificial punctuation, a given rigid group of forms was developed from a loose juxtaposition into a living unity. These are, of course, effects which we can certainly describe, but which remain outside our comprehension if they are not experienced. A Flemish Quattrocentist like Dirk Bouts (see reproduction, p. 147) and his Italian contemporary Credi⋆ resemble each other in that the head is in neither case subjected to a system. There is as yet no reciprocal tension of the forms of the face, which therefore do not act as independent parts. If we now look at a Dürer (see reproduction, p., 42) or at that Orley (p. 136) which in subject is especially akin to Credi, it seems as though we were realising for the first time that the mouth has a horizontal form, and it seems to assert itself against the

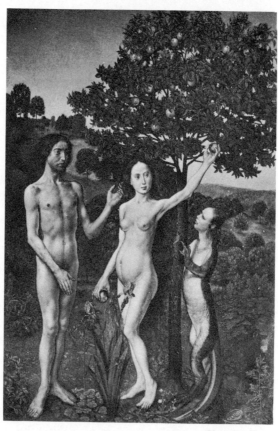

Van der Goes

Lorenzo di Credi

vertical form with a special power. At the very moment, however, at which the forms settle into the elementary directions, the total organisation becomes firm: the part achieves a new meaning within the whole. We have already had occasion to speak of the characteristic accessory of the headgear. The total picture in the portrait participates in the same transformation. A window slit, for instance, only appears in the sixteenth century if it is called upon to act as a definite oppositional form.

Although the Italians have by nature a special inclination to the tectonic, and hence to the system of independent parts, the results of the development along the German line are surprisingly similar. Holbein's head of the French Ambassador (see reproduction, p. 167) is based on exactly the same system of accents as Raphael's drawing of Pietro Aretino in Marc Antonio's engraving.* It is just in such international parallels that we can best train our feeling for that relationship of effect between part and whole which it is so difficult to describe.

That feeling is what the historian needs if he is to grasp the transformation which takes place in the advance from Titian to Tintoretto and El Greco, from Holbein to Moro and Rubens. "The mouth has become more speaking," we say, "the eye more expressive." Certainly, but the point at issue here is not the problem of expression, but a schema of unification with single salient points which, as a decorative principle, is also binding for the arrangement of the picture as a whole. Forms come into flux and hence there arises a new unity, a new relation of the detail to the whole. Correggio already had a distinct feeling for the effects which come about when the component part is deprived of its independence. The late Michelangelo and the late Titian, each in his own way, press to the same goal, and Tintoretto, and still more El Greco, attacked with real passion the problem of making the higher unity of the picture pro-

ceed from the annihilation of its separate entities. Under separate entities, of course, we must not think only of the separate object: the problem remains identical for the mere head as for the figure composition, for colour as for the geometric directions in the picture. The point at which we must apply the new definition of style can certainly not be fixed. Everything is transitional and relative in its effect. Giovanni da Bologna's group of the *Rape of the Women* (Florence, Loggia dei Lanzi), to close with an example from sculpture, seems to have been designed with no other aim than absolute unity if we come from

Raphael (Engraving by Marc Antonio)

the High Renaissance, but as soon as we compare it with Bernini, the (early) *Rape of Proserpine*, the whole thing disintegrates into separate effects.

Of all nations, Italy has given the classic type its clearest impress; that is the glory of her architecture as of her design. Even in the baroque she never went so far in depriving the parts of their independence as Germany. We could characterise the difference of imagination by a musical metaphor. Italian church bells always hold to definite tone-figures: when German bells ring it is merely a weft of harmonious sound. Certainly the comparison with the Italian "jangle" does not quite fit: the decisive factor in art is the demand for the independent part within the self-contained whole. It is certainly significant that only the north produced a Rembrandt, in whose art the dominant light and colour form seems to rise from out mysterious depths, but we cannot dispose of what we call Nordic baroque unity with the single case of Rembrandt. There exists in the north from the outset a general feeling for the immersion of the detail in the whole, the feeling that every entity can have sense and significance only in connection with others, with the whole world. Hence that preference for the representation of masses which struck Michelangelo as characteristic of Nordic painting. He takes exception to it, if we are to believe Francesco da Holanda: the Germans say far too much at a time, he complains; one motive would suffice to make a picture. Here the Italian could

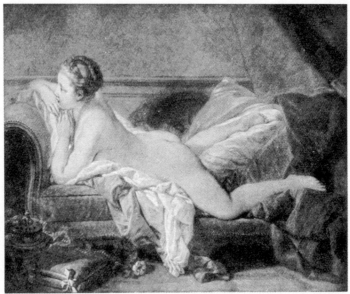

Boucher

not do justice to the national difference in the point of departure. A multiplicity of figures is not at all necessary, but the figure must seem bound up in an indissoluble unity with the rest of the form in the picture. Dürer's *St. Jerome in his Cell** is still not unified in the sense of the seventeenth century, but in the entwining of the forms Dürer signifies an exclusively Nordic possibility.

When then, towards the end of the eighteenth century, occidental art set about a renewal, one of the first manifestations of modern criticism was that, in the name of true art, it again demanded the isolation of the detail. Boucher's nude figure on the sofa* creates a unity of form with the drapery and all the other details appearing in the whole, the body collapses if we take it out of its context. David's *Madame Récamier*, on the other hand, is once more the self-sufficing, independent figure. The beauty of the rococo lies in the indissoluble whole: for the neo-classic taste, the beautiful form is what it once was, a harmony of members perfect in themselves.

ARCHITECTURE

1. GENERAL REMARKS

Whenever a new system of forms arrives, it goes without saying that at first the detail is rather obtrusive. The consciousness of the higher significance of the whole is not lacking, but the detail is apt to be felt as a separate entity and

to assert itself as such in the general impression. This was the case when the modern (renaissance) style lay in the hands of the primitives. They are masters enough not to let the detail get the upper hand, but the detail in its turn must be seen for itself alone beside the whole. The Renaissance first brings the balance. A window is even now a clearly isolated part, but, for the feeling, it does not separate. We cannot see it without simultaneously becoming aware of its connection with the larger form of the bay, of the total surface of the wall; and conversely, if we concentrate on the whole, it must immediately become clear to the spectator to what an extent this is in its turn conditioned by the parts.

What then the baroque brings as something new is not merely unity, but that conception of absolute unity in which the part, as an independent value, is swallowed up in the whole. No longer do beautiful elements combine in a unity in which they continue to breathe independently, but the parts have submitted to a dominating total motive, and only the co-operation with the whole gives them sense and beauty. That classic definition of the perfect in L. B. Alberti—the form must be of such a kind that we could change or remove no smallest part without destroying the whole—applies to renaissance as well as to baroque art. Every architectonic whole is a perfect unity, but the concept unity has a different sense in classic art from the sense it has in the baroque. What was unified for Bramante is multiple for Bernini, however much Bramante, in his turn, compared with primitive multiplicity, may be regarded as a powerful agent of unity.

Baroque unification comes about in various ways. In some cases unity is enforced by every part being deprived of its independence, or again, single motives are so developed that, as dominants, they take precedence of the others as subordinates. Dominant and subordinate also existed in renaissance art, but there the subordinate part has still an independent value, while here, even the dominant member, taken out of its context, would more or less lose its meaning.

In this sense the vertical and horizontal form-series are transformed, and there arise those great unified recessional compositions in which great sections of space have abdicated their independence in favour of a new total effect. Doubtless an enhancement exists here. But the transformation of the concept of unity has nothing to do with affective motives, or at least not in such a way that we might say that the broader outlook of the generation had created the colossal orders running through more than one storey, or that the serenity of the Renaissance had created the type with independent parts, and the gravity of baroque had then insisted on the suppression of this independence. We

certainly get the impression of happiness where beauty is poised in free members only, but even the contrary type has given form to happiness. What gayer style is there than French rococo? But this epoch would have found it impossible to revert to the expressional methods of the Renaissance. And precisely there lies our problem.

Clearly the development borders on what we have already described as the development into the painterly and the a-tectonic. The painterly effect of continuous movement always implies a certain subordination of the parts and every unification will be readily inclined to ally itself with motives of the a-tectonic taste, just as, conversely, articulated beauty is fundamentally familiar with all tectonics. Nevertheless, the concepts of multiple unity and unified unity require special treatment here too. It is just in architecture that the concepts attain an unusual lucidity.

2. EXAMPLES

It is especially Italian architecture in which we find examples of what we might call ideal lucidity. We take sculpture in the same connection, its special quality with reference to painting coming to light essentially in plastic-architectonic problems such as tombs, etc.

The Venetian and Florentino-Roman tomb achieves its classic type in a continued process of differentiation and integration of the form. The parts are opposed in increasingly definite mutual contrasts, and thus the whole achieves more and more the character of inevitability in the organisation, so that no part could be changed without the whole organism coming to grief. The primitive and renaissance types are unities with independent parts, but among the primitives, the unity is still lax. Only in combination with restraint does freedom become expressive. A. Sansovino's ecclesiastical tombs in S. Maria del Popolo in Rome give this impression in contrast to Desiderio and A. Rossellino, Leopardi's Vendramin tomb in SS. Giovanni e Paolo (Venice) in contrast to the Doges' tombs of the Quattrocento. A concentration of unprecedented effect is given by Michelangelo in the Medici tombs: essentially still the classic articulation with independent parts, but the opposition of the upright central figure and the reclining accessory figures has become tremendous. We must have our minds full of such images if we are to do justice to Bernini's achievement in the history of the development. It was impossible to enhance the effect on the basis of the isolated detail, but the baroque enters into no rivalry: the imaginary barriers between figure and figure fall, and the total mass of created forms rolls on in a broad, unified stream. That is true of

the tomb of Urban VIII. in St. Peter's and of the still more unified tomb of Alexander VII.* (reproduction, p. 107). In both cases, the opposition of seated main figures and reclining accessory figures is abolished in order that greater unity may be achieved. The accompanying figures are standing, and are brought into immediate visual contact with the figure of the Pope. How far this unity comes home to the spectator is a personal matter. We *can* spell out Bernini, but he does not intend to be read in that way. Whoever has understood the meaning of this art knows that the individual form was not only invented in connection with the whole—that is the sense of renaissance art too—but that it has abdicated its independence in favour of the whole and draws life and breath only from the whole.

In the domain of the Italian secular building we may take the Roman Cancelleria* (p. 189), although the building no longer bears the name of Bramante, as the classic example of multiple renaissance unity. A three-part composition, thoroughly self-contained in effect, but the storeys, the corner projections, the windows and bays are clearly isolated entities. It is the same with Lescot's Louvre façade. The same with the Otto Heinrichsbau in Heidelberg. Everywhere the equivalence of homogeneous parts.

If we look closer we shall, it is true, be obliged to modify the notion of equivalence. The ground floor of the Cancelleria, with regard to the other floors, is still clearly characterised as a ground floor, and hence is, in a certain sense, subordinate. Only above do the linking pilasters appear. And in this range of pilasters, which divides the wall into separate bays, it is again not simple co-ordination which is envisaged—on the contrary, broader bays alternate with narrower. That is what might be called the relative co-ordination of renaissance style. We know the Quattrocentist preliminary form in the Palazzo Rucellai* in Florence. There, complete equality of the bays prevails, and, as regards the articulation, complete equality of the storeys. The main conception in both buildings the same—the system with independent parts—but the Cancelleria already shows a more vigorous organisation of the form. The difference is identical with that which we have already described in representative art as the lax symmetry of the Quattrocentists and the strict symmetry of the Cinquecentists. In Botticelli's picture in Berlin of the *Virgin with the two Sts. John*, the juxtaposition of the figures is absolutely equibalanced, and the Virgin has only a formal precedence as the central figure. With a classic such as Andrea del Sarto—I am thinking of the *Madonna delle Arpie* in Florence— Mary is in every way raised above her companions, though they have not ceased to have their centre of gravity in themselves. That is the real point. The classic character of the series of bays of the Cancelleria is given in the fact

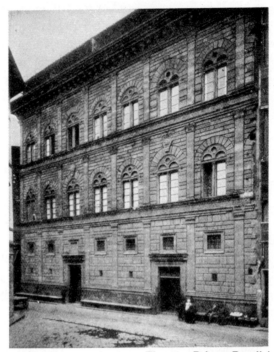

Florence, Palazzo Rucellai

that even the narrow bays are still independent proportional values, and the ground floor, for all its subordination, remains an element that has a beauty of its own.

Composed, as it is, merely of beautiful separate elements, a building like the Cancelleria is the architectonic pendant to the form of Titian's *Venus*, reproduced above (p. 170). And if we have contrasted with this Velasquez' *Venus* as the type of the living form drawn into absolute unity, we should have no difficulty in producing architectonic parallels for that too.

Hardly is the renaissance type developed when the desire becomes manifest to overcome multiplicity by greater general motives. Then, no doubt, we speak of the "larger outlook" which determined the more comprehensive form. That is wrong. Who could not be convinced from the outset that the patrons of building in the Renaissance—a Pope Julius was among them—sought the highest that human will could reach? But not everything is possible at all times. The form of multiple beauty had to be experienced before unified arrangements became imaginable. Michelangelo, Palladio are transitional. The pure baroque pendant to the Cancelleria is given in Rome in the Palazzo Odescalchi,* which shows in the two upper storeys that colossal order which

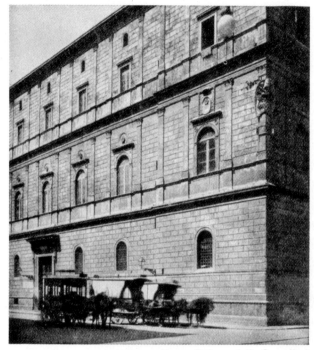

Rome, Palazzo della Cancelleria

from now on becomes the standard for the occident. The ground floor thereby receives the definite character of a plinth, that is, it becomes a dependent member. While in the Cancelleria every bay, every window, even every pilaster has a clearly expressive beauty of its own, the forms here are all handled in such a way that they are more or less fused in a mass effect. The separate sections between the pilasters present no value which could have a meaning outside of the whole. The windows are meant to blend with the pilasters and the pilasters themselves take hardly any further effect as separate forms, but only in the mass. The Palazzo Odescalchi was a beginning. Later architecture continued on the lines here indicated. The Palais Holnstein* (to-day the Archiepiscopal Palace) in Munich, a particularly distinguished building by the elder Cuvilliés, is only effective as a moving surface: no bay can be separately apprehended: the windows are blended with the pilasters, which have almost entirely lost their tectonic significance.

It is a natural result of the facts here given that the baroque façade will tend to emphasise individual parts, at first in the sense of a dominating central motive. Indeed, even in the Palazzo Odescalchi, the relation of middle block and wings (invisible in the photograph) already plays a part. Before we go

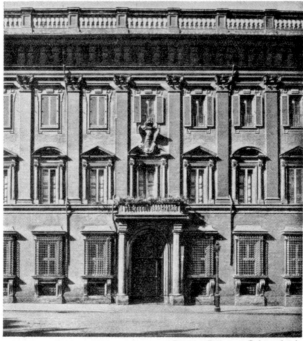

Rome, Palazzo Odescalchi

into this, we must make ourselves clear as to whether the schema with the colossal order of pilasters or columns was the only one or only the prevailing one.

Even in façades without any vertical combination of the storeys the desire for unity could be satisfied. We reproduce the Palazzo Madama in Rome *— the present Palace of the Senate. The superficial spectator may think that the building does not look essentially different from what was current in the Renaissance. The decisive factor is how far we feel the part as an independent and integral element and how far the detail is swamped in the whole. It is characteristic here that in the striking effect of the total movement, the separate storey retreats, and that beside the lively speech of the window pediments, which co-operate as one mass, the separate window can hardly be felt as a constituent part of the whole. On this line lie the manifold effects which northern baroque achieved even without plastic exuberance. By the mere rhythm of the subordinated windows, a strong impression of mass-movement was imparted to the wall.

But, as we have said, the tendency to the salient point is always present in the baroque: the effect tends to be gathered into a main motive which holds the

secondary motives in permanent dependence, but for all that is dependent on these accessories and of itself alone can have no meaning. Even in the Palazzo Odescalchi the middle projects in a broad surface, quite slightly, without practical significance, and at the side there remain short wings without pro- · portional independence. (Later they were lengthened.) This subordinating type of style is to be seen on the largest scale in châteaux, in the middle and corner pavilions, but even in the small dwelling-house we find central projections where the difference only amounts to a few inches. Instead of one central accent, two accents flanking the middle can be set in long façades— not at the corners, of course, that is renaissance (cf. the Cancelleria in Rome), but removed from the corners: *e.g.* Kinsky Palace, Prague.

In church façades essentially the same development is repeated. The Italian High Renaissance bequeathed to the baroque, in its full perfection, the type of the two-part façade with five bays below and three above with transitional volutes. But now the bays lose more and more of their proportional independence, the series of equivalent parts is replaced by a decided predominance of the middle, there lie the strongest plastic and dynamic accents, the crest of the movement swelling from the sides. For the unity of the vertical order, baroque buildings rarely resorted to the method of connected storeys, but, while the building remains two-storeyed, care is taken that one storey should have a decided predominance over the other.

We have already had occasion to recall the analogy of the development in so remote a domain as Dutch landscape painting, and it might be well to repeat

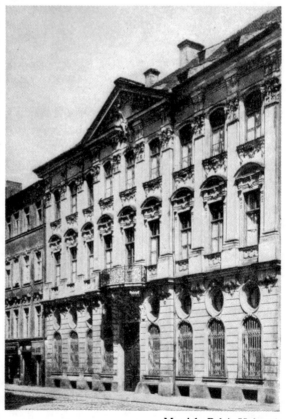

Munich, Palais Holnstein

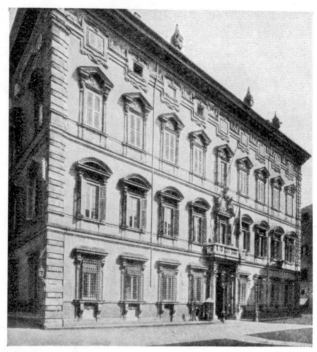

Rome, Palazzo Madama

the reference here so that we may avoid losing sight of the general principle among isolated facts of architectural history. It is, in fact, the same notion of the unified effect concentrated in salient points which distinguishes the Dutch landscape of the seventeenth century from the uniformly co-ordinated presentment of the sixteenth.

Examples, of course, are not only to be found in major architecture, but in the smaller world of furniture and utensils. We can feel that practical reasons played a part in transforming the two-storey cupboard of the Renaissance into the unified baroque cupboard, but the transformation lay in the general trend of taste, and would in any case have come about.

For every horizontal series of forms the baroque seeks the unified grouping. When it decorates a uniform series of choir stalls it tends to unite the series under a curved moulding, just as in churches, for no practical reason, it makes the columns of the nave gravitate towards the middle of the row (cf. the choir stalls of St. Peter's in Munich * and the church of Steingaden, Bavaria).

Certainly, in all these cases, the entire work is not exhausted by the description of the general motive; the effect of unity always depends, too, on a transformation of the elements by which it becomes difficult for them to assert

themselves as separate entities. Those choir stalls have entered into a unified form not only because of the crowning arch, but because the separate panels are so formed that they *must* find their support in each other. They are no longer self-supporting.

And it is exactly the same with the example of the cupboard. The rococo connects the two wings of the door with a curved moulding. If then the upper edges of the doors follow this line, that is, rise towards the middle, it is natural to see them as a pair. The separate part has no further independence. And in the same way the rococo table no longer has legs which look like independent forms and are worked out as such: they are welded into the whole. A-tectonic demands are fundamentally related to the demands for absolute unity. The ultimate result is to be seen in those rococo interiors, principally in churches, in which the entire furniture is so blended into the whole that we cannot even imagine the single object isolated. Incomparable examples are to be found in the north.

At all points we encounter general differences of national imagination: the Italians developed the part more freely than the Nordic peoples and never

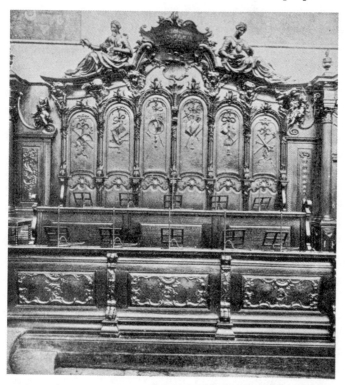

Munich, Choir Stalls in St. Peter's

sacrificed its independence so completely. But the free parts do not exist from the beginning: they are something which must first be created, that is, felt. We refer to the introductory sentences of this section. The special beauty of the Italian Renaissance lies in the unique way in which it worked out the part— a column, a panel, a member of a space—to a perfection at rest within itself. Germanic imagination never allowed the part to attain such independence. The concept of articulated beauty is essentially a Latin concept.

This seems to be contradicted by the fact that northern architecture is credited with a very powerful individualisation of the separate motives, that an oriel or a tower is not embodied into the whole at all, but resists it by its own individual will. Yet this individualism has nothing to do with the freedom of the parts in a whole whose coherence is law. And the accentuation of the individual will does not explain everything: the characteristic thing is how these offshoots of wilfulness remain firmly rooted in the building. Such an oriel could not be detached without bloodshed. That quite heterogeneous parts can be sustained by a common will to life is a concept of unity inaccessible to the Italian imagination. The "wild" manner of the first German Renaissance, which we find in the Town Halls of Altenburg, Schweinfurt and Rothenburg, gradually sobered down, but even in the measured monumentality of the Town Halls of Augsburg or Nuremberg there lives a secret unity of formative power which is different from the Italian type. The effect lies in the great flow of the form, not in members and caesurae. In all German architecture, the rhythm of movement is the decisive factor, not "beautiful proportion".

Though that is true of the baroque in general, the north sacrifices the significance of the individual member to the total movement with much more far-reaching results than Italy. It is especially in interiors that it achieved thereby wonderful effects. And we may well say that the style reveals its ultimate possibilities in German churches and châteaux of the eighteenth century.

Even in architecture the development is not a uniform progress, and in the midst of the baroque we meet reactions to the plastic-tectonic taste which were, of course, always reactions in favour of the separate part too. That a building such as the Rathaus of Amsterdam* could come into being in the age of Rembrandt must be a warning to anyone who might attempt to draw inferences affecting the whole of Dutch art from Rembrandt alone. But on the other hand, we must not exaggerate the contrast of style. We might well believe at the first glance that there was nothing in the whole world so completely in conflict with baroque unity as this house with its clear-cut separations of cornices and pilasters and its bare windows cut flat into the wall. Yet

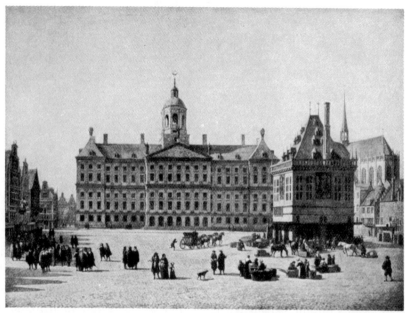

Amsterdam, the Rathaus (Berck-Heyde)

the grouping is still the unified grouping of the baroque, and the intervals no longer speak as separate beautiful bays. And then we have in contemporary pictures the proof of how far the forms may be seen for their total effect, and of how far they were so seen. It is not the separate window opening which means anything, but only the movement which results from the sum of the windows. The thing can certainly be looked at otherwise, and when, about 1800, the isolating style reappeared, then, of course, the Rathaus of Amsterdam too assumed a new physiognomy in painting.

At that time, however, in the new architecture, it was seen that suddenly the elements again separated. The window is again a total form for itself, the panel has again a life of its own, the piece of furniture becomes independent, in the interior the cupboard falls into free parts, and the table again has legs which are no longer welded into the whole as something indissoluble, but separate as vertical posts from the table top and their sockets, and can in cases be screwed off.

It is just in the comparison with neo-classic architecture of the nineteenth century that we can properly appreciate a building such as the Rathaus of Amsterdam. Think of Klenze's Neuer Königsbau in Munich: the storeys, the bays, the windows—nothing but parts which, beautiful in themselves, assert themselves in the total picture as independent members.

V

CLEARNESS AND UNCLEARNESS
(Absolute and Relative Clearness)

PAINTING

1. General Remarks

EVERY age has required of its art that it should be clear, and to call a representation unclear has always implied a criticism. But the word has a different sense in the sixteenth century from the one it had later. For classic art, all beauty meant exhaustive revelation of the form; in baroque art, absolute clearness is obscured even where a perfect rendering of facts is aimed at. The pictorial appearance no longer coincides with the maximum of objective clearness, but evades it.

Now it is well known that all art in advancing seeks to make the task of the eye increasingly difficult; that is to say, when once the problem of lucid representation has been grasped, it will come about of itself that certain difficulties are placed in the way of perception, that the picture form becomes complicated, and that the spectator, for whom the simple has become all too transparent, finds an interest in the solution of the more complicated problem. Yet the baroque obscuring of the picture, of which we have to speak, could only be partially understood as an enhancement of interest in this sense. The phenomenon is of a more profound and more comprehensive kind. It is not a question of an increased difficulty in the solution of a problem which, after all, may still be elucidated; there is always an unsolved remainder. The styles of absolute and relative clearness form a representational contrast which is absolutely parallel to the concepts hitherto dealt with. They correspond to two radically different attitudes, and, if the baroque feels the old display of the forms in the picture to be something unnatural, which it cannot repeat, that is something more than a mere desire for an increase of interest.

While in classic art every resource is at the service of formal clarity, the baroque on principle avoids making the picture look as if it were arranged for

contemplation, and could ever be exhausted in contemplation. I say, 'avoids' making the picture look so: in reality, of course, the whole is calculated with reference to the spectator and his visual needs. Every real unclearness is inartistic. But, to use a paradox, there is a clearness of the unclear. Art is art even if it abandons the ideal of complete objective clarity. The seventeenth century found a beauty in the darkness which swallows up the form. The style of movement, impressionism, of its very nature tends to a certain unclearness. It is adopted, not as the product of a naturalistic conception —the visible world simply not yielding fully clear pictures—but because there is a taste for indeterminate clarity. Only in this way did impressionism become possible. Its conditions lie in the field of decoration, not only of imitation.

On the other hand, Holbein was perfectly aware that things do not appear in nature as they do in his pictures, that the edges of objects are not seen with the uniform distinctness which he represents, and that, for actual sight, the individual forms of embroideries, jewellery, beard, and so on are more or less lost. But he would not have admitted the reference to ordinary sight as a criticism. For him, the only beauty was that of absolute distinctness, and it was just in the assertion of this demand that he saw the difference between art and nature.

There were artists before and beside Holbein who thought less strictly, or, if you like, in a more modern way. That does not alter the fact that he represents the apex of a curve of style. In general, however, we must say that the notion of clearness in the qualitative sense has no bearing on the difference between the two styles. Here it is a question of a difference of purpose, not of a difference of capacity, and the "not-clearness" of baroque art always presupposes the renaissance clarity through which the development passed. A qualitative difference only exists between the art of the primitives and the art of the classics. The concept of clarity was not present from the beginning; it had gradually to be achieved.

2. The Principal Motives

Every form has certain modes of appearance in which the highest degree of distinctness resides. The first of these involves that it should be visible down to its smallest details. Now nobody is going to expect that, in a composite narrative picture, every figure should be made clear down to the hands and feet, and even strict renaissance style never put the requirement in this way; yet it is significant that in Leonardo's *Last Supper*, of the twenty-six hands—Christ's

and the twelve disciples'—not one has "dropped under the table". And in the north it is just the same. We can test this in Massys' *Pietà*★ in Antwerp or count up the extremities in the *Pietà* of Joos van Cleve★ (Master of the Death of Mary). The hands are all there, and for the north this is much more significant, because no tradition of the kind existed there. In opposition to this the fact remains that in so matter-of-fact a study as Rembrandt's *Staal-meesters*,★ in which six figures are shown, only five of the twelve hands are visible. Terborch in his two music-making ladies (Berlin) makes one hand do. In his genre study of the *Goldwägers*, Massys, of course, gives both pairs of hands complete.

Setting aside this objective completeness, all renaissance design every-where aimed at a presentment which might be regarded as an exhaustive revelation of form. All form is compelled to yield its characteristic content. The separate motives are developed in speaking contrasts. The distances can all be exactly measured. Apart from any question of the quality of the drawing, the mere lay-out of the body in Titian's *Venus*★ or *Danae*, or in Michel-angelo's *Soldiers Bathing* is an absolute *ne plus ultra* of clearly exposed form which leaves no question unanswered.

The baroque avoids this acme of clarity. It will not say everything where it can leave something to be guessed. We can go farther—beauty no longer resides in fully apprehensible clarity at all, but passes to those forms which cannot quite be apprehended and always seem to elude the spectator. Interest in moulded form yields to the interest in indeterminate, mobile appearance. Hence the elementary, explicit full face and full profile aspects disappear, and the expressive is sought in the adventitiousness of an appearance.

For the sixteenth century, design is completely subservient to clarity. That does not mean that merely explicit aspects are shown, but in every form there lies the impulse to self-revelation. Though the ultimate degree of clear self-revelation may not be reached throughout—that is not possible in a picture of fuller content—there is still no unsolved residue. Even the most hidden form is somehow to be apprehended, but the essential motive is brought into the focus of the clear view.

Firstly, this is true of the silhouette. Even the foreshortened view, which swallows up much of the characteristic shape, is so handled that the silhouette remains communicative, that is, contains much form. Conversely, the char-acteristic of "painterly" silhouettes is that they look poor in form. They no longer coincide with the sense of the figure. Line has achieved complete independence, and therein lies the new interest we have already discussed. Naturally, artists take care throughout that the essential facts are transmitted

to the eye, but they no longer admit the clarity of the presentment as the guiding principle of the picture. What is completely based on clarity becomes suspect, as though it might have no life. If the case occurs—though it is rare —that a nude, for instance, is silhouetted in a full front view, it is doubly interesting to see how every possible means of distraction is brought into play to break up its clarity; in other words, to prevent the clear form from conveying the impression.

On the other hand, it goes without saying that even classic art has not always at its disposal the means of reducing the appearance to utter clarity. In a tree seen from some distance, the leaves always coalesce in a mere massimpression. But that is not a contradiction. We only fully realise here that we must not understand the principle of clarity as a question of raw material, but must take it as a decorative principle. The decisive point is not whether the single leaf on the tree is visible or not, but that the formula by which the leafage is rendered should be clear and uniformly comprehensible. Within the art of the sixteenth century the tree-masses of A. Altdorfer signify an advanced painterly style, but they are not yet of the true painterly type, because the individual scrolls still represent definite, comprehensible, ornamental figures, and in the foliage of a Ruysdael that is no longer the case.[1]

The unclear in itself is no problem for the sixteenth century. The seventeenth century recognises it as an artistic possibility. The whole of impressionism rests upon it. To represent movement by obscuring the form (cf. the rolling wheel) first became possible when the eye had found some charm in the half clear. But not only actual phenomena of movement, *all* form retains some indeterminateness for impressionism. And so it is not to be wondered at if it is just resolutely advanced art which often reverts to the simplest aspects. For all that, the exigencies of the interest of relative clearness are complied with.

We see into the very soul of classic art when Leonardo insists that even what is admittedly beauty should be sacrificed as soon as it interferes with clarity, if ever so little. He confesses that there is no more beautiful green than the green of the leaves when the sun shines through them, yet at the same time he warns artists against painting such things, for misleading shadows easily arise, the distinctness of the formal appearance is troubled.[2]

Light and shade serve classic art to define form just as much as drawing (in the narrower sense). Every light defines form in the detail, articulates and

[1] We can, moreover, see in Altdorfer a development from the less to the more completely clear.

[2] Leonardo, *Trattato della pittura*.

orders in the whole. Nor can baroque art dispense with these aids, but light
is no longer exclusively form-defining. In places it passes over the form, it
can veil the important motives and emphasise the subsidiary: the picture is
filled with a light-movement which in any case is not intended to comply
with the exigencies of objective distinctness.

There are cases of open conflict between form and lighting. This happens
when in the portrait the upper part of the head stands in shadow and only
the lower part is in the light, or if in a representation of the Baptism of Christ,
the Baptist alone has the light and Christ stands in the darkness. Tintoretto
is full of lighting effects which clash with the sense of the object, and what
wilful light-figures did not the young Rembrandt make the dominants in his
pictures! What is important for us, however, is not the unusual, the striking,
but what appears as the normal course of change, and was not at all specially
noticed by the contemporary public. The classics of the baroque are more
interesting than the masters of the transition, and Rembrandt has more to
say to us in his age than in his youth.

There is nothing simpler than his *Emmaus*★ etching of 1654. Lighting and
object apparently fully coincident. The Lord in the halo which illuminates
the back wall, one disciple light in the light of the window, the other dark
because he sits against the light. The boy, too, in the foreground on the stair-
case dark. Is there anything here which could not have been rendered in this
way even in the sixteenth century? But in the lower right-hand corner there
sits a dark, the strongest in the picture, which marks the plate as baroque.
Not that it is unmotivated. We can see exactly why it must be dark there,
but by the way the shadow lies, unrepeated, once for all and unique, and in
addition, excentric, it acquires a great significance. Suddenly we see a move-
ment of light in the picture which obviously does not fall in with the august
symmetry of the company at the table. We must compare a composition such
as Dürer's *Emmaus* plate in the Little Passion woodcut, to realise how fully
the lighting here has acquired independent life outside of the object. No dis-
cord between form and content—that would be a criticism—but the old
relation of form and content is sundered, and in this new freedom the scene
first wins the breath of life for the baroque age.

Everything which is called "picturesque lighting" in the ordinary sense is
a play of light which has become independent of the object, whether it be the
light of a stormy sky driving over the earth in separate patches, or the light
which, falling from above into the church, breaks against walls and pillars
and where the twilight in niches and corners turns the circumscribed space
into something limitless and inexhaustible. The classic landscape knows light

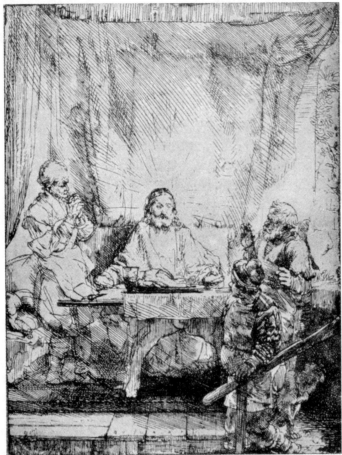

Rembrandt

as the bond between objects, then, here and there, bold contrasts are sought, but the new style is only accomplished when light is fundamentally admitted as irrational. Then it does not divide the picture into separate zones, but, independently of any plastic motive, a light lies athwart a road, or passes, a wandering gleam, over the waves of the sea. And nobody now thinks that a conflict with the form could lie in it. Motives such as the shadows of leaves playing on a house wall are now possible. Not because they are now observed for the first time, they had always been seen, but art in the spirit of Leonardo was unable to exploit them because they were indeterminate in form.

And finally, it is the same with the single figure. Terborch can paint a girl reading at a table: the light comes from behind her, glancing over the temples, and a free falling curl casts a shadow over the smooth surface. That all seems

very natural, but renaissance art did not admit this naturalism. We need only think of the pictures of the Master of the Female Half-Figure, akin in subject matter, in which lighting and modelling completely coincide. Individual liberties may be taken, but then they are exceptions and were felt as such. Irrational lighting is now the normal thing, and where it happens that objects are illuminated, that is not meant to look intentional but casual. In impressionism, however, the light-movement in itself gains so much energy that art can abandon "picturesquely" obscuring motives in the arrangement of light and dark.

The form-annihilating effects of a very strong light and the form-dissolving effects of a very weak light are both problems which, for the classic period, lay outside of art. Even the Renaissance depicted night. The figures are then kept dark, but retain their distinctness of form. Now, on the other hand, the figures coalesce with the general darkness and only an approximation remains. Taste had developed to the point of finding even this relative clearness beautiful.

The history of colouring too can be brought under the head of relative and absolute clarity.

Leonardo, who already possessed accurate theoretic knowledge of colour reflexes and the complementary colours of shadows, would not suffer the painter to bring these phenomena into his picture. He was obviously afraid that the distinctness and self-assurance of the object would suffer. Thus he speaks of the "true" shadows of things, for which only a mixture of black to the local colour might be used.[1] The history of painting is not the history of a growing insight into the facts of coloured phenomena; observations of colour are rather utilised in a selection which is made from quite other than purely naturalistic standpoints. That Leonardo's formulation can claim only a limited validity is borne out by Titian. Titian, however, is not only much younger, but, with his long development, forms here as elsewhere the transition to the other style, in which colour is on principle no longer something adhering to objects but the great element in which things attain visibility, something coherent, uniformly moving and changing every minute. We must refer back to the arguments which were made in connection with the concept of painterly movement. Here we must only say that even the extinction of colour must have had an interest for the baroque. Uniform clearness of colour is replaced by partial unclearness of colour. Colour is not there from the outset, finished at all points: it becomes. In the same way as the expressive spots

[1] Leonardo, *op. cit.* Cf. his observations on the "true" colour of foliage. A leaf should be taken from the tree to be painted, and the colour mixed by this pattern.

in drawing, of which we spoke in the preceding chapter, which partly demand and presuppose indistinctness of form, the schema of colour spots is based on the admission, as a factor in the picture, of unclear colouring.

According to the principles of classic art, colour subserves form, not merely in the detail, as Leonardo means, but in the whole too. Colour articulates the picture, seen as a whole, into its component parts, and the colour accents are also the factual accents of the composition. Soon artists found pleasure in slightly shifting the accents, and even earlier, individual anomalies in colour arrangement can be demonstrated, but the real baroque only sets in when colour has on principle been relieved of the obligation to illuminate and elucidate the form. Colour will not counteract clarity, yet the more it quickens to a life of its own, the less it can remain in the service of things.

Even the repetition of a colour at various points in the picture manifests the intention to weaken the objective function of colour. The spectator unites what belongs together in virtue of colour, and thereby enters on paths which have nothing to do with the interpretation of subject matter. A simple instance —Titian, in the portrait of *Charles V.* (Munich) introduces a red carpet, and Antonio Moro, in the portrait of *Mary of England* (Madrid) a red chair, both of which speak powerfully as local colour and impress themselves on the imagination as objects—as a red carpet and a red chair. That is just the effect which later artists would have avoided. Velasquez' method in well-known portraits was to repeat the given red on other objects—clothes, cushions, curtains, in each case slightly modified, whereby the colour easily enters into a combination detached from the thing and more or less parts company with the underlying object.

The more tonal relation there is, the more easily will the process be accomplished. The independent effect of colouring can also be promoted if one and the same colour is distributed over things of quite different meaning, or, on the other hand, if what is actually a unity is separated by treatment. A herd of sheep by Cuyp will not be an isolated whitish yellow mass, but will tend to impinge on the light of the sky, and at the same time some of the animals can be shown in conditions which separate them from their fellows and establish a relation rather with the brown of the earth (cf. the picture in Frankfort-on-the-Main).

There is an infinity of such combinations. But the strongest colour effect does not need to be bound at all to the actual main motive. In Pieter de Hooch's picture (Berlin)★ where the mother sits by the child in the cradle, the colour scheme is based on the harmony of a gleaming red and a warm yellow brown. The most intense yellow brown is on the door-post in the back-

ground, the highest red—not, as one might expect, in the woman's dress, but in a skirt which has been hung up casually on the bed. The consummation of the play of colour leaves the figure quite out of account.

Nobody will feel this to be an undue interference with the clarity of the composition, but for all that it is an emancipation of colour which the classic epoch would simply not have understood.

The problem is similar, but not identical, in pictures such as Rubens' *Andromeda*★ or Rembrandt's *Susanna* (both in Berlin). If, in the *Susanna*, Susanna's discarded cloak with its brilliant red, enhanced by the ivory-coloured body, gleams far out of the picture, we cannot be mistaken as to the object which this patch of colour signifies, and shall hardly forget that this red is a dress, Susanna's dress, yet we feel far removed from all the pictures of the sixteenth century. That is not only a question of design. Certainly the red mass is difficult to apprehend as a figure, and the way in which the red glow as it were drips off the hanging cords and seems to collect again below in the slippers as in a fiery pool is thoroughly painterly in feeling: but the decisive factor in the effect is the uniqueness of this colour, placed as it is quite unilaterally. The picture receives thereby an accent which has nothing to do with the necessities of the situation.

Rubens, too, in his quite matter-of-fact picture of *Andromeda*, felt the need of throwing a baroque, irrational patch of colour into the composition. In the lower right-hand corner, at the foot of the figure, which is seen full front in dazzling nudity, an unruly crimson heaves. Though quite explicable as an object—it is the discarded velvet robe of the king's daughter—in this place and with this emphasis, the colour comes as a surprise to any one familiar with the sixteenth century. The significant point as far as the history of style is concerned lies in the power of the colour accent, which stands in no relation at all to the real value of its underlying object, but just on that account leaves the colour in the picture free to play its own game.

The way in which similar things are usually rendered in the classic style can be seen in a Titian in the same gallery, namely in the portrait of the little daughter of Roberto Strozzi, where a red plush is also introduced at the edge, but this time is sustained and tempered from all sides by accessory colours, so that it does not stand out and causes no surprise. Real things and pictorial form completely coincide.

Finally, it follows in the spatial figure composition that beauty no longer resides in the arrangements of most perfect and most complete clarity. Though the baroque avoids teasing the spectator with an unclearness which would compel him to seek the motives, on principle it also reckons with the less

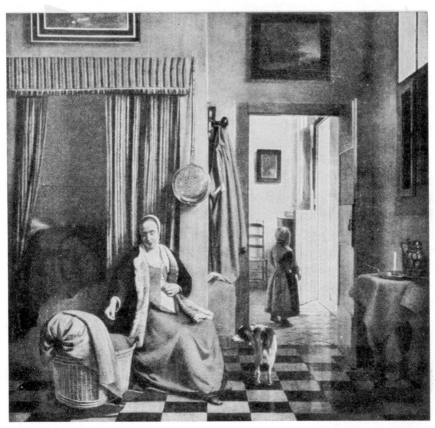

Pieter de Hooch

clear, even with the permanently unclear. Displacements occur which repress
the important elements and make the unimportant look big: that is not only
permitted, but desired, although in a hidden way the main motive must, in
its turn, be brought out.

We can here link up our consideration with Leonardo and take him as
spokesman of sixteenth century art. It is a well-known and favourite motive of
baroque painting to intensify the recessional movement by an "exaggerated"
foreground. The case occurs as soon as a very near station point is chosen for
the view. The scale of magnitude into the distance will then diminish relatively
quickly; that is, the motives of the immediate vicinity will look dispropor-
tionately big. Now Leonardo also observed this phenomenon,[1] but it had for
him only a theoretic interest; for the practice of art it seemed to him useless.
Why? Because it impairs clarity. He regarded it as inadmissible to alienate

[1] Leonardo, *op. cit.*

things in the perspective representation which are in reality closely related. Every recession, of course, involves a diminution of the object, yet in the sense of classic art Leonardo recommends a gentle progress in the diminution of the perspective scale, and declines to pass without transition from the quite small to the quite big. If later artists took pleasure just in this form, it signified no small gain for recessional impressions, but the pleasure in the interest arising from the obscuring of the picture had its say too. Vermeer might be taken as the most striking instance.

In the same way we can quote as instances of baroque obscuring all those combinations in which things which have nothing to do with each other are brought into close visual relation either because they approach in perspective or because they overlap. There had always been overlapping. The important point is how far we are compelled to unite near and far, the overlapping and the overlapped figure. This motive too intensified recessional tension and hence has been mentioned before. But we may return to it even from the standpoint of a consideration of real objects, for the result is always a picture which is surprising by reason of the characteristic strangeness of the new configuration, however familiar the forms of the separate things may be in themselves.

But the new style reveals its physiognomy perfectly clearly when, in a corporate presentment, the individual head and the individual figure no longer reckon at all on being completely recognisable. The figures which surround the preaching Christ in Rembrandt's etching (p. 164) are only partly distinguishable. There is a residue of unclearness. The more distinct form arises from the ground of the less distinct, and therein lies a new interest.

But with that the spiritual stage-setting of a story now changes completely too. While classic art aimed at revealing the motive in absolute clarity, the purpose of the baroque is not to be unclear, but to make clarity look like an accidental by-product. Sometimes the baroque plays with the charm of the hidden. Everyone knows Terborch's picture, the *Paternal Admonishment*.* The title does not fit the picture, but in any case, the point of the representation lies in what the seated male figure is saying to the standing girl, or rather in how she takes the speech. But just here the artist leaves us in the lurch. The girl, who with her white satin dress already forms, as light tone, the chief centre of attraction, remains with averted face.

That is a representational possibility which only the baroque knows.

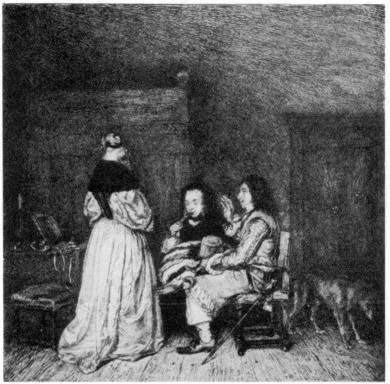

Terborch

3. SUBJECT MATTER

If the concept of clearness and unclearness is not applied here for the first time, but has constantly been applied before, the reason is that it is in some way connected with all the factors of the great process, while with the contrast of linear and painterly it partially coincides. All painterly motives live by a certain obscuring of the tangible form, and painterly impressionism, as the fundamental abolition of the palpable quality of visible things, first became possible when the "clearness of the unclear" had been made free of art. We need only refer back to an example such as that *St. Jerome** of Dürer and Ostade's *Studio** to feel how the "picturesque" in every sense postulates the notion of relative clarity. In the former case, a room in which the least object in the farthest corner still looks perfectly distinct; in the latter, the twilight which very soon makes walls and objects indistinguishable.

Yet the concept is not quite covered by what has been said up to now. The leading motives having been discussed, we shall now follow, from various

standpoints, the transformation of the completely clear into the relatively clear in individual pictures, without exhaustive analysis of individual cases, in the hope that we may in this way best do justice to the phenomenon all round.

As always, we begin with Leonardo's *Last Supper*. There is no higher stage of classic clarity. The unfolding of the form is perfect, and the composition of such a kind that the picture accents absolutely coincide with the factual accents. Tiepolo,* on the other hand, gives the typical baroque version. Christ certainly bears all the necessary emphasis, but he obviously does not determine the movement of the picture, and among the disciples abundant use is made of the principle of covering and darkening of the form. The clarity of renaissance art must have seemed lifeless to this generation. Life does not arrange its scenes in such a way that we can see everything and that the content of what is happening is determined by the grouping. It is only accidentally that, in the surging waves of real life, the essential can impress the eye as such. On such moments the new art is based. But it would be false to seek the basis of this style in the aim at naturalism; only when relative indistinctness was quite generally felt as a motive of interest could this naturalism of portrayal have its say.

For Dürer, in the same way as for Leonardo, in the woodcut of the *Virgin's Death*,* the absolutely distinct was the natural thing. The German artist does not take this requirement so seriously as the Italian, and, especially in a woodcut, is apt to leave the lines free play, but for all that, this composition is a typical example of the coincidence of real object and pictorial appearance. Every light—and this is especially in black and white the chief thing—clearly expresses a definite form, and although from the sum of all the lights a significant figure develops too, even in this effect the real object makes itself felt as the decisive factor. The painted *Virgin's Death* of Joos van Cleve* is, in the reproduction, inferior to Dürer, but only because the colour which orders the whole is lacking. Out of the system of the various colours and their repetitions, even here a total impression arises, but every colour rests on the underlying object and, even if it is repeated, it is not a homogeneous living element which makes its appearance in both places, but simply beside the red bed-cover there stands a red bed canopy.

There lies the difference from the following generation. Colour begins to acquire independence and light emancipates itself from things. In connection with this, the interest in the complete working out of the plastic motive recedes more and more, and if it is impossible to abandon distinctness of narration, this distinctness is not won directly from the object, but is yielded, apparently casually, as a felicitous by-product.

In a well-known great etching, Rembrandt translated the *Virgin's Death*★ into baroque language. A mass of light which includes the bed too, with bright clouds streaming diagonally upwards, in both cases, powerful accents of opposition, the whole a living picture of lights and darks in which the single figure is engulfed. The event is not indistinct, but we cannot for an instant doubt that this rolling light passes over the objects and is not held fast by them. The etching of the *Virgin's Death*, which was produced shortly before the *Night Watch*, belongs to the things which Rembrandt felt later to be too theatrical. In mature years his story is much simpler. That does not mean that he returned to the style of the sixteenth century—he could not have done so even if he had wished to—but he laid aside the fantastic. And so the lighting is then quite simple too, but of a simplicity which is full of mystery.

Of this type is the *Deposition*.★ Though we have already dealt with this important plate under the heading of unity, we may now add that this unity is, of course, only achieved at the cost of uniform clearness. Of Christ's body, only the bent knees are really visible, the upper part of the body is partially lost in darkness. Out of this darkness a hand comes towards Him, the one light hand of a figure the rest of which remains almost indistinguishable. The degree of distinguishability fluctuates. From the depths of the night we see single lights breaking, but in such a way that they seem bound together by a living bond. The main accents lie absolutely where the sense of the story demands, but the congruity is secret, hidden. Every sixteenth-century arrangement looks, in its direct distinctness, artificial and precious, whether as regards the whole or in relation to the separate figure.

In the *Bearing of the Cross*, it was for Raphael a matter of course to place the fallen Christ in the clearest aspect possible, and at the same time to give Him the place in the picture which the imagination, trained to distinctness, demands for Him. He is placed as the central figure in the first great stratum of space. Rubens,★ on the other hand, worked with different fundamental ideas. Just as, for the sake of the impression of movement, he avoids the plane and the tectonic, so for him only the apparently unclear is living. The soldier in Rubens' picture who rams his shoulder under the Cross is, in apparent value, more important than Christ, deep shadowing plays its part in discounting the spiritual main figure, and the incident itself, as a plastic motive, is not easily apprehended. And yet we cannot say that legitimate demands for clarity remain unsatisfied. In a covert way the spectator is led from all sides to the insignificant figure of the hero, and in the motive of the collapse everything is emphasised for the eye that at the moment is most important.

The obscuring of the main figure is, of course, only *one* mode of application

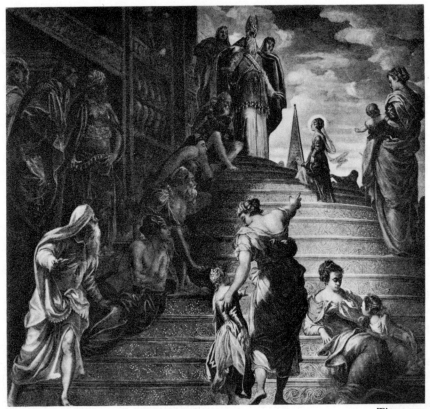

Tintoretto

of the principle, and really rather a transitional mode. Later artists are perfectly clear in the essential motives, and yet in the total appearance strangely unclear—inexplicit. The story of the *Good Samaritan*, for instance—also a *via dolorosa*—cannot be more clearly depicted than the mature Rembrandt renders it in the picture of 1648.* But as destroyer of renaissance requirements, nobody is more important than Tintoretto, in almost all subjects.

A story which, if it is to look clear at all, seems in all cases to demand a longitudinal evolution of the figures is the *Presentation of the Virgin in the Temple*.* Tintoretto did not abandon the meeting in profile of the main figures, even if he naturally avoids the pure plane, and the mountainous stairway, which must not achieve a silhouette effect, is taken rather diagonally, but he gives the forces pressing into and out of the picture by far the greater emphasis. The figure of the pointing woman, seen from behind, and the row of figures in the shadow of the wall which, in an uninterrupted stream, bear the movement into the background, would, by their mere direc-

tion, drown the main motive, even if they did not possess an immense superiority in apparent magnitude. The light-figure on the stairway also flickers away into the background. The composition, bursting with spatial energy, is a good example of a recessional style working with essentially plastic methods, but it is, in addition, just as typical for the divergence of picture accent and subject accent. Yet the little girl is not lost in space. Sustained by unobtrusive accessory forms, which are repeated with no second figure in the picture, she holds her own and asserts her relation to the High Priest as the crux of the whole, although the lighting also separates the main figures. That is Tintoretto's new stage-setting.

In the *Pietà**—one of his mightiest pictures, where, in a truly significant sense, the effect is violently concentrated on a few main accents—how much is due to the principle of clear-unclear presentment! Where artists had hitherto striven to mould every form into uniform clearness, he has omitted, obscured, repressed. Over Christ's face there falls a cast shadow which completely ignores the plastic basis, but compensates by emphasising a part of the forehead and a part of the lower face, and is of inestimable value for the impression of suffering. And how expressive are the eyes of the fainting

Tintoretto

Virgin! The whole eye-socket is one great round hole filled with a single darkness. Correggio was the first to think of such effects. But the strict classics, even when they handle shadow expressively, never dare to transgress the limits of formal clarity.

Even the north, where the concept tended to be taken more freely, developed the composite *Pietà* in famous examples to perfect clarity. Who will not think of Quinten Massys★ and Joos van Cleve?★ Not a figure which is not explicit down to its last extremities, and, in addition, a lighting which serves no other purpose than that of the most objective modelling.

The part played by light in landscape contributed less to classic clarification than to baroque obscuration. The application of light and dark on a large scale was only an achievement of the transition. Those bands of light and dark, such as earlier art used before and at the time of Rubens (cf. the river landscape of J. Brueghel the Elder, 1604★), combine while they separate, and while they really senselessly dismember the whole, they are still so far clear that they coincide with individual motives of the terrain. Only in definite baroque does the light move in free patches over the landscape. And that means that the shadow of leaves on the wall and the sun-soaked wood are now on principle possible too.

To the peculiarities of baroque landscape—to pass to another point—there

Master of the Death of Mary (Joos van Cleve)

Jan Brueghel the Elder

also belongs that the picture content must not look objectively justified. The theme loses its immediate plausibility, and we now get those scenes, dis-interested as far as the subject matter is concerned, for which landscape, of course, is more appropriate ground than portrait or story, *e.g.* Vermeer's *Street in Delft**: nothing whole, neither the individual house nor the street. Architectonic views may be rich in actual content, but they must behave as though they were not concerned with the communication of actual facts. The pictures of the Rathaus of Amsterdam are made artistically possible either by sharp foreshortening, or, if the building is shown frontally, then it is, in the context, partly discounted as an object. For the church interior, we give in the conservative Neefs the Elder* an example of the older style. Clear as regards the objects, the lighting certainly striking, but still essentially sub-servient to form: the light enriches the picture without separating from the form. In contrast to this E. de Witte* represents the modern type: the lighting is fundamentally irrational. On the floor, on the walls, on the columns, in the space, it creates clearness and unclearness simultaneously. It is indifferent how intricate the architecture is in itself: what is made of space here busies the eye as an endless, never quite soluble problem. Everything looks so simple and is not so, just because light, as incommensurable magnitude, has been divorced from form.

Part of the impression is here determined by the incompleteness in the appearance of the form, which yet satisfies the spectator. In all baroque design this complete-incomplete type must be distinguished from what with

Vermeer

the primitives is a lack of developed contemplation. In the one case, conscious unclearness; in the other, unconscious unclearness. Between the two, however, stands the will to the perfection of explicit representation. This cannot be better demonstrated than in the human figure.

We recall once more the splendid example of the recumbent female nude in which Titian took up a notion of Giorgione's (p. 170). It is more correct to take this imitation than the original, for here alone the part by the feet shows the original version—I mean the indispensable motive of the visible foot beyond the covering leg. The design appears as a wonderful self-revelation of form, everything as if of itself strives towards complete expression. The essential points are all laid clear and every component part is recognisable by its size and characteristic form. Art here revels voluptuously in lucidity, beside which beauty in the specific sense seems almost secondary. Naturally, the impression will only be properly appreciated by one who knows the primitive stages, and recognises how little a Botticelli, a Piero di Cosimo possessed this mode of beholding—not because of imperfect personal talent, but because the mind of the generation was not quite awake.

But even Titian's sun had its evening. Why does the seventeenth century no

longer produce such pictures? Did the ideal of beauty change? Certainly, but this mode of interpretation would have been felt as too artificial, too pedantic. Velasquez* (p. 171) abandons complete visibility, the normal oppositions of form: exaggerations here, suppressions there. The projection of the hip is no longer classic clarity, just as little as the disappearance of arm and leg. If in Giorgione's Venus the lower extremity of the intersected leg has vanished, we at once feel that an essential element is missing: later, much more extensive covering no longer strikes us. On the contrary, it plays its part in the interest of the picture, and if ever a body appears completely, it is made to look as if that happened by accident and not for the sake of the spectator.

It is only in connection with the general tendency that we can understand Dürer's labours on the human figure, those theoretic labours which he could not put into practice. The engraving of *Adam and Eve* (1504) is not identical with what he finally understood by beauty, but as a perfectly clear design the plate already stands on classic ground. When Rembrandt in his youth brings the same theme on to his plate, from the outset the event of the Fall is more interesting than the representation of the nude: hence the stylistically fruitful parallels to Dürer will be found rather among the later nudes. *The Woman with the Arrow** is a capital example of the perfect simplicity of his final style.

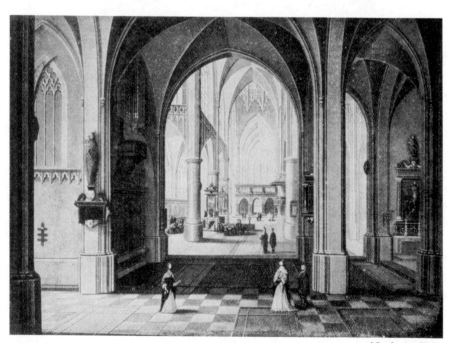

Neefs the Elder

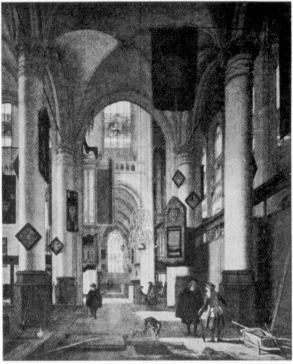

E. de Witte

The problem is stated in exactly the same way as in Velasquez' *Venus*.* Not
the body in itself but the movement is the chief thing. And the movement of
the body is only one ripple in the movement of the picture. We hardly think
of the objective clarity which has been sacrificed by the displacement of the
limbs, but, by the fascinating rhythm of the lights and darks in which the body
is exposed, we are led far beyond the effect of the mere plastic form. That is
the secret of Rembrandt's late formulation: things look quite simple and yet
stand there like miracles. Concealments and artificial obscurings are not at all
necessary; after all, he was able from pure front views and simple matter-of-
fact lighting to produce the impression that he is not dealing with single
objects but with a general element in which the objects are transfigured. I am
thinking of the so-called *Jewish Bride* (Amsterdam), a man laying his hand on
the breast of a girl. A classically clear configuration is here surrounded with
all the mystery of the inexplicable.

We shall always be apt in Rembrandt to seek in the magic of his colour and
the way in which the light dawns out of the dark the explanation of the riddle,
and not unjustifiably. But Rembrandt's style is only a particular side-track of

the general style of this epoch. The whole of impressionism is only a mysterious obscuring of the given form, and thus even a portrait by Velasquez painted soberly in broad daylight can possess the full decorative interest of the oscillation between clear and not-clear. Certainly the forms attain shape in the light, but light is again an element for itself which seems to play freely over the forms.

4. Historical and National Characteristics

Italy has rendered no greater service to the occident than by reviving to new life, for the first time in later art, the concept of perfect clarity. It was not the *bel canto* of the outline which Italy made the *haute école* of design, but the complete visibility of the form within this outline. We can say what we like in praise of a figure like Titian's recumbent Venus:* the crux of the matter remains the way in which, in the melody of this form-weft, the plastic content is perfectly expressed.

Of course this notion of perfect clarity was not present in the Renaissance from the beginning. However important it must be to a primitive art to be clear in its communication, it gives us from the outset few completely explicit forms. The sense for such things was not yet awake. The clear is mingled with the half-clear, not because artists cannot do better, but because the demand for absolute clarity does not yet exist. In opposition to the conscious unclearness of the baroque there was, in the pre-renaissance epoch, an unconscious unclearness, which is only apparently related to the other.

While Italy was always to a certain extent in advance of the north in the will to the lucid, we are astonished at the crudities which even the Florence of the Quattrocento admitted. On Benozzo Gozzoli's frescoes in the domestic chapel of the Medici there appear in the most

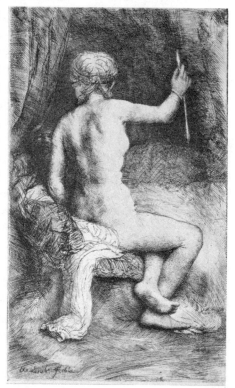

Rembrandt

visible places such things as the back view of a horse, the whole of whose
front part is covered by the rider. There remains a torso which the spec-
tator will easily complete with his intelligence, but which high art would have
repudiated as intolerable to the eye. It is a similar case with those crowding
figures in the back rows. We can see what is meant, but the design does not
give the eye sufficient clues to obtain a really complete notion of the picture.

The immediate objection is that, in a mass-representation, that is not even
possible, yet we have only to glance at a picture such as Titian's *Presentation of
the Virgin* to realise what the Cinquecento could achieve. Here too there is a
crowd of people, and the problem is not solved without figures being boldly
cut into, but the imagination is perfectly satisfied. It is the same difference
which divides the heap of figures of a Botticelli or a Ghirlandaio from the lucid
wealth of a Roman Cinquecentist. We may recall the crowd in Sebastiano's
Raising of Lazarus.

The contrast is still more obvious if, in the north, we look back from Holbein
and Dürer to Schongauer and his generation. Schongauer worked more than
all his contemporaries on the clarification of the picture, and yet, for the
spectator who has been trained by the sixteenth century, it is sometimes
painful to seek the essential point in his intricate weft of forms and to find a
whole in the dispersed and dismembered form.

I take as example a plate from the Passion—*Christ before Annas*.* The chief
figure is somewhat wedged in, but that can be left out of account. Above His
folded hands, however, there appears a hand which holds the rope round His
neck. To whom does it belong? We seek and find a second hand in a mailed
glove beside Christ's elbow, clasping a halberd: above, at the shoulder, a
helmeted head partially appears. That is the owner of the hands. And if we
look very closely, we can discover a leg in armour which completes the figure
below. It seems to us preposterous to expect the eye to collect such *membra
disjecta*: the fifteenth century thought differently. There are, of course, more
complete figures, and our example, after all, only concerns a secondary figure,
yet it is the figure which stands in direct relation to the suffering hero of the
story.

How simply and naturally, on the other hand, does the picture unfold in
Dürer's version of such a scene (*Christ before Caiaphas*, copper engraving,
p. xli). The figures separate without difficulty. As a whole and in the detail
every motive is clearly and easily apprehended. We begin to realise that a
reformation of vision has taken place, as important as Luther's clear speech
was for thought. And in reference to Dürer, Holbein seems like the fulfilment
of the prophecy.

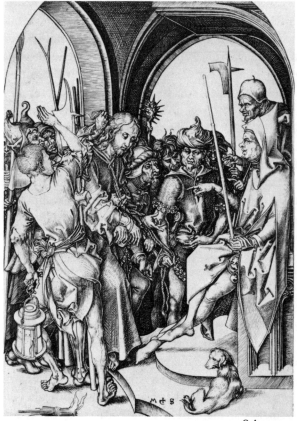

Schongauer

Parallels of this kind are, of course, only a more easily comprehensible expression of that transformation which was fulfilled in the drawing of the single form as in the stage-setting of the narrative. But, beside all that the six-teenth century achieved in objective clarity, there goes a clarification of the picture in the subjective sense, which aims at making the sensuous effect of the picture coincide with its material content. We have denoted as a characteristic of the baroque that the accents of the picture and of its subject diverge, or that at least the impression of things is accompanied by an effect which is not based on the things. Something similar is present as an unintentional by-product in pre-Renaissance art too. The design weaves its own web. The late Dürer engravings are not poorer in effect than the earlier, but this effect is completely derived from the factual motives. Composition and lighting are completely subservient to the clarity of the facts, while the early engravings

do not distinguish between effects which are produced by things and those which are not. Incontestably the example of Italian art had a "purifying" influence in this sense, yet the Italians could never have been taken as models save by a related mentality. But it has always been a trait of Nordic imagination to yield to the play of lines and patches as independent utterances of life. Italian imagination is more fettered. It does not know the fairy-tale.

Yet within the Italian High Renaissance we meet a Correggio, in whom the needle moves sharply away from the pole of clarity. He consistently seeks to deprive the objective form of its distinctness and to force familiar things into a new, different appearance by complications and misleading motives. Things which do not belong to each other are combined, things which do, separated. Without losing the connection with the period ideal, this art still intentionally avoids the absolutely clear. Baroccio, Tintoretto take up the tone. Folds cut across the figure precisely at the point at which explicitness is expected. In standing figures, just that form is made most visible on which the emphasis does not lie. Insignificant things become big, important things little—there are even places in which real traps are set for the spectator.

Meanwhile, false scents of this kind are not the ultimate formulation, but only products of the transition. We are repeating familiar things if we say that the real intention envisages a total impression distinct from the objective content, be it in the movement of the form, of the light, of the colour. To such effects the north was always susceptible. In the masters of the Danube, as in Holland, we meet even in the early sixteenth century surprising cases of free pictorial representation. If, then, later a Pieter Brueghel gives the main theme a quite small and inapparent form (*Bearing of the Cross*, 1564, *Conversion of St. Paul*, 1567), that again is a characteristic impression of the transition. The decisive factor is the ability to surrender to appearance as such without troubling about objective values. It is such a surrender if, in spite of the protest of rational vision, the foreground is seen in the "exaggerated" dimensions which a close range determines. But on the same foundations rests the power to perceive the world as a juxtaposition of patches of colour. Where that happened there was fulfilled the great metamorphosis which forms the real content of the development of occidental art, and with that the discussions of this last section link up with the theme of the first.

It is well known that the nineteenth century drew much more extreme conclusions from these premises, but only after painting had begun again at the beginning. The return to line about 1800 of course signified the return to a purely matter-of-fact pictorial appearance. From this standpoint, the art of the baroque was subjected to a criticism which was necessarily anni-

hilating, because any effect which did not proceed directly from the meaning of the representation was repudiated as mannerism.

ARCHITECTURE

Clearness and unclearness, as we understand them here, are concepts of decoration, not of imitation. There is a beauty of the absolutely clear, perfectly comprehensible appearance of form, and by the side of that there is a beauty which has its roots just in the not fully comprehensible, in the mystery which never quite unveils its face, in the inassimilable which seems to change at every moment. The former is the type of classic, the latter of baroque architecture and decoration. In the one case, form which is completely apparent; in the other, a creation which is, it is true, clear enough not to trouble the eye, but still not so clear that the spectator could ever reach the end. In this type late Gothic proceeded beyond high Gothic, the baroque beyond the classic Renaissance. It is not true that man can only take delight in the absolutely clear: he at once desires to get away from the clear to what can never be exhausted by visual perception. However manifold the post-renaissance transformations of style may be, they have all this remarkable quality, that the picture in some way eludes perfect comprehensibility.

Naturally, everybody thinks here of the processes of formal enrichment: how the motives, whether of an architectonic or a decorative nature, are worked out ever more richly, just because the eye of itself demands that its task be made more difficult. Yet with the realisation of a difference of degree between simpler and more intricate visual problems, we have not yet reached the essential point: it is a question of two radically different types of art. Not whether something is more difficult to apprehend is the question, but whether it is completely apprehensible or only incompletely. A baroque work such as the Spanish Steps in Rome can never, even in repeated contemplation, achieve the clarity which we recognise from the outset in face of a building of the Renaissance: it keeps its secret, even if we know its forms by heart down to their very details.

Once renaissance architecture had seemed to find an ultimate expression for wall and joint, for pillar and beam, for supporting and supported members, came the moment when all these formulations were felt to be rigid and lifeless. The change does not take place sporadically in details: the principle is changed. It is not possible—so ran the new creed—to set up anything as finished and ultimate, the life and beauty of architecture lies in the incon-

clusiveness of its appearance, in the fact that, eternally becoming, it approaches the spectator in ever new pictures.

It was not a childish love of play, finding its outlet in all kinds of change, which broke up the simple and rational forms of the Renaissance, but the will to do away with the limitation of the self-contained form. We no doubt say that the old forms have been deprived of their meaning and continue to be used wilfully, "merely for the effect". But this wilfulness has quite a definite purpose: by the depreciation of the clear, separate form the semblance of a mysterious general movement is produced. And if the old sense of the forms departs too, the result is not nonsense. But the idea of architectonic life which plays about the Dresden Zwinger can hardly be defined in the same words as that of a building by Bramante. To make the relation clear by a comparison, the elusive current of strength in baroque art stands to the definitely encompassed strength of the Renaissance in the same relation as Rembrandt's lighting to Leonardo's. Where the latter models in nothing but clear forms, the former makes the light sweep over the picture in mysteriously gliding masses.

To put it otherwise, classic clearness means representation in ultimate, enduring forms; baroque unclearness means making the forms look like something changing, becoming. The whole transformation of classic form by the multiplication of the members, the whole deformation of the old forms by apparently senseless combinations, can be put under *one* heading. In absolute clearness there lies a motive of that fixation of the figure which the baroque eschewed on principle as something unnatural.

Intersections there had always been, but it is not the same thing when they are felt as an inessential by-product of the lay-out and when a decorative accent lies on them.

The baroque loves such motives. It does not only see one form in front of another, the intersecting in front of the intersected, but enjoys the configuration which is yielded by the intersection. It is therefore not left to the spectator's free choice to create intersections by his choice of standpoint: they are adopted in the architectonic plan as inevitable.

Every intersection is an obscuring of the formal appearance. A gallery intersected by columns or pillars is naturally less clear than if it lies open to the view. But if the spectator in such an interior—we might think of the Vienna Hofbibliothek or the convent church at Andechs on the Ammersee—feels impelled repeatedly to change his standpoint, the impulse here is not to clear up the shape of the hidden form—this appears clearly enough to prevent any dissatisfaction from arising—we rather move round it because in the inter-

sections new pictures constantly arise. The goal cannot lie in a final revelation of the intersected form—that is not even desired—but in the perception, from as many sides as possible, of the potentially existing views. But the problem remains infinite.

In a more limited way this is true of the baroque ornament.

The baroque reckons with intersections, *i.e.* with the obscured and hence indeterminate aspect even where the architectonic lay-out, seen full front, in no way contains it.

We have already referred to the fact that the baroque avoids classic frontality. The motive must be discussed here again from the standpoint of clarity. Non-frontal perspective will always occasion slight intersections, but it signifies a visual obscuring by the mere fact that, given two equal sides of a court or church interior, it necessarily makes one look bigger than the other. Nobody will feel this illusion to be displeasing. On the contrary, we know how the thing is in reality and regard the difference in the picture as a gain. The lay-out of baroque château buildings, even if a series of corresponding buildings lies round the central block in a wide semicircle (*e.g.* Nymphenburg), is throughout based on this kind of observation. The front perspective yields the least characteristic picture. We are justified in so judging, not only by the standard of contemporary reproduction, but because of the indication given by the approach roads (cf. above, p. 118). As a prototype of all these lay-outs, we must always refer to Bernini's colonnade of St. Peter's.

Since classicism represents an art of tangible values, it must always have at heart to make these values appear in most perfect visibility: the well-proportioned space is quite clearly kept within its bounds: the decoration can be assimilated down to the last line. Conversely, the baroque, knowing the beauty of mere *pictorial* appearance, has the possibility of taking into account the mysterious obscuring of the form, veiled distinctness. Indeed, only in these conditions can it quite realise its ideal.

How the beauty of a renaissance interior, the ultimate effect of which lies in the geometric proportions, is distinguished from the beauty of a rococo mirror hall is not only a question of tangible and intangible, but also a question of clearness and unclearness. Such a mirror hall is extraordinarily painterly, but also extraordinarily unclear. Creations of this kind assume that the demands for the clarity of the appearance have been transformed, that —a paradox for the Renaissance—there is a beauty of the unclear. With the reservation, of course, that unclearness must not become disturbing.

For the Renaissance, beauty and absolute visibility coincide. Here there are no mysterious vistas, twilight depths, no shimmer of a decoration indis-

Holbein (Etching by W. Hollar)

tinguishable in its details. Everything is completely revealed, and is meant to be assimilated at the first glance. The baroque, on the other hand, on principle avoids that complete revelation of the form which reveals its limitations too. In its churches it introduces light not only as a factor of new importance—that is a painterly motive—but forms its spaces in such a way that they are never quite assimilable by the eye or by the mind. Of course even the interior of Bramante's St. Peter's cannot be completely taken in from any standpoint, but we always know what we have to expect. The baroque envisages a tension which is never meant to be completely explained. No art is more inventive in creating surprising spatial relations of this kind than German art of the eighteenth century, especially the great monastic and pilgrimage churches of South Germany. But even in quite modest ground plans this effect of mystery was attained. This is the case in the St. John Nepomuk church by the Asam brothers (Munich), which is, for the imagination, simply inexhaustible.

It was an innovation of the High Renaissance in relation to the primitives only to provide so much ornamentation as could be assimilated in a view of the whole. The baroque takes its stand on the same principle, but arrives at other results because it no longer demands absolute distinctness of the representation to be preserved in every detail. The decoration of the Residenz theatre in Munich does not need to be seen in detail. The eye seizes main points between which zones of variable distinctness remain, and it was by no means the architect's intention that the spectator should make the form clear to himself by close inspection. On close inspection only an empty husk would remain. The soul of this art is only revealed to the spectator who is able to accept the charming shimmer of the whole.

With all that we touch no really new point: our object was only to recapitulate former discussions from the standpoint of objective clarity. In every chapter the baroque standpoint meant a kind of obscuring.

If, in the painterly picture, the forms coalesce in an impression of a general independent movement, that can only take place if they do not make their

individual value too strongly felt. But what else is it than a diminution of the clarity of the object? That goes so far that darkness completely swallows up certain parts. On the principle of the painterly this must be desirable, and no objection is raised on behalf of the subject. And so the other pairs of concepts are completed by the present one. The articulated is clearer than the un-articulated, the determinate clearer than the indeterminate, and so on. The motives of unclearness lavished by the so-called art of the decline arose just as much from an artistic necessity as the behaviour of renaissance art.

It remains a postulate that the apparatus of form in both cases is the same. The form as such must be perfectly familiar before it can be translated into the new appearance. Even in the most complicated gable-breaking of the baroque the recollection of the primary forms continues to live, only that the old forms, like the old shapes of façades and spaces, were no longer felt to be quite living.

Not until neo-classicism were the "pure" forms again felt to have life.

As illustration to this whole section we give only the comparison of two vases, Holbein's design for a tankard★ (etched by W. Hollar) and a rococo vase★ from the Schwarzenberg garden at Vienna. In the former case, the beauty of a form which fully reveals it-self; in the latter, the beauty of a form which can never quite be assimilated. The modelling and filling of the sur-faces are as important as the course of the outline. In Holbein, the plastic form falls into a perfectly clear and perfectly exhaustive silhouette, and the ornamental design not only exactly and neatly fills the surface given in the main aspect, but draws its general effect from the per-fectly lucid appearance. The rococo artist, on the other hand, on principle avoided what Holbein sought: we can set it up as we like, the form can never quite be grasped and fixed: the "pictur-esque" picture retains for the eye some-thing inexhaustible.

Vienna, Schwarzenberg Garden

CONCLUSION

1. External and Internal History of Art

IT is no felicitous metaphor to call art the mirror of life, and a survey which takes the history of art essentially as the history of expression runs the risk of disastrous one-sidedness. We can contribute what we like to the question of subject matter, we must still reckon with the fact that the expressional organism did not always remain the same. Naturally, in the course of time, art manifests very various contents, but that does not determine the variation in its appearance: speech itself changes as well as grammar and syntax. Not only that it is differently pronounced in different places—that we can easily admit —but it has absolutely its own development, and the most powerful individual talent has only been able to win from it a definite form of expression which does not rise very far above general possibilities. Here too the objection will certainly be made that that goes without saying, the means of expression were only gradually achieved. That is not what is meant here. Even when the means of expression are fully developed, the type varies. To put it differently—the content of the world does not crystallise for the beholder into an unchanging form. Or, to return to the first metaphor, beholding is just not a mirror which always remains the same, but a living power of apprehension which has its own inward history and has passed through many stages.

This change of the form of beholding in the contrast between the classic and baroque types has here been described. It is not the art of the sixteenth and seventeenth centuries which was to be analysed—that is something richer and more living—only the schema and the visual and creative possibilities within which art remained in both cases. To illustrate this, we could naturally only proceed by referring to the individual work of art, but everything which was said of Raphael and Titian, of Rembrandt and Velasquez, was only intended to elucidate the general course of things, not to bring to light the special value of the picture chosen. That would have required more extensive and more exact treatment. But, on the other hand, it is inevitable to refer to important

226

works: the tendency is, after all, most clearly to be seen in the most out-
standing works as the real pioneers.

Another question is how far we have the right to speak of two types at all.
Everything is transition and it is hard to answer the man who regards history
as an endless flow. For us, intellectual self-preservation demands that we
should classify the infinity of events with reference to a few results.

In its breadth, the whole process of the transformation of the imagination
has been reduced to five pairs of concepts. We can call them categories of
beholding without danger of confusion with Kant's categories. Although they
clearly run in one direction, they are still not derived from one principle.
(To a Kantian mentality they would look merely adventitious.) It is possible
that still other categories could be set up—I could not discover them—and
those given here are not so closely related that they could not be imagined in
a partly different combination. For all that, to a certain extent they involve
each other and, provided we do not take the expression literally, we could call
them five different views of one and the same thing. The linear-plastic is
connected with the compact space-strata of the plane-style, just as the tectonic-
ally self-contained has a natural affinity with the independence of the com-
ponent parts and perfected clarity. On the other hand, incomplete clarity of
form and the unity of effect with depreciated component parts will of itself
combine with the a-tectonic flux and find its place best in the impressionist-
painterly conception. And if it looks as though the recessional style did not
necessarily belong to the same family, we can reply that its recessional tensions
are exclusively based on visual effects which appeal to the eye only and not to
plastic feeling.

We can make the test. Among the reproductions illustrated there is hardly
one which could not be utilised from any of the other points of view.

2. Forms of Imitation and Decoration

All five pairs of concepts can be interpreted both in the decorative and in
the imitative sense. There is a beauty of the tectonic and a truth of the tectonic,
a beauty of the painterly and a definite content of the world which is mani-
fested in the painterly, and only in the painterly, style, and so on. But we will
not forget that our categories are only forms—forms of apprehension and
representation—and that they can therefore have no expressional content in
themselves. Here it is only a question of the schema within which a definite
beauty can manifest itself and only of the vessel in which impressions of
nature can be caught and retained. If the apprehensional form of an epoch is

tectonic in type, as in the sixteenth century, that is by no means sufficient to
explain the tectonic strength of the picture and figures of a Michelangelo
and a Fra Bartolommeo. There is a "bony" feeling which must first have
poured its marrow into the schema. That of which we speak was in its (re-
lative) expressionlessness a matter of course for mankind. When Raphael
sketched his compositions for the Villa Farnesina there was no other possi-
bility of thought than that the figures in "closed" form had to fill the surfaces,
and when Rubens designed the procession of children with the wreath of
fruit the "open" form—the figures set in space without filling it—was just as
much the only possibility, although in both cases the same theme of grace and
joy was to be treated.

False judgments enter art history if we judge from the impression which
pictures of different epochs, placed side by side, make on us. We must not
interpret their various types of expression merely in terms of *stimmung*. They
speak a different language. Thus it is false to attempt an immediate compari-
son of a Bramante with a Bernini in architecture from the point of view of
stimmung. Bramante does not only incorporate a different ideal: his mode
of thought is from the outset differently organised from Bernini's. Classic
architecture appeared to the seventeenth century as no longer quite living.
That is not to be attributed to the repose and clarity of the atmosphere but
to the way in which it is expressed. Contemporaries of baroque were also able
to dwell in the same spheres of feeling and yet be modern, as we can see from
French buildings of the seventeenth century.

Every form of beholding and representation will of its very nature incline
to one side, to a certain beauty, to a certain type of presentment of nature
(we are about to speak of this), and in so far it again appears false to call
the categories expressionless. Yet it should not be difficult to eliminate the
misunderstanding. What is meant is the form in which the living is seen,
without this life being already determined by its *more specific* content.

Whether a picture or a building, a figure or an ornament, is at issue, the
impression of the living has its roots, independently of a special tone of feeling,
in a different schema in the two cases. But the readjustment of seeing cannot
quite be detached from a different orientation of interest. Even when no
definite content of feeling is in question, the value and meaning of being
is sought in a different sphere. For classic contemplation the essence lies in
the solid, enduring figure which is delineated with the greatest definiteness
and all-round distinctness; for painterly contemplation the interest and
warrant of life lies in movement. The sixteenth century, of course, did not
quite abandon the motive of movement, and a drawing by Michelangelo

must in this point have seemed unsurpassable, yet only the seeing which aimed at mere appearance, painterly seeing, gave representation the means of producing the impression of movement in the sense of change. That is the decisive contrast between classic and baroque art. Classic ornament has its meaning in the form as it is, baroque ornament changes under the spectator's eyes. Classic colouring is a given harmony of separate colours, baroque colouring is always a movement of colour and is bound up with the impression of becoming. In another sense than of the classic portrait we should have to say of baroque that not the eye but the look was its content, and not the lips but the breath. The body breathes. The whole picture space is filled with movement.

The idea of reality has changed as much as the idea of beauty.

3. The Why of the Development

There is no denying it—the development of the process is psychologically intelligible. It is perfectly comprehensible that the notion of clarity had first to be developed before an interest could be found in a partially troubled clarity. It is just as comprehensible that the conception of a unity of parts whose independence has been swamped in the total effect could only succeed the system with independently developed parts, that to play with the hidden adherence to rule (a-tectonic) presupposes the stage of obvious adherence to rule. The development from the linear to the painterly, comprehending all the rest, means the progress from a tactile apprehension of things in space to a type of contemplation which has learned to surrender itself to the mere visual impression, in other words, the relinquishment of the physically tangible for the sake of the mere visual appearance.

The point of departure must, of course, be given. We spoke only of the transformation of a classic art into the baroque. But that a classic art comes into being at all, that the striving for a picture of the world, plastically tectonic, clear, and thought out in all its aspects, exists—that is by no means a matter of course, and only happened at definite times and at certain places in the history of mankind. And though we feel the course of things to be intelligible, that, of course, still does not explain why it takes place at all. For what reasons does this development come about?

Here we encounter the great problem—is the change in the forms of apprehension the result of an inward development, of a development of the apparatus of apprehension fulfilling itself to a certain extent of itself, or is it an impulse from outside, the other interest, the other attitude to the world,

which determines the change? The problem leads far beyond the domain of descriptive art history, and we will only indicate what we imagine the solution to be.

Both ways of regarding the problem are admissible, *i.e.* each regarded for itself alone. Certainly we must not imagine that an internal mechanism runs automatically and produces, in any conditions, the said series of forms of apprehension. For that to happen, life must be experienced in a certain way. But the human imaginative faculty will always make its organisation and possibilities of development felt in the history of art. It is true, we only see what we look for, but we only look for what we can see. Doubtless certain forms of beholding pre-exist as possibilities; whether and how they come to development depends on outward circumstances.

The history of generations does not proceed differently from the history of the individual. If a great individual like Titian incorporates perfectly new possibilities in his ultimate style, we can certainly say a new feeling demanded this new style. But these new possibilities of style first appeared for him because he had already left so many old possibilities behind him. No human personality, however mighty, would have sufficed to enable him to conceive these forms if he had not previously been over the ground which contained the necessary preliminary stages. The continuity of the life-feeling was as necessary here as in the generations which combine to form a unit in history.

The history of forms never stands still. There are times of accelerated impulse and times of slow imaginative activity, but even then an ornament continually repeated will gradually alter its physiognomy. Nothing retains its effect. What seems living to-day is not quite completely living to-morrow. This process is not only to be explained negatively by the theory of the palling of interest and a consequent necessity of a stimulation of interest, but positively also by the fact that every form lives on, begetting, and every style calls to a new one. We see that clearly in the history of decoration and architecture. But even in the history of representative art, the effect of picture on picture as a factor in style is much more important than what comes directly from the imitation of nature. Pictorial imitation developed from decoration—the design as representation once arose from the ornament—and the after-effects of this relation have affected the whole of art history.

It is a dilettantist notion that an artist could ever take up his stand before nature without any preconceived ideas. But what he has taken over as concept of representation, and how this concept goes on working in him, is much more important than anything he takes from direct observation. (At least as long as art is creative and decorative and not scientifically analytic.) The observa-

tion of nature is an empty notion as long as we do not know in what forms the observation took place. The whole progress of the "imitation of nature" is anchored in decorative feeling. Ability only plays a secondary part. While we must not allow our right to pronounce qualitative judgments on the epochs of the past to atrophy, yet it is certainly right that art has always been able to do what it wanted and that it dreaded no theme because "it could not do it", but that only that was omitted which was not felt to be pictorially interesting. Hence the history of art is not secondarily but absolutely primarily a history of decoration.

All artistic beholding is bound to certain decorative schemas or—to repeat the expression—the visible world is crystallised for the eye in certain forms. In each new crystal form, however, a new facet of the content of the world will come to light.

4. PERIODICITY OF THE DEVELOPMENT

In these circumstances, it is of great importance that certain permanent developments may be observed in all the architectonic styles of the occident. There is classic and baroque not only in more modern times and not only in antique building, but on so different ground as Gothic. In spite of the fact that the calculation of forces is totally different, High Gothic, in the most general aspect of creation, can be defined by the concepts which we developed for the classic art of the Renaissance. It has a purely "linear" character. Its beauty is a plane-beauty and is tectonic in so far as it too represents the bound-by-law. The whole can be reduced to a system of independent parts: however little the Gothic ideal coincides with the ideal of the Renaissance, there are in it nothing but parts which look self-contained, and everywhere within this world of forms, absolute clarity is envisaged.

In contrast to this, late Gothic seeks the painterly effect of vibrating forms. Not in the modern sense, but compared with the strict linearity of High Gothic, form has been divorced from the type of plastic rigidity and forced over towards the appearance of movement. The style develops recessional motives, motives of overlapping in the ornament as in space. It plays with the apparently lawless and in places softens into flux. And as now calculations with mass effects come, where the single form no longer speaks with a quite independent voice, this art delights in the mysterious and unlucid, in other words, in a partial obscuring of clarity.

For, in fact, what else shall we call it but baroque if we—with the realisation of a totally different system of structure always in mind—meet exactly

the same formal transformations as we know in later times (cf. the examples referred to in the third and the fifth chapters)—down to the turning inwards of the frontal towers—Ingolstadt, Frauenkirche—which break the plane into recession with a quite unprecedented boldness?

On quite general considerations, J. Burckhardt and Dehio supported the view that a periodicity in the history of architecture was to be assumed. That every occidental style, just as it has its classic epoch, has also its baroque, assuming that time is given it to live itself out. We can define baroque in any way we please—Dehio has his own opinion[1]—the decisive point is that he, too, believes in a history of form working itself out inwardly. The development, however, will only fulfil itself where the forms have passed from hand to hand long enough or, better expressed, where the imagination has occupied itself with form actively enough to make it yield up its baroque possibilities.

But that by no means asserts that style in this baroque phase could not be the organ of expression of the mood of an epoch. The new contents to be elicited seek their expression only in the forms of a late style. The late style in itself can take on the most various aspects; as we know, what it primarily gives is only the form of the living. Just the physiognomy of Nordic late Gothic is very strongly affected by new elements of subject matter. But Roman baroque, too, is not to be characterised merely as a late style, but must be understood as conveying new emotional values.

How should such processes of the history of architectonic forms not have their analogy in representative art too? It is really an uncontested fact that, with longer or shorter wave-lengths, certain homonymous developments from linear to painterly have taken place more than once in the occident. The history of antique art works with the same concepts as the modern and—in essentially different circumstances—the spectacle is repeated in the Middle Ages. French sculpture from the twelfth to the fifteenth centuries offers an extraordinarily clear example of such a development, to which parallels in painting are not lacking. We must only, in reference to modern art, reckon with a fundamentally different point of departure. Medieval design is not the perspective, spatial design of recent times, but more an abstract, plane type which only at the end breaks into the recessions of three-dimensional pictures. We cannot apply our categories immediately to this development, but the total movement obviously runs parallel. And that is the thing that counts, not that the development curves of the various periods of the world should absolutely coincide.

Even within a period, the historian will never be able to reckon with a

[1] Dehio u. Bezold, *Kirchliche Baukunst des Abendlandes*, ii. 190.

uniformly progressive element. Peoples and generations diverge. In one case the development is slower, in another quicker. It happens that developments which have been begun are broken off and only later resumed, or the tendencies branch, and beside a progressive style a conservative one asserts itself, receiving a special quality by the contrast. These are things which can properly be left out of consideration here.

Even the parallel between the individual arts is not complete. That they move so completely abreast as in later Italy occurs in parts of the north, but as soon, for instance, as there is anywhere an inclination to foreign models in form, the parallelism is disturbed. Then foreign matter appears on the horizon which immediately brings with it an adaptation of the eye, for which the history of German renaissance architecture offers a striking example.

Another point is that architecture retains fundamentally the elementary stages of the representation of form. When we speak of painterly rococo, we must not forget that beside those interior decorations for which the comparison holds, there is always a much more discreet exterior architecture. Rococo *can* evaporate into the free and imponderable, but it is not obliged to do so and really only did so on rare occasions. In this there lies just the peculiar character of the art of building as compared with all the other arts which, proceeding from it, have gradually quite emancipated themselves. It always retains its own degree of tectonic clarity and tangibility.

5. The Problem of Recommencement

The notion of periodicity involves the fact of a cessation and recommencement of developments. We must here too ask for the why. Why does the development ever rebound?

In the whole course of this survey, we have had in mind the renewal of style about 1800. With extraordinarily penetrating definiteness, a new "linear" mode of vision rises in opposition to the painterly mode of the eighteenth century. The general explanation that every phenomenon must beget its opposite does not help us much. The interruption remains something "unnatural" and will only happen in connection with profound changes in the spiritual world. If seeing changes from the plastic to the painterly imperceptibly and almost of itself, so that we can ask if it is not in fact just a matter of a purely inward development, in the return from the painterly to the plastic, the main impetus lies certainly in outward circumstances. The proof in our case is not difficult. It is the epoch of a revaluation of being in all spheres. The new line comes to serve a new objectivity. Not the general effect is now de-

sired, but the separate form: not the charm of an approximate appearance, but the shape as it is. The truth and beauty of nature lies in what can be grasped and measured. From the outset criticism expresses this most distinctly. Diderot contests in Boucher not only the artist but the man: This purely human feeling seeks the simple. And now appear the demands we already know: the figures in the picture shall remain isolated and give proof of their beauty by being capable of being carried into the relief, by which, of course, linear relief is meant.[1] In the same sense, later, Friedrich Schlegel said: "No confused heap of human beings but a few, distinct figures, perfected with industry, grave and austere forms distinctly outlined, standing out resolutely, no painting of clear-obscure and murk in night and shadows, but pure proportions and masses of colours as in clear chords ... but in the faces throughout and everywhere that good-natured simplicity ... which I am inclined to regard as the original character of the human being: that is the style of the old painting, the only style I love."[2]

What is expressed here in rather Preraphaelite tone is naturally nothing but what lies at the base of the new reverence for the purity of the antique-classic form, in the domain of a more general humanity.

But the case of the renewal of art about 1800 is unique, as unique as the accompanying conditions were. Within a relatively short span of time, occidental humanity then passed through a process of total regeneration. The new directly opposes the old and at all points. It really seems here as if it had been possible to begin again at the beginning.

A closer inspection certainly soon shows that art even here did not return to the point at which it once stood, but that only a spiral movement would meet the facts. But if we enquire into the beginnings of the preceding development, we look in vain for a corresponding situation where everywhere, and with quick resolution, a will to the linear and austere should have cut off a picturesque-free tradition. Certainly there are analogies in the fifteenth century, and when we denote the Quattrocento as primitive, we mean by that that the beginning of modern art lies there. Yet Masaccio takes his stand on the Trecento and Jan van Eyck's pictures are not the beginning of a tendency, but the efflorescence of a late Gothic painterly tradition reaching far back. In spite of that it is quite in order if, from certain points of view, this art

[1] Diderot, *Salons, Boucher*: "il n'y a aucune partie de ses compositions qui, *séparée des autres*, ne vous plaise ... il est sans goût: dans la multitude de figures d'hommes et de femmes qu'il a peintes, je défie qu'on en trouve quatre de caractère *propre au bas relief*, encore moins à la statue" (*Œuvres choisies*, ii. 326 ff.).

[2] F. Schlegel, *Gemaldebeschreibungen aus Paris und den Niederlanden in den Jahren 1802–1804* (*Sämtliche Werke*, vi. 14 f.).

appears to us as the preliminary stage of the classic epoch of the sixteenth century. Old and new, however, so dovetail here that it is difficult to make the section. Thus historians are always uncertain where to make the chapter on modern art history begin. Strict claims for "clear-cut" period divisions do not carry us very far. In the old form, the new is already contained just as, beside the withering leaves, the bud of the new already exists.

6. NATIONAL CHARACTERISTICS

In spite of all deviations and individual movements, the development of style in later occidental art was homogeneous, just as European culture as a whole can be taken as homogeneous. But within this homogeneity, we must reckon with the permanent differences of national types. From the beginning we have made reference to the way in which the modes of vision are refracted by nationality. There is a definite type of Italian or German imagination which asserts itself, always the same in all centuries. Naturally they are not constants in the mathematical sense, but to set up a scheme of a national type of imagination is a necessary aid to the historian. The time will soon come when the historical record of European architecture will no longer be merely subdivided into Gothic, Renaissance, and so on, but will trace out the national physiognomies which cannot quite be effaced even by imported styles. Italian Gothic is an Italian style, just as the German Renaissance can only be understood on the basis of the whole tradition of Nordic-Germanic creation.

In representative art, the relation comes more clearly to light. There is a Germanic imagination which certainly passes through the general development from plastic to painterly, but still, from the very beginning, reacts more strongly to painterly stimuli than the southern. Not the line but the web of lines. Not the established single form but the movement of form. There is faith even in the things which cannot be grasped with hands.

The form assembled in the pure plane does not long appeal to such people. They plough up the depths, they seek the stream of movement working upward from below.

Even Germanic art had its tectonic age, but not in the sense that the most rigid order was at any time also felt to be the most living. Here there is also room for the flash of inspiration, for the apparently wilful, the indirectly applied rule. The presentment strives to pass beyond the law-bound towards the unbound and unbounded. Rustling woods mean more to the imagination than the self-sufficing tectonic structure.

What is so characteristic for Romanesque feeling—articulated beauty, the

transparent system with clear-cut parts—is certainly not unknown to Germanic art as an ideal, but immediately thought seeks the unity, the all-filling, where system is abolished and the independence of the parts is submerged in the whole. That is the case with every figure. Certainly art attempted to set it on its own feet, but in secret there was always a living imaginative impulse to weave it into a more general context, to fuse its separate value into a new total appearance. And just in that fact lie the conditions of northern landscape painting. We do not see tree and hill and cloud for themselves, but everything is absorbed in the breath of the one great scene.

At a remarkably early stage, the imagination yields to those effects which do not proceed from things themselves, but leave the thing out of account—those pictures in which not the individual form of objects and their rational connection convey the impression but what, so to speak, rises as an adventitious configuration over the head of the separate form. We refer back to what was discussed above as content of the concept of artistic "unclearness".

With this is certainly connected the fact that, in northern architecture, formations were admitted which for southern imagination could no longer be understood, that is, experienced. In the south, man is the "measure of all things", and every line, every plane, every cube is the expression of this plastic anthropocentric conception. In the north there are no binding standards taken from the human being. Gothic reckons with powers which elude any possibility of human comparison, and when the newer architecture makes use of the apparatus of Italian forms, it seeks effects in a life of the form so mysterious that everyone must immediately recognise the fundamental difference in the demands made on the imitating imagination.

7. Shifting of the Centre of Gravity

It is always a little invidious to play one epoch off against another. Yet we cannot get over the fact that every people has epochs in the history of its art which seem, more than others, the peculiar revelation of its national virtues. For Italy, it was the sixteenth century which was most productive of elements peculiar only to this country; for the Germanic north, it was the period of the baroque. In Italy, a plastic talent, which shapes its classic art on the basis of linearism; in the north, a painterly faculty which only first expresses itself quite individually in baroque.

That Italy could once become the artistic centre of Europe arises naturally from other causes than those of the history of art, but it is comprehensible that in a homogeneous artistic development of the occident, the centre of gravity

must shift according to the particular faculties of the individual peoples. Italy once treated general ideals in a peculiarly clear way. Not the accident of Italian journeys undertaken by Dürer or other artists created Romanesque for the north; the journeys were the result of the attraction which the land, given the contemporary orientation of European vision, was bound to exert on the other nations. However different national characters may be, the general human element which binds is stronger than all that separates. A constant compensation takes place, and this compensation remains fecund even when at first confusion arises and—what is inevitable in every imitation —it also brings with it elements which are not understood and remain foreign.

The connection with Italy did not cease in the seventeenth century, but the most peculiar elements of the north arose without Italy. Rembrandt did not make the customary artistic journey over the Alps, and even if he had, he would hardly have been touched by the Italy of that epoch. It could not have given his imagination anything which he did not already possess in a much higher degree. But we may ask—why did the opposite movement not set in then? Why, in the painterly epoch, did the north not become the master of the south? To that we might answer that the occidental schools all passed through the plastic zone, but that for the further development into the painterly, national limits were set from the beginning.

As every history of vision must lead beyond mere art, it goes without saying that such national differences of the eye are more than a mere question of taste: conditioned and conditioning, they contain the bases of the whole world picture of a people. That is why the history of art as the doctrine of the modes of vision can claim to be, not only a mere super in the company of historical disciplines, but as necessary as sight itself.

Dover Books on Art

AFRICAN SCULPTURE, Ladislas Segy. 163 full-page plates illustrating masks, fertility figures, ceremonial objects, etc., of 50 West and Central African tribes—95% never before illustrated. 34-page introduction to African sculpture. "Mr. Segy is one of its top authorities," NEW YORKER. 164 full-page photographic plates. Introduction. Bibliography. 244pp. 6⅛ x 9¼.

T396 Paperbound $2.00

CALLIGRAPHY, J. G. Schwandner. First reprinting in 200 years of this legendary book of beautiful handwriting. Over 300 ornamental initials, 12 complete calligraphic alphabets, over 150 ornate frames and panels, 75 calligraphic pictures of cherubs, stags, lions, etc., thousands of flourishes, scrolls, etc., by the greatest 18th-century masters. All material can be copied or adapted without permission. Historical introduction. 158 full-page plates. 368pp. 9 x 13.

T475 Clothbound $10.00

A DIDEROT PICTORIAL ENCYCLOPEDIA OF TRADES AND INDUSTRY. Manufacturing and the Technical Arts in Plates Selected from "L'Encyclopédie ou Dictionnaire Raisonné des Sciences, des Arts, et des Métiers," of Denis Diderot, edited with text by C. Gillispie. Over 2000 illustrations on 485 full-page plates. Magnificent 18th-century engravings of men, women, and children working at such trades as milling flour, cheesemaking, charcoal burning, mining, silverplating, shoeing horses, making fine glass, printing, hundreds more, showing details of machinery, different steps in sequence, etc. A remarkable art work, but also the largest collection of working figures in print, copyright-free, for art directors, designers, etc. Two vols. 920pp. 9 x 12. Heavy library cloth.

T421 Two volume set $18.50

SILK SCREEN TECHNIQUES, J. Biegeleisen, M. Cohn. A practical step-by-step home course in one of the most versatile, least expensive graphic arts processes. How to build an inexpensive silk screen, prepare stencils, print, achieve special textures, use color, etc. Every step explained, diagrammed. 149 illustrations, 201pp. 6⅛ x 9¼.

T433 Paperbound $1.55

STICKS AND STONES, Lewis Mumford. An examination of forces influencing American architecture: the medieval tradition in early New England, the classical influence in Jefferson's time, the Brown Decades, the imperial facade, the machine age, etc. "A truly remarkable book," SAT. REV. OF LITERATURE. 2nd revised edition. 21 illus. xvii + 240pp. 5⅜ x 8.

T202 Paperbound $1.65

Dover Books on Art

THE COMPLETE BOOK OF SILK SCREEN PRINTING PRO-DUCTION, J. I. Biegeleisen. Here is a clear and complete picture of every aspect of silk screen technique and press operation—from individually operated manual presses to modern automatic ones. Unsurpassed as a guidebook for setting up shop, making shop operation more efficient, finding out about latest methods and equipment; or as a textbook for use in teaching, studying, or learning all aspects of the profession. 124 figures. Index. Bibliography. List of Supply Sources. xi + 253pp. 5⅜ x 8½.

T1100 Paperbound $2.00

A HISTORY OF COSTUME, Carl Köhler. The most reliable and authentic account of the development of dress from ancient times through the 19th century. Based on actual pieces of clothing that have survived, using paintings, statues and other reproductions only where originals no longer exist. Hundreds of illustrations, including detailed patterns for many articles. Highly useful for theatre and movie directors, fashion designers, illustrators, teachers. Edited and augmented by Emma von Sichart. Translated by Alexander K. Dallas. 594 illustrations. 464pp. 5⅛ x 7⅛.

T1030 Paperbound $2.75

CHINESE HOUSEHOLD FURNITURE, G. N. Kates. A summary of virtually everything that is known about authentic Chinese furniture before it was contaminated by the influence of the West. The text covers history of styles, materials used, principles of design and craftsmanship, and furniture arrangement—all fully illustrated. xiii + 190pp. 5⅝ x 8½.

T958 Paperbound $1.50

THE COMPLETE WOODCUTS OF ALBRECHT DURER, edited by Dr. Willi Kurth. Albrecht Dürer was a master in various media, but it was in woodcut design that his creative genius reached its highest expression. Here are all of his extant woodcuts, a collection of over 300 great works, many of which are not available elsewhere. An indispensable work for the art historian and critic and all art lovers. 346 plates. Index. 285pp. 8½ x 12¼.

T1097 Paperbound $2.50

Dover publishes books on commercial art, art history, crafts, design, art classics; also books on music, literature, science, mathematics, puzzles and entertainments, chess, engineering, biology, philosophy, psychology, languages, history, and other fields. For free circulars write to Dept. DA, Dover Publications, Inc., 180 Varick St., New York, N.Y. 10014.